D0516888

THE
PAUL HAMLYN
LIBRARY

DONATED BY
THE PAUL HAMLYN
FOUNDATION
TO THE
BRITISH MUSEUM

opened December 2000

# Batak Cloth and Clothing

# Batak Cloth and Clothing

## A Dynamic Indonesian Tradition

SANDRA A. NIESSEN

KUALA LUMPUR
OXFORD UNIVERSITY PRESS
OXFORD SINGAPORE NEW YORK
1993

Oxford University Press

Oxford New York Toronto
Delhi Bombay Calcutta Madras Karachi
Kuala Lumpur Singapore Hong Kong Tokyo
Nairobi Dar es Salaam Cape Town
Melbourne Auckland Madrid

and associated companies in
Berlin Ibadan

Oxford is a trade mark of Oxford University Press

Published in the United States
by Oxford University Press, New York

© Oxford University Press 1993
First published 1993

All rights reserved. No part of this publication may be reproduced,
stored in a retrieval system, or transmitted, in any form or by any means,
without the prior permission in writing of Oxford University Press.
Within Malaysia, exceptions are allowed in respect of any fair dealing for the
purpose of research or private study, or criticism or review, as permitted
under the Copyright Act currently in force. Enquiries concerning
reproduction outside these terms and in other countries should be
sent to Oxford University Press at the address below

British Library Cataloguing in Publication Data
Data available

Library of Congress Cataloging in Publication Data

Niessen, S. A.
Batak cloth and clothing: a dynamic Indonesian tradition/
Sandra A. Niessen.
    p.   cm.—(The Asia collection)
Includes bibliographical references.
ISBN 9676530409:
1. Batak (Indonesian people)—Costume.    2. Textile fabrics.
Batak—History.   I. Title.   II. Series.
DS632.B3N54    1993
391'.0089'9922—dc20
93–4636
CIP

THE
BRITISH
MUSEUM
THE PAUL HAMLYN LIBRARY

WITHDRAWN

Typeset by Indah Photosetting Centre Sdn. Bhd., Malaysia
Printed by Kyodo Printing Co. (S) Pte. Ltd., Singapore
Published by Oxford University Press,
19–25, Jalan Kuchai Lama, 58200 Kuala Lumpur, Malaysia

*To my grandmother, Emily Jane Duncan*

# Preface

THE study of Batak cloth has eclipsed the study of Batak clothing.

No wonder, it might be said in response. Batak clothing is nothing to write home about. A foreign visitor to the area, roaring through Kaban Jahe, the capital of Karo Batak country, in a luxurious Mercedes tourist bus with the one-way windows, would notice much colour: bright synthetic dresses in the Western style (floral patterns are the favourites), schoolchildren dressed in the red and white of the Indonesian flag, men dressed in dark pants and light-coloured shirts.... As the Batak were climbing out of draped, handspun, handwoven cloths and into trousers, shirts, and dresses, times were changing throughout the world. The gentleman ethnographer type was disappearing, and with him, his prose. His was the pen which committed Batak clothing descriptions to paper, and with the decline of his ethnographic genre, a clothing tradition disappeared from literary view.

Not so the cloth. The first descriptions of the Batak textile arts were disparaging. Nineteenth-century explorers wrote that the coarse cloth was fitting to the unrefined character of their makers; their colour palette of natural dyes was deemed limited; examples were hung in World Fairs of the late nineteenth century to inspire European youth to go out and improve the technology of the weavers. The first lyrical passages finally admiring the weaving arts of the Batak (in the first decades of the twentieth century), however, were uttered woefully. Even as the textiles were being recognized, it was becoming clear that these great cultural achievements were in decline, even doomed to disappear. It was as though the blinkers had been ripped off, and the new powers of sight left the witnesses wringing their hands, torn with regret that the very fact of Western access to these treasures implied their demise—oh, the irony! Strains of this sentiment reverberate up to the present:

In truth, times have changed. Indonesia is eagerly modernizing. The weaving communities have all been affected. Some early customs and beliefs still prevail, in whole or in part, depending upon the island or region; but they are fast disappearing, and, in fact, no great textiles are produced anywhere in Indonesia today (Holmgren and Spertus, 1989: 23 n. 1).

Since the aesthetic quality of the old textiles has been acknowledged, sights have been fixed on the 'traditional cloth', heirs without descendants. We have vested them with special magical and primitive

powers; they are fabrics turned fetish. We have invested our money in them knowing that our investments are safe: there are no more of them; the areas where they once were are cleaned out; they are no longer being made in the way that they used to be made. They are treasures and therefore to be hoarded. How could we ever have missed their aesthetic quality? Museums, too, began to show less of the current times and of clothing in their exhibits and to show more of the 'glorious textiles' from a time 'before Western encroachment'.

The real irony of this moment in history, however, is the unsuspected set of new ideological blinkers that the aesthetic orientation brought with it. While eyes were opened to textile art and to 'primitive' aesthetics (our version of it, at least), they were closed to the world around. Exclusive attention to the 'ancient' cloth *is* no other than the end of recorded Batak clothing history. When it became fashionable to attend to the great art of a mysterious and sublime past, the miserable present was precluded and excluded. Even the people disappeared as their body wraps were displayed as two-dimensional design works.

The old and revered handwoven textiles do not represent the end of a weaving tradition but rather the limits of our vision. The mournful predictions of writers in the early decades of this century have not come true. Batak weavers are as active—or more active—than they have ever been, albeit with all the attendant changes that the passage of about two centuries of radical social change can bring. When the Western pen ceased to write about Batak clothing styles, the modern weavings were also written off. The epithet 'modern' became as damning a criticism as the word 'traditional' had once been.

An internal logic resides here: modern Batak apparel and the modern Batak weaving industry are closely tied together as aspects of the same Batak fashion complex. The clothing system has always been the heart of Batak textile production. The old textiles are yesterday's apparel, and the modern textiles are today's apparel. It is today's much ignored clothing system which maintains today's much maligned weaving tradition.

The following is a history of Batak clothing. It attempts to replace nostalgia for a textile tradition of the past with respect for how the Batak people have ingeniously manipulated their craft and their appearance to claim a place for themselves in a rapidly changing world.

*National Museum of Ethnology*       SANDRA A. NIESSEN
*Osaka*             (br. Hutabarat)
*1992*

# Acknowledgements

I have been able to indulge a passion for Batak textiles for a long time, in order to write this book. Several generous sources of funding have made that indulgence possible, and numerous people and institutions along the way have contributed immeasurably. It is impossible to repay such support, but at least this opportunity presents itself to acknowledge and thank those who gave it. On this occasion I thank, though insufficiently in this more general acknowledgement, those who have assisted me in the long term with my study of Batak clothing and textiles. I mention specifically only those who have been directly involved in this book project.

The Social Sciences and Humanities Research Council of Canada (SSHRCC) provided me with a research grant from 1988 to 1989 which allowed me, among other things, to follow up on previous Batak textile research in Indonesia—also supported by SSHRCC and ZWO-WOTRO, the Netherlands foundation for the advancement of tropical research. I was supported by an Isaak Walton Killam Postgraduate Fellowship at the University of Alberta between 1988 and 1990 which also provided me with generous research support. The Central Research Fund of the University of Alberta provided the funding necessary to purchase and produce the graphics in this book. I wrote the first draft in a quiet studio provided and subsidized by the Leighton Artist Colony of the Banff School of Fine Arts, Banff, in May 1992. The final draft was written in the fall of 1992 at the National Museum of Ethnology, Osaka, Japan, where I was granted a visiting associate professorship and enjoyed a fully equipped office, an excellent library, and kind assistance of every type.

After receiving the publishing contract, the University of Alberta assisted me in a variety of ways to fill it. Dr Betty Crown and Dr Nancy Kerr deserve special thanks for giving me the space to do the research and writing. The staff and students of the Department of Clothing and Textiles provided a forum for the exchange of ideas. Mr Geoff Lester, superb cartographer of the Geography Department, made the maps; Mr Dick Woolner of Photographic Services took many of the studio photographs, assisted by the creative talents of Ms Wendi Weir. Ms Linda Turner, graphic assistant in the Department of Clothing and Textiles, helped in the early stages of designing some graphic materials. The heroic efforts of the Interlibrary Loans Department allowed me to do South-East Asian research while in Edmonton.

Numerous museums have provided crucial assistance by allowing me to go through their Batak collections, and more specifically for this book, by providing me with photographic materials. I especially want to thank Ms Brigitte Majlis of the Rautenstrauch-Joest Museum fur Volkerkunde in Cologne, Dr Urs Ramseyer of the Museum fur Volkerkunde und Schweizerisches Museum fur Volkskunde in Basel, and the Staatliche Museen zu Berlin–Preussischer Kulturbesitz, Museum fur Volkerkunde, Abteilung Sudasien, for unstinting support in providing me with photographs. I am also thankful to the Vereinigte Evangelische Mission in Wuppertal, the Royal Institute of Linguistics and Anthropology, Leiden, the State Museum of Ethnology, Leiden, the Royal Tropical Institute, Amsterdam, and the Ethnographic Museum, Frankfurt.

Individuals who have helped me in my quest for Batak photographs include Mr Sitor Situmorang, Dr Petrus Voorhoeve, Mr Bill Rice, Tengku Luckman Sinar, Dr Rita Smith Kipp, and drs H. J. A. Promes. In Japan, Mr Koichi Nishimura provided me with excellent studio photographs.

Ms Mary Frame was available to discuss the project in its initial stages, Ms Sita van Bemmelen put her stimulating and inspiring research on Batak women's education during the colonial era at my disposal, Dr Rita Smith Kipp advised me on Karo Batak history, and Dr Anthony Reid assisted me with the nineteenth century. Discussions with Mr Sitor Situmorang have inspired much of this book, and as always, his support has been boundless.

Nothing equals obtaining feedback on a finished manuscript. I was lucky that Dr Anthony Reid, Mr Sitor Situmorang, Dr John Markakis, Dr Etsuko Kuroda, and Ms Margot Schevill were willing to read the completed drafts and offer invaluable suggestions and much encouragement. These people gently assisted me over the hurdle. All responsibility for the text and the translations from the Dutch and German remains my own, however.

Special thanks are reserved for the Hutabarat and Hutagalung families in North Sumatra who gave me a home in a profound way while I was there. It was pure serendipity which made me a member of the Parbaju branch of the Hutabarat clan. The name means 'owner of, or, the one with, clothing', of the Western Village clan.

There are many others who have supported this project in a myriad of ways. To you all, a heartfelt thanks.

# Contents

# 1 Introduction

Under the influence of the irrevocable levelling process, the clothing of the Batak, once the primary feature from which it was possible to make out the 'nationality' of the wearer, as well as his social position, has virtually lost its characteristic stamp (Joustra, 1910: 126).

THE starting-point was distinct clans or tribes of Batak, each with a unique dress code and set of clothing. The disparateness converged with time in a common clothing, a *vestimentum communis*, just as the common tongue, the lingua franca, became Malay. Between the two was a tide of change which swept through the Batak area in the nineteenth century and on into the twentieth. The region became increasingly penetrable, penetrated, and then subjugated by European powers. The Dutch colonial presence was long felt in trade on the coasts and its political/military might was first flexed in the name of protecting the folk in the Southern Batak regions from the invading fanatical Islamic *padri* sect from Minangkabau. Change fed off the plantation-oriented east coast economy; it was facilitated by roads and railways built inland. The requirements of the new economy were translating rapidly into governmental control. The Batak region was named, carved up, pacified, put down, and regulated for the facilitation of central governance. Christian missionaries moved into the region in the 1860s. The momentum of change secured itself as the new colonial power and its religious handmaiden entrenched themselves into the fabric of social life. Experiments in cohabitation between the newcomers and the Batak people were the substance of everyday life.

It is too easy to interpret that critical period of social change which brought the Batak from wearing distinctive 'national' garb to wearing a common Euro-Malay garb, as a period of loss and decline. The process of changing clothes is complex, not as simple as purchasing a new suit from the store. In a change of clothing, people express their response to a changing world, and they claim, even create, a place within that world. Clothing has meaning. It is designed from the interpretation of the social climate and sewn from the fruits of economics. Many phases and many choices are represented in the laborious passage from 'national' clothing to the sartorial proclamation of involvement in a wider, and different, social milieu.

For all its regional differences and syncopated rhythm, that change unified the Batak area for the first time. The entire region entertained

similar political and economic challenges from a similar set of cultural forces. The definition of anarchy was settled by military shows of force from the colonial power. SiSingamangaraja, the hereditary spiritual/political leader of a great part of the Batak folk, and the most fervent opponent of the Dutch, was killed by the Dutch in 1907 and a year later the annexation of the entire Batak area was complete. Ever masters at the game of chess, and keen to accept a political challenge, the Batak learned, for their own interests, from whom to take their cues for success—or survival—in the twentieth century. The *vestimentum communis* which they adopted was imbued with a common political/cultural/historical message. Batak handwoven textiles became symbols for meaningful interpretation only in the ritual context, and even here, the diversity and appearance of these cloths exhibited the shared effects of the new world in which the Batak were living. The starting-point of each region in the race towards the *vestimentum communis* was as unique as each Batak group, and the end-point as shared as the common forces binding the Batak people together (Plate 1).

To emphasize the common social threads, to highlight the parallels and differences in Batak response to their changing social environment, this book examines Batak clothing change thematically. After reviewing the early sketchy records to obtain a sense of the clothing traditions in the early nineteenth century, it treats, with the aid of more documentation, the impacts of Malay and Islam, colonialism, and Christianity on men's and women's dress. It is not the goal of the book to describe all the subtleties of Batak clothing transformations. In any case, such a goal is impracticable due to the scantiness of the data. Instead, where the data allow, illustrative cases are examined to distil some of the meanings which clothing may have had for the Batak. Only sporadically can enough details be pulled together to

1. The *vestimentum communis*: Four Toba Batak women of Harian Boho (Ompu ni SiSihol is second from the right).
Photograph: S. Niessen, 1981.

Four neighbours on the west bank of Lake Toba in an impromptu photography session are wearing their daily dress consisting of the *vestimentum communis* of modern-day Batak: a combination of Malay and European elements. The two women in the middle are wearing Malay sarongs of local manufacture, the woman on the left a batik print sarong, and the woman on the right a European skirt. Sarongs are often worn over skirts when working. The blouses and sweaters are European in style. Wealth rather than ethnicity is shown by this clothing.

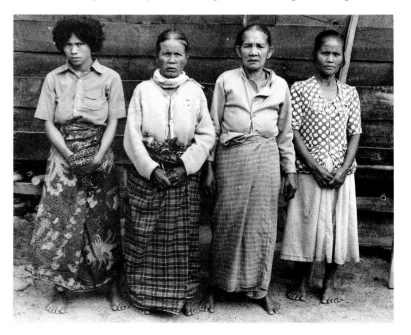

allow a picture to emerge. Areas such as Pakpak and Simalungun, about which very little is written, in general, are virtually blank spots in North Sumatran clothing history. By contrast, the amount of material devoted to the Toba Batak is almost unending. Still, relatively little is available on the clothing.

In other words, Batak clothing has not received fair or due treatment by ethnographers and writers of any generation. References to dress are tossed out in passing, often to liven the prose with a little local colour:

They are dark cobalt blue, with dark red wide border stripes and small, woven edges. They look very pretty and tasteful, full in colour, somewhat subdued in tone and look especially good on the warm, brown skin of a beauty ... (Volz, 1909: 168).

and sometimes in the scientific voice:

In general, the clothing is sufficient as regards the climate (except for the colder plateaus and mountain valleys where the mornings are sometimes very chilly and sharp temperature variations occur). However, people change them seldom, but rather put on new ones when they are completely worn out ... (Joustra, 1912: 49).

Some lighter, popular publications review the Batak weaving arts (Joustra, 1914; Tichelman, 1938). One of the best sources has been early travel accounts which paid the requisite attention to the dress of the natives between pronouncements on geography, agriculture, flora and fauna, native customs, events of the journey, and so on. Clothing has not figured largely in serious historical discussions in which social changes are reviewed. That is to say, the insights clothing can generate into the processes of social change have gone unnoticed.

The published records fail in this regard to represent the folk about whom they were written. The Batak were extremely conscious of their clothing and also that of their foreign visitors which they inspected in detail and initially also in awe. The first European visitors were required to bring elaborate clothing gifts ('a so very treasured brocade from Aceh') for the chiefs whose hospitality they enjoyed (Von Brenner-Felsach, 1890: 282). Even still, the references are skimpy. Much more, the written records reflect their writers. Joustra, for instance, prolific and faithful scribe of Batak life during the colonial era, is so focused on Dutch accomplishments, it is as though while travelling through North Sumatra he did not meet any indigenous inhabitants. The opinions he relates are developed from discussions he had with missionaries and colonial officials (Joustra, 1915a).

Furthermore, clothing was women's stuff—both Batak and Western. Had the wives of the missionaries and colonial officials written about their experiences, clothing might have loomed larger in the published records. However, these women sewed rather than wrote, for themselves and often for the Batak, and they taught them needlework, knitting, tatting, and other skills. Ironically, it is to the cloth that we must turn to learn a little about the Western wives (who are also almost entirely ignored in the colonial literature).

The cloth(e)s themselves are an invaluable primary research source. Even recent ones, when examined, show themselves to be the result of a history of social forces; the textiles may be inspected for specific data from the time when they were woven. These objects may be taken at face value. They are honest expressions of the people. Administrative and political affairs of the land may have been decided by an élite core group, and become the focus of historical debate, but how these decisions and political forces filtered down is recorded in the cloth and clothing of the people. Fashion decisions are not haphazard or fortuitous, however frivolous fashion's reputation. They are vestments of the times, and records of how the masses are digesting their circumstances and orienting themselves toward the future. The key is learning how to read them.

If clothing details provide a special insight into historical process, the items of clothing stored in museums enhance the written historical documents immeasurably. The largest and the earliest Batak collections were made at the same time as the gentleman explorers were writing travel accounts, and these men were also the authors of many of the collections (for example, the Volz collection in the Ethnographic Museum in Berlin, the Hagen collection in the Ethnographic Museum in Frankfurt, the Modigliani collection in the Ethnographic and Anthropological Museum in Florence). Unfortunately, the documentation of the collections is uneven (Niessen, 1991a). When and where the cloth was made is often vague, so that the specific historical interpretations, to which they so brilliantly lend themselves, cannot be made. Bias in the collections towards the finest textiles also limits their use. It is difficult, if not impossible, to now determine with any precision which social sectors are represented by the textiles collected in the past.

Archival photographs supplement the collections, as they depict the cloths in use. Again, the biases of the photographers must be taken into account as well as the reactions of the people to being photographed (Niessen, 1992). A preponderance of 'Sunday best of the élite' is represented in the Batak photographic archives (see, for example, Plates 5, 17, 43, 53, and 54). Extraordinarily well-behaved schoolchildren and new converts seem to have been well-loved subjects for missionary cameras (see Plates 84–86 and 88–90), young Karo Batak women for travellers' cameras (Plates 2–5), Batak leaders for administrators' cameras (see Plates 66–73), and so on.

In the pages below, I have treated clothing as a riddle. The power of clothing resides in its tangibility. It challenges in the way that an ancient bridge may challenge an archaeologist. It demands that the researcher work out the question or problem to which it was the solution. Anthropologists have traditionally correlated clothing and social structure to show how 'clothing styles ... correspond to crucial differences of class, status, sex, age, wealth, and ethnicity' (Kuper, 1973: 365). While this is a static model, it has been useful to me for the relationship it posits between cloth and society. Below, I have used cloth and clothing to interpret social events, and social events to

---

(*Opposite page*)
2–5. Karo women were a favourite subject for photographers.
Photographs 2 & 5: Museum für Volkerkunde und Schweizerisches Museum für Volkskunde, Basel; Photographs 3 & 4: Tengku Luckman Sinar, reproduced by W. Rice from Anon. (n.d.).

Meint Joustra found the thinner (imported) cotton from which the Karo Batak made their clothing more supple than the 'stiff' handwoven cotton of the Simalungun Batak, and therefore 'more becoming especially to the girls' (1910: 128). 'And don't the coquettish Karo girls pay great care to their toilet, however simple! Aren't they proud of their beautifully polished padungs (heavy silver earrings), which they wear with grace, regardless of their weight' (Joustra, 1915b: 16).

The young women are wearing clothing made from imported European cotton. A *kellamkellam* textile is a plain, indigo-dyed imported cotton cloth with no decorative embellishments of any kind. It can be used as a headcloth and is usually used as a shouldercloth. It is called a *cabin* when it is worn as a shawl around the neck. A *sambat* is composed of two *kellamkellam* sewn together so that they are wide enough to serve as an *abit* (hipcloth).

The young women in Plates 3 and 4 are wearing *batu jala* textiles as headcloths. The name of the cloth compares the white edging on the cloth to the stone weights (*batu*) tied to the edge of a fishing net (*jala*) (see Plate 49).

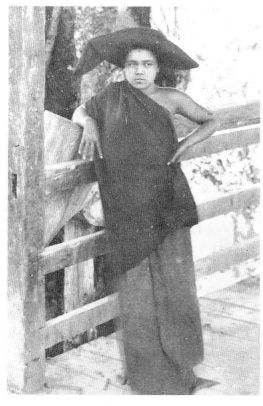
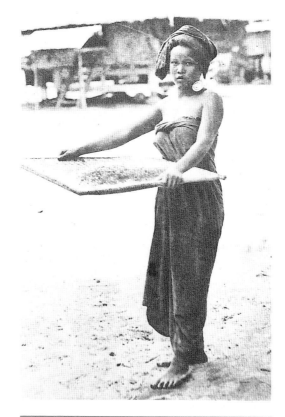
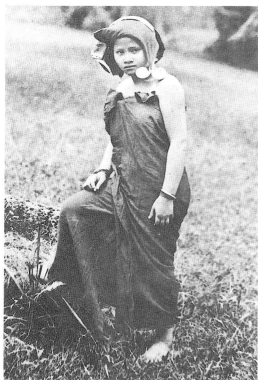
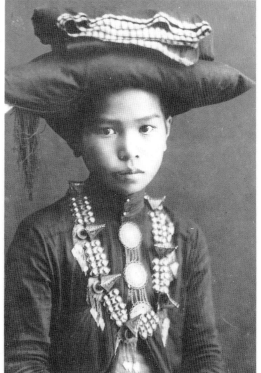

interpret cloth and clothing. With no informants from a past century with whom to verify conclusions, I have had to make do with what I have found to be a good fit. The Batak were experimenting with their identity in a new and changing world. They tried on different interpretations for size. Some selected one interpretation, and some another. What they wore is not easily, nor necessarily appropriately, interpretable as a mirror of social structure. What they wore represented the range of choices which their social circumstances permitted, and their creative struggle with these choices. The clothing betrays their social circumstances as a sentence betrays its grammar and the study of Batak social circumstances allows the interpretation of Batak clothing as grammar permits the reading of a sentence. The special quality of clothing, so valuable for the researcher, is its capacity to give 'a symbolic rendering of the cultural categories it distinguishes' (McCracken, 1988: 99).

# 2 Sumatra on the Global Economic Stage

JOHN ANDERSON explored the east coast of Sumatra in the early nineteenth century. He was on a mission for the East India Trading Company to appraise the potential of the area as a market for British manufactures. It was in the Company's interests to have detailed records of the clothing tastes and customs of the local inhabitants and their textile products and markets. Anderson tried to create friendly trade relations with the local leaders of industry and trade. He was an actor playing at a critical moment on the global stage of the industrial revolution; his business ventures were one small step in a process which achieved enough momentum to displace India as the foremost provider of cotton cloth to the world, and to similarly erode Indonesian textile production. Today, Indonesia imports cotton, and clothing production and consumption are tied in with the global market economy. The Batak area has not been exempted from this process. While most of the Batak relied on their own handmade cloth early in the nineteenth century, by the middle of the twentieth century, all the clothing systems of the Batak had radically changed.

## The Strait of Malacca and Global Commerce

The British traders in the Strait of Malacca at the turn of the nineteenth century had not come to virgin territory. They were newcomers on an ancient scene whose reputation had already been established: whoever controlled the Strait of Malacca, controlled the wealth of the world (Van Leur, 1955: 161). Foreign traders had been coming to these shores for more than 1,500 years (Map 1).

Indian beads have been found in Sumatra which date to AD 100 (Dubin, 1987: 195); Indians had voyaged across the Bay of Bengal, and presumably into the Malaccan Strait by AD 200 (Andaya and Andaya, 1982: 14). Equally possibly, they could have found themselves on the west side of Sumatra. Hindu and Buddhist influence in the language, religion, and social and political organization on both sides of the Strait attest to long and intensive contact. Whatever the early relations with India, they must have been maintained for centuries.

The Chinese, too, made their way to the Strait of Malacca. First

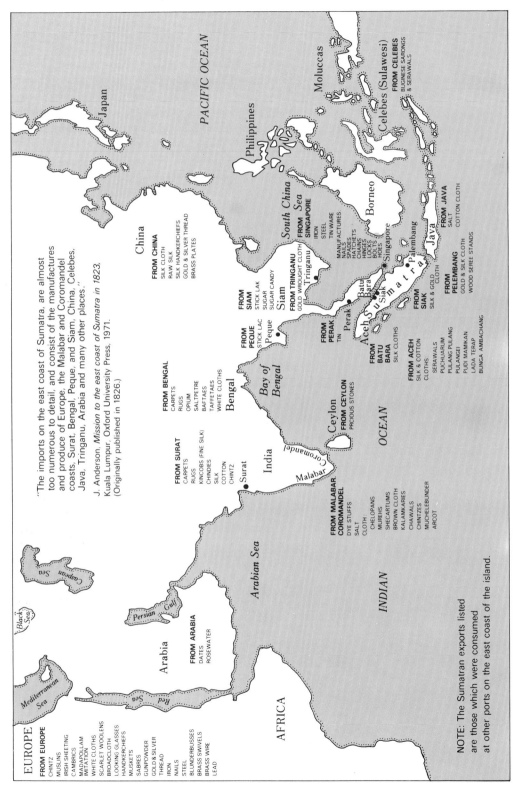

EUROPE
**FROM EUROPE**
CHINTZ
MUSLINS
IRISH SHEETING
CAMBRICS
MADAPOLLAM
IMITATION
WHITE CLOTHS
SCARLET WOOLENS
BROADCLOTH
LOOKING GLASSES
HANDKERCHIEFS
MUSKETS
SABRES
GUNPOWDER
GOLD & SILVER
THREAD
IRON
NAILS
STEEL
BLUNDERBUSSES
BRASS SWIVELS
BRASS WIRE
LEAD

Mediterranean Sea
Black Sea
Caspian Sea
Red Sea
Persian Gulf
AFRICA
Arabia
Arabian Sea

**FROM ARABIA**
DATES
ROSEWATER

"The imports on the east coast of Sumatra, are almost too numerous to detail, and consist of the manufactures and produce of Europe, the Malabar and Coromandel coasts, Surat, Bengal, Peque, and Siam, China, Celebes, Java, Tringanu, Arabia and many other places."

J. Anderson, *Mission to the east coast of Sumatra in 1823.* Kuala Lumpur. Oxford University Press, 1971. (Originally published in 1826)

Surat
India
Malabar
Coromandel

**FROM SURAT**
CARPETS
RUGS
KINCOBS (FINE SILK)
CHINDIES
SILK
COTTON
CHINTZ

**FROM MALABAR.
COROMANDEL**
DYE STUFFS
SALT
CLOTH
CHELOPANS
SHECARTUMS
MUREHS
BROWN CLOTH
KALAMKARIES
CHAWALS
CHINTZES
MUCHELEBUNDER
ARCOT

**FROM BENGAL**
CARPETS
RUGS
OPIUM
SALTPETRE
BAFTAES
TAFFETAES
WHITE CLOTHS

Bengal
Bay of Bengal

Ceylon
**FROM CEYLON**
PRECIOUS STONES

INDIAN OCEAN

China
**FROM CHINA**
SILK CLOTH
RAW SILK
SILK HANDKERCHIEFS
GOLD & SILVER THREAD
BRASS PLATES

Japan

PACIFIC OCEAN

Philippines

Moluccas

Celebes (Sulawesi)
**FROM CELEBES**
BUGINESE SARONGS
& SERAWALS

South China Sea

Borneo

Singapore
**FROM
SINGAPORE**
IRON
STEEL
TIN WARE
MANUFACTURES
NAILS
SPADES
HATCHETS
HINGES
CHAINS
LOCKS
BOLTS
HOES

**FROM SIAM**
STICK LAK
SUGAR
SUGAR CANDY

Siam

**FROM TRINGANU**
GOLD WROUGHT CLOTH
Tringanu

**FROM PEQUE**
STICK LAC
Peque

**FROM PERAK**
TIN
Perak

Batu Bara
**FROM BATU
BARA**
SILK CLOTHS

Aceh
Sumatra
Siak
**FROM SIAK**
SILK & GOLD
CLOTH

**FROM ACEH**
SILK & COTTON
CLOTHS.
SERAWALS
PUCHUARUM
PULANG PULANG
PULANGEI
PUDI MAMIKAN
LADA TERAP
BUNGA AMBACHANG

Palembang
**FROM
PELEMBANG**
GOLD & SILK CLOTH
WOOD SERE STANDS

Java
**FROM JAVA**
SALT
COTTON CLOTH

NOTE: The Sumatran exports listed are those which were consumed at other ports on the east coast of the island.

Map 1. Imports to the east coast of Sumatra during John Anderson's visit in 1823.

they came overland from the north, through Siam. They were keen to have access to the goods which India brought to the Malay Archipelago, but did not have an ocean-going fleet until the eighth or ninth century. By AD 400 they were depending on Indonesian and Malay craft to bring goods to them (Andaya and Andaya, 1982: 17).

The Strait of Malacca lay not only at the crossroads of world trade, but Sumatra sheltered the shores of Malaya, which had numerous good harbours, from high winds and tides. Ports here developed as entrepôts between India and China. The local traders/settlers at these ports offered the itinerant traders the advantage of not having to make the full journey between India and China, of not having to wait the many months for the monsoonal winds to change in order to continue on their journey. They could do their business at the half-way point and return home as quickly as possible.

Numerous ports responded to the increasing trade along the Strait in the fifth century. Srivijaya, the Hindu kingdom, probably located in Southern Sumatra, was perhaps the greatest trade emporium between approximately AD 700 and AD 1300. By the fifteenth century, it was Malacca which was rising to prominence. The important ports of Samudra-Pasai and Aru developed in the northern end of Sumatra, the former Acehnese, and the latter originally Batak, located just north of Deli.

Early on, Arab traders claimed a prominent position in this trade. By embracing Islam and creating a hospitable environment for these Muslim traders, the Sumatran ports saw economic advantage in the Indian cloth trade in the early fourteenth century, as did Malacca in the fifteenth century.

By the sixteenth century, Europeans had made their way to the scene. The Portuguese captured Malacca in 1511 and Aceh vied for it unsuccessfully in the early decades of the seventeenth century, but it was the Dutch who managed to steal it from the Portuguese in 1641. The Bugis made an unsuccessful bid for it in the eighteenth century, as did the British. In addition to these prominent, warring actors, virtually every nation of the world that could, made its entrance here. Van Leur has sketched the scene, basing his summary on the accounts of witnesses at the time:

The trade involved great multitudes of people moving from place to place, and there were colonies of foreigners everywhere. A thousand traders from Gujarat lived in Malacca before it fell in 1511, and three or four thousand were constantly travelling between India and there. To those numbers should be added the Indian traders from Coromandel, the foreigners from Persia and Arabia, the Chinese settlement [Plate 6], and the quarter or quarters of the 'foreign Indonesians', chiefly Javanese—altogether surely ten to fifteen thousand traders. It was the same picture at Bantam, a smaller size staple port: 'In the towne there is great resort of divers Countries and nations ...' (Rouffaer and Ijzerman, 1915: 24). There were people from every part of India and from Pegu and Siam, Persians, Arabs, Turks, and Chinese, as well as 'foreign Indonesians'—Malays, Ternatese, Bandanese, Banjarese, Macassarese, Buginese—each 'nation' living in its quarter inside the wall or its suburb outside. It was the same situation on the spice islands; in 1609 there were fifteen

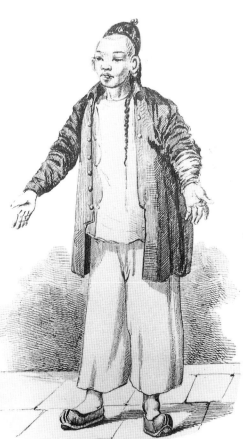

6. Chinese rice trader.
Reproduced from Bastin and Brommer (1979).

There were Chinese traders living on the east coast of Sumatra in Anderson's day, although the huge influx of Chinese did not begin until the plantation boom in the latter half of the century. The Batak would have seen the typical Chinese jacket and the pants with short, wide pipes.

Trade in the Strait of Malacca attracted traders of many nationalities, each with their own clothing traditions.

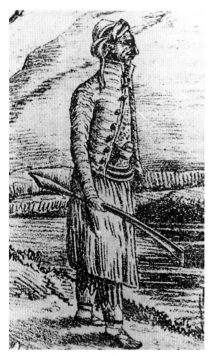

7. Haji Jat from Aceh.
Reproduced from Bastin and Brommer (1979).

The Acehnese traded actively on both east and west coasts of Sumatra and involved themselves in Batak politics throughout the centuries. In addition to their soft silk textiles, the Batak would have been familiar with their Malay-style *baju* or jackets, *serawal* or wide, low-crotched pants which narrowed at the calf and extended to the ankles, and the sarong which they wore over it.

hundred traders for the purchase of the spice crop on Banda alone, and there was a Gujarati quarter there.

It is the same picture in every port. The traders swarmed out by tens and hundreds along every coast on the whole route in southeast Asia, flocking together by thousands at the staple points ... (1955: 194–5).

The description must apply to the ports along the east coast of Sumatra as well (see Map 1).

On the west coast of Sumatra, a long-term trading relationship existed between the Batak and the Acehnese (Plate 7). West coast ports (Plate 8) appear to have developed direct trade exchanges between the Batak and foreigners (of increasing variety), rather than serving as an entrepôt between India and China (Ritter, 1839).

## No Cloth, No Trade

European cloth producers began their trade conquest of the Malay Archipelago from a position of disadvantage: they were not able to compete with Indian cloth in international trade. 'The Dutch and English companies soon discovered that cloth was the most valuable article of import to exchange against pepper and spices they wished to carry to Europe' (Reid, 1984: 157). In order to do trade and turn profits the companies had to participate in the cloth trade from India; Indian goods were universally in high demand, and even Europe developed a voracious appetite for them. European cloth manufacturers were not happy with this state of affairs:

The stream of silk and cotton materials, which was poured into Europe by the various East India Companies and their interloping competitors towards the end of the seventeenth century, impressed European producers primarily as a disagreeable form of competition which could only be dealt with by the complete prohibition of the new fabrics. In almost every country the ruin of existing manufactures was loudly prophesied ... efforts to make woollen goods popular in the East met with no success.... In the almost total absence of commodities which could be sold in the East, it was necessary to export bullion, a flat violation of the mercantilist principles still in the ascendant ... (Wadsworth and de Lacy Mann, 1931: 116–17).

The only way to compete in this climate was in the terms dictated by the competitors. The strategy used by Europe was to copy the goods of the competitors in an effort to win back their markets. Access to cotton was critical to this strategy, however, and it did not grow in Europe.

The British obtained cotton from India at the end of the seventeenth century, until 1708; Scottish mills were working with it by 1676. In the eighteenth century it came primarily from the West Indies, which also supplied France and Switzerland, and from various Mediterranean countries (Wadsworth and de Lacy Mann, 1931: 170, 183–92). In the nineteenth century, the southern states of the USA, relying on the labour of African slaves, were able to provide the bulk of Britain's cotton needs (Farnie, 1979: 5).

8. Punchong Kechil.
Reproduced from Bastin and Brommer (1979).

The Dutch set up their base of trade on 'Punchong Kechil' (Pulau Poncan Kecil/Little Poncan Island), a small island in the beautiful Bay of Tapanuli: 'The celebrated bay of Tappanuli stretches into the heart of the Batta country, and its shores are everywhere inhabited by that people, who barter the produce of their land for the articles they stand in need of from abroad, but do not themselves make voyages by sea. Navigators assert, that the natural advantages of this bay are scarcely surpassed in any other part of the globe; that all the navies of the world might ride there with perfect security in every weather; and that such is the complication of anchoring-places within each other, that a large ship could be so hid in them, as not to be found without a tedious search. At the island of *Punchong Kechil*, on which our settlement stands, it is a common practice to moor the vessels by a hawser to a tree on shore.... Not being favourably situated with respect to the general track of outward and homeward-bound shipping, and its distance from the principal seat of our important Indian concerns being considerable, it has not hitherto been much used for any great naval purposes ... parties of Achinese traders (without the concurrence of knowledge, as there is reason to believe, of their own government), jealous of our commercial influence, long strove to drive us from the bay, by force of arms, and we were under the necessity of carrying on a petty warfare for many years in order to secure our tranquillity' (Marsden, 1811: 367–8).

The success in the European cloth industry may be attributed in great part to the competitive price of US cotton. Because the raw resource was the single largest component in the cost of the finished product, and the USA had been able to reduce the price of production almost in proportion to its increase of production, it outstripped its competitors. America controlled the world price (Farnie, 1979: 15–16). In part, success was also due to technological innovations which, because they speeded the processes of both spinning and weaving, reduced the price of the finished products.

Outstripping the needs of the local population and the capacity of the local markets, the volume of production engendered a search for more and larger markets, hence the voyages of the British traders to Sumatra in the late eighteenth and early nineteenth centuries. Their intentions were undisguised—and also welcomed by the cloth-loving inhabitants along the coasts of Sumatra. Europeans were successful in marketing their textiles in large part because they were plugging into a cloth trade system which had been operating for centuries. European goods had also already made it to South-East Asia via other

nationalities of traders before these British gentlemen arrived on the scene and they were greeted by a well-established demand for them.

The role of the East Indies was seen by these British traders primarily in terms of a consumer market, but her role in cotton production had been developed earlier. The major cotton growing areas in the archipelago were East Java, Bali, Sumbawa, Buton, and South Sulawesi. To compete with the booming British mills in the nineteenth century, the Dutch needed a cheap source of cotton and they tried to find their own 'cotton states' in the East Indies. Numerous agricultural experiments were conducted to intensify cotton production there. On Sumatra, the rich soils of Palembang and Lampong were best suited for cotton cultivation, but experiments there and on Sumatra's west coast (Minangkabau) with imported species were unsuccessful (Veth, 1867: 38). On Java, imported varieties failed due to disease, and it was finally conceded that the land was better used for other crops (Krajenbrink, 1874: 262). However, indigenous cotton production was of some significance. For instance, in Veth's general description of Sumatra in the second half of the nineteenth century, a dramatic increase in cotton cultivation in Palembang and Padang Lawas between 1857 and 1863 was noted (1867: 38). These dates coincide with the cotton dearth of 1857 and the so-called Cotton Famine of 1862–4 when there was a poor harvest in the USA and may be one indicator of the extent to which Sumatran cotton production was already tied in with the global market. Sumatran cotton was being sent to the Minangkabau cloth industries located in Batu Bara and Siak. A half century later, these industries had been put out of business entirely (Hamerster, 1926: 74). By the late eighteenth century, the impact of the colonial economy had already been felt on textile production in West Sumatra to the extent that one of the main areas of cotton cultivation had been put into coffee (Reid, 1988: 92). When coffee prices fell, the attempt to put the land back into cotton for local cloth production failed because local cloth could no longer compete with the cheap European imports (Veth, 1867: 38; Reid, 1984: 157–8). This was an echo of what was happening in the rest of the archipelago.

The 10,000 tonnes of cotton which had been produced annually in West Java and South Sumatra in the early years of the 19th century declined to almost nothing by 1850.... By mid-century Java was almost entirely clothed in British manufactures, and in the latter part of the century even the old exporting centres of South Sulawesi, Central Sumatra and Nusa Tenggara yielded before the much cheaper imports (Reid, 1984: 158).

A close-up picture of these developments are found in the reports of British traders in the early nineteenth century. John Crawfurd, for instance, wrote in 1820 that the British goods were overtaking both the Indian and the Javanese made goods:

The consequence of the influx of British goods has already been the entire superseding of all the finer Indian cloth formerly consumed.... Manchester *madapolams* and Glasgow cottons, put up in imitation of *Irish shirting*, ... are

used chiefly by the Chinese ... and have of late years entirely superseded the India and Chinese fabrics formerly consumed them. The *bandana* handkerchiefs, manufactured at Glasgow, have long superseded the genuine ones [from Java] ... (1820: Vol. 3, 502–5).

Price was understood by John Anderson to be the single, most significant factor in the success of the imports:

Although [the inhabitants] manufacture such a variety of cloths, they prefer wearing our European chintzes, and the coarse coast and Bengal cloths, principally on account of their comparative cheapness (1826: 116).

So powerful was the European export market in the East Indies that as early as 1820 Crawfurd was expressing amazement that ever cloth should have been exported from there to Europe:

The raw silk brought at present into the Indian Island, from China, is of inferior quality. From it the native women manufacture heavy rich stuffs, principally tissues, which, it is remarkable enough, were at one period imported into Europe, such, at that early time, was the rude state of our manufactures (1829: 517).

Sixty years later, a published complaint originating from a different perspective on the European 'success' explained that regardless of how well made the handmade goods, and how poorly constructed the machine-produced goods, the latter won the market because of their lower price. The writer went on to point out that the finest and most sophisticated handmade goods had suffered most from European competition, and that the market only provided room for the coarser stuff (Anon., 1887: 388–9).

## John Anderson on Sumatra's Shores

John Anderson made no attempt to disguise the goal of his mission to Sumatra's east coast: he was looking for British markets, and trying to excite a taste for British goods. That cloth figured so strongly in his mission revealed the extent to which West had already met East. Anderson was encouraging the consumption of British manufactured cloth, but he was also responding to the seemingly boundless South-East Asian interest in cloth. The tribute of cloth most desired by the potential South-East Asian trading partners was the tribute which Anderson most desired to present:

I made Raja Graha a small present of European chintz, which he returned by some fruits; and we parted in the most friendly manner (1826: 31).

The Pemagang Haji met us at the mouth of the small river.... I gave him a present of white European cloth, with which he was much pleased, having never seen any so fine. He told me that European white cloths were very saleable in the country at present (p. 47).

I repaid the Che Abang's hospitality by a present of chintz and handkerchiefs to himself and his two sons (pp. 47–8).

I presented the young sultan with some European cloths, rose-water, &c. and the same to his uncle (p. 60).

... we paid a visit to ... Rajah Wan Chindra Dewi, wife of the Kejuruan Muda of Langkat.... I presented her with a shawl and a piece of muslin (pp. 74–5).

Anderson negotiated with the Malay traders on Sumatra's east coast. They had settled at the mouths of the rivers leading to the interior; they were gatekeepers who controlled the inland trade, and with them, Anderson believed his overtures would be most effective.

He did not meet with the Batak formally, but he had ample opportunity to observe them as he made his way down the coast. His explorations consisted of following numerous rivers inland, stopping at villages along the way, progressing until he reached an impassable point. At these final stops, such as Bandar Pulo on the Asahan River, the opportunity might arise to watch Batak traders making their arduous descent from the inland forests. On the long way down the river, he also saw many settlements of Batak whose lives were more thoroughly entangled with the vast mixture of ethnic groups on the coast, all of whom, with the exception of the Chinese and Indians, Anderson called 'Malay': 'descendants of Malabar people, Javanese, Buggese, Achenese, Chinese, Tringanu people, &c.' (p. 209).

The Batak he encountered were themselves a varied lot, representing numerous tribes, each 'differing in personal appearance, dress, and habits ...' (p. 209). They also entered into relations with the coastal inhabitants to access the wealth there. Anderson was displeased when he came across the 'untractable' Simalungun Batak near Batu Bara who were—mysteriously to him—disinterested in consuming more and labouring harder to do so (p. 315), but he was delighted with the spirit and especially the potential market in the form of the clever and 'avaricious' Karo Batak (p. 222). In Langkat and Deli, Karo and Simalungun Batak were employed as soldiers and plantation workers. Many of the Batak whom John Anderson met on the east coast and William Marsden met on the west coast were emerging from trade paths from deep in the island's interior. Marsden wrote of the salt traders who trekked to the west coast to replenish their supplies: 'an hundred thousand bamboo measures are annually taken off in the Bay of Tapanooli' (1811: 379). Obviously the trek was a popular one. Anderson's report contains vivid descriptions of the arrival of the Batak along the steep path from the mountainous interior to the lowlands of the east coast:

Twenty small prows were lying in the river, disposing of their cargoes of salt, cloths, &c. Beyond this, no boat can ascend, owing to the interruption from falls and rocks in the river. We heard at a distance the rushing of waters, as from a high fall. The Battas ascend some of the steep hills and precipices in this quarter, by ropes of rattan, which are fastened to trees above, and left for the general use of passengers. By this they scramble up. If the rope breaks, they are dashed to pieces....

6th March ... Our boat arrived this day at an early hour. During the morning, several large parties of Tubba Battas descended the steep pathways on the opposite side of the river. They resembled wild goats clambering down the rugged crags. In crossing the ferry, one party had overloaded the boat, which sunk under them, and damaged all their merchandise, which they had brought across the country several days' journey. They came from the borders of the great lake ... (1826: 145−6).

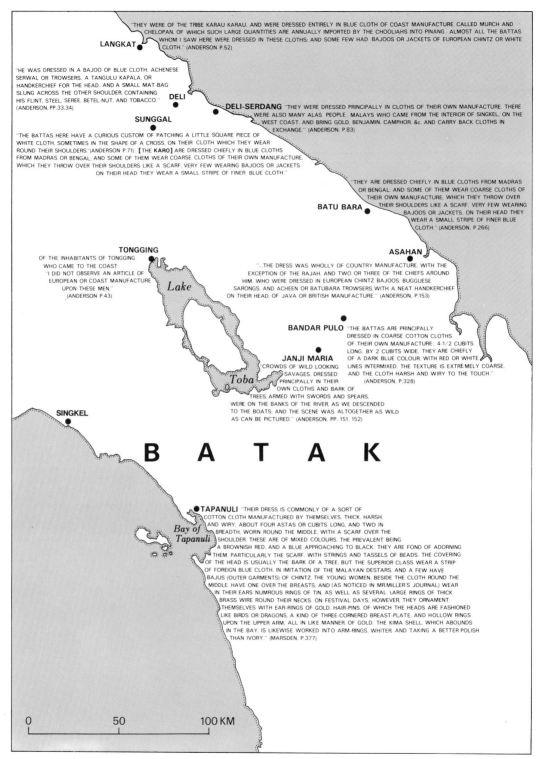

LANGKAT "THEY WERE OF THE TRIBE KARAU KARAU, AND WERE DRESSED ENTIRELY IN BLUE CLOTH OF COAST MANUFACTURE, CALLED MURCH AND CHELOPAN, OF WHICH SUCH LARGE QUANTITIES ARE ANNUALLY IMPORTED BY THE CHOOLIAHS INTO PINANG. ALMOST ALL THE BATTAS WHOM I SAW HERE WERE DRESSED IN THESE CLOTHS; AND SOME FEW HAD BAJOOS OR JACKETS OF EUROPEAN CHINTZ OR WHITE CLOTH." (ANDERSON P.52)

DELI "HE WAS DRESSED IN A BAJOO OF BLUE CLOTH, ACHENESE SERWAL OR TROWSERS, A TANGULU KAPALA, OR HANDKERCHIEF FOR THE HEAD, AND A SMALL MAT-BAG SLUNG ACROSS THE OTHER SHOULDER, CONTAINING HIS FLINT, STEEL, SEREE, BETEL-NUT, AND TOBACCO." (ANDERSON, PP.33,34)

DELI-SERDANG "THEY WERE DRESSED PRINCIPALLY IN CLOTHS OF THEIR OWN MANUFACTURE. THERE WERE ALSO MANY ALAS PEOPLE, MALAYS WHO CAME FROM THE INTERIOR OF SINGKEL, ON THE WEST COAST, AND BRING GOLD, BENJAMIN, CAMPHOR, &c, AND CARRY BACK CLOTHS IN EXCHANGE." (ANDERSON, P.83)

SUNGGAL "THE BATTAS HERE HAVE A CURIOUS CUSTOM OF PATCHING A LITTLE SQUARE PIECE OF WHITE CLOTH, SOMETIMES IN THE SHAPE OF A CROSS, ON THEIR CLOTH WHICH THEY WEAR ROUND THEIR SHOULDERS."(ANDERSON P.71). [THE KARO] ARE DRESSED CHIEFLY IN BLUE CLOTHS FROM MADRAS OR BENGAL; AND SOME OF THEM WEAR COARSE CLOTHS OF THEIR OWN MANUFACTURE, WHICH THEY THROW OVER THEIR SHOULDERS LIKE A SCARF, VERY FEW WEARING BAJOOS OR JACKETS. ON THEIR HEAD THEY WEAR A SMALL STRIPE OF FINER BLUE CLOTH."

BATU BARA "THEY ARE DRESSED CHIEFLY IN BLUE CLOTHS FROM MADRAS OR BENGAL; AND SOME OF THEM WEAR COARSE CLOTHS OF THEIR OWN MANUFACTURE, WHICH THEY THROW OVER THEIR SHOULDERS LIKE A SCARF, VERY FEW WEARING BAJOOS OR JACKETS. ON THEIR HEAD THEY WEAR A SMALL STRIPE OF FINER BLUE CLOTH." (ANDERSON, P.266)

TONGGING OF THE INHABITANTS OF TONGGING WHO CAME TO THE COAST: "I DID NOT OBSERVE AN ARTICLE OF EUROPEAN OR COAST MANUFACTURE UPON THESE MEN." (ANDERSON P.43)

ASAHAN "...THE DRESS WAS WHOLLY OF COUNTRY MANUFACTURE, WITH THE EXCEPTION OF THE RAJAH, AND TWO OR THREE OF THE CHIEFS AROUND HIM, WHO WERE DRESSED IN EUROPEAN CHINTZ BAJOOS, BUGGUESE SARONGS, AND ACHEEN OR BATUBARA TROWSERS, WITH A NEAT HANDKERCHIEF ON THEIR HEAD, OF JAVA OR BRITISH MANUFACTURE." (ANDERSON, P.153)

*Lake*

BANDAR PULO "THE BATTAS ARE PRINCIPALLY DRESSED IN COARSE COTTON CLOTHS OF THEIR OWN MANUFACTURE, 4-1/2 CUBITS LONG, BY 2 CUBITS WIDE. THEY ARE CHIEFLY OF A DARK BLUE COLOUR, WITH RED OR WHITE LINES INTERMIXED. THE TEXTURE IS EXTREMELY COARSE, AND THE CLOTH HARSH AND WIRY TO THE TOUCH." (ANDERSON, P.328)

JANJI MARIA "CROWDS OF WILD LOOKING SAVAGES, DRESSED PRINCIPALLY IN THEIR OWN CLOTHS AND BARK OF TREES, ARMED WITH SWORDS AND SPEARS, WERE ON THE BANKS OF THE RIVER, AS WE DESCENDED TO THE BOATS; AND THE SCENE WAS ALTOGETHER AS WILD AS CAN BE PICTURED." (ANDERSON, PP. 151, 152)

*Toba*

SINGKEL

# B A T A K

TAPANULI "THEIR DRESS IS COMMONLY OF A SORT OF COTTON CLOTH MANUFACTURED BY THEMSELVES, THICK, HARSH, AND WIRY, ABOUT FOUR ASTAS OR CUBITS LONG, AND TWO IN BREADTH, WORN ROUND THE MIDDLE, WITH A SCARF OVER THE SHOULDER. THESE ARE OF MIXED COLOURS, THE PREVALENT BEING A BROWNISH RED, AND A BLUE APPROACHING TO BLACK. THEY ARE FOND OF ADORNING THEM, PARTICULARLY THE SCARF, WITH STRINGS AND TASSELS OF BEADS. THE COVERING OF THE HEAD IS USUALLY THE BARK OF A TREE, BUT THE SUPERIOR CLASS WEAR A STRIP OF FOREIGN BLUE CLOTH, IN IMITATION OF THE MALAYAN DESTARS, AND A FEW HAVE BAJUS (OUTER GARMENTS) OF CHINTZ. THE YOUNG WOMEN, BESIDE THE CLOTH ROUND THE MIDDLE, HAVE ONE OVER THE BREASTS, AND (AS NOTICED IN MR.MILLER'S JOURNAL) WEAR IN THEIR EARS NUMROUS RINGS OF TIN, AS WELL AS SEVERAL LARGE RINGS OF THICK BRASS WIRE ROUND THEIR NECKS. ON FESTIVAL DAYS, HOWEVER, THEY ORNAMENT THEMSELVES WITH EAR-RINGS OF GOLD, HAIR-PINS, OF WHICH THE HEADS ARE FASHIONED LIKE BIRDS OR DRAGONS, A KIND OF THREE-CORNERED BREAST-PLATE, AND HOLLOW RINGS UPON THE UPPER ARM, ALL IN LIKE MANNER, OF GOLD. THE KIMA SHELL, WHICH ABOUNDS IN THE BAY, IS LIKEWISE WORKED INTO ARM-RINGS, WHITER AND TAKING A BETTER POLISH THAN IVORY." (MARSDEN, P.377)

*Bay of Tapanuli*

0     50     100 KM

Map 2. Batak appearance as observed and described by two early British traders, Anderson and Marsden.

# 3 Anderson's Description of Batak Clothing

PROBABLY no one would be more surprised than John Anderson to learn that the reports he wrote of his voyage of 1823 would become the starting-point of Batak clothing history. Anderson was a businessman, and he was more interested in what the Batak enjoyed of foreign import cloth than in the cloth which they themselves produced, as he discovered the latter to have minimal market value. But he was a sensitive observer as his notebooks attest. The sketches by his draughtsman (Plate 9a–d) and his own verbal sketches are the earliest detailed account we have of Batak clothing.[1]

At every stop along his way, he made a point of describing the inhabitants (Map 2). Out of his notes can be distilled the colourful diversity of clothing that existed then. It was a later colonial development that grouped Batak clans together into the large subgroups with which we are familiar today. In Anderson's time, they were affiliated with smaller kingdoms or clans. Their political diversity appears to have been reflected in their dress, and the cloth types they wove. Moreover, on the coast, they had access to Malay, Acehnese, Minangkabau, Javanese, Bugis, Indian, Arab, and European styles of clothing as well as a range of their own handmade goods brought in by their neighbours from the interior to sell on the coast (Table 1). Their own fully fledged clothing tradition was the simplest attire in construction terms, consisting of a wide oblong fabric wrapped around the hips, and a narrower one draped over the shoulders. A strip of tree bark, or cloth, or a bundle of yarn served as a headcloth for men. Women wore headcloths, if at all, according to the customs of their clan. Batak migrants to the coast learned new ways of tying the headcloth, and developed a taste for tailored Malay garments. Each of the ethnic groups which Anderson referred to as 'Malay' had certainly developed its own fashions so that even within the so-called Malay style, the Batak would have been able to select from great variety. From Anderson's descriptions of the Batak (see Map 2), it appears that these foreign items of clothing were worn by Batak of higher station and those with access to trade, wealth—and Malay culture. Of its desirability to the Batak, Anderson's descriptions leave no doubt. He was delighted that there were profits to be made here by the British.

[1]Chinese sources were not consulted.

(a)

(b)

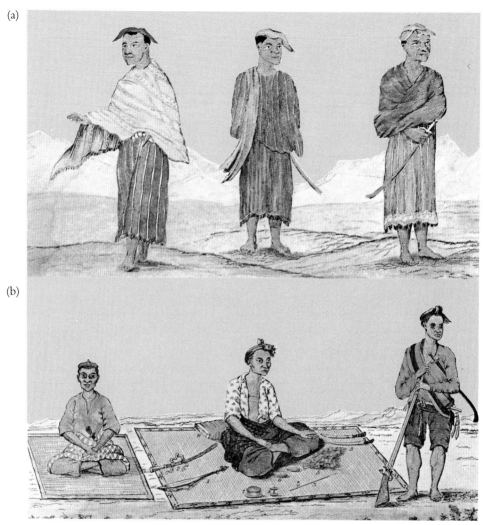

9a–d. John Anderson's draughts-man's portraits of inhabitants of the east coast.
Reproduced from Anderson (1826).

John Anderson's draughtsman provided some of the earliest sketches of the Batak on Sumatra's east coast during the voyage of 1823. The degree of Malay acculturation in the apparel is already strikingly evident. Only the 'Karau Karau Battas from Tongking, inland of Delli' (Plate 9a) are wearing unacculturated Batak clothing. Although Anderson's draughtsman took liberties in painting their dress yellow, purple, green, and orange, the etch-

ing shows the simple Batak attire, consisting of one cloth wrapped around the hips, one thrown over the shoulders, and a headcloth. The fringe around the hipcloth of the man at the right should be oriented vertically from top to bottom. Probably these men were from Tong-ging, at the northern tip of Lake Toba.

Plate 9b–d shows the Batak wearing apparel strongly influenced by the Malay style. The 'Native of Padang [Minangkabau] on the east coast of Sumatra' sitting to the far left in Plate 9b is wearing the more or less standard dress of traders from different parts of the archipelago,

which Anderson described as 'Malay': 'The men are usually dressed in short bajoos or jackets, of European chintz or white cloth, with Achenese serawals or trowsers, a Bugginese sarong or tartan petticoat, and on their head a batik or European handkerchief. A handkerchief which contains their betel and seree, is usually hung over their shoulder, and a kris fastened on the left side. The women wore long bajoos of blue or white cloth or chintz, with a cotton or silk sarong. Their hair is neatly fastened by long gold, silver, or copper pins, according to their rank. The higher order, in addition to the dress I have described, wear a belt or

18

(c)

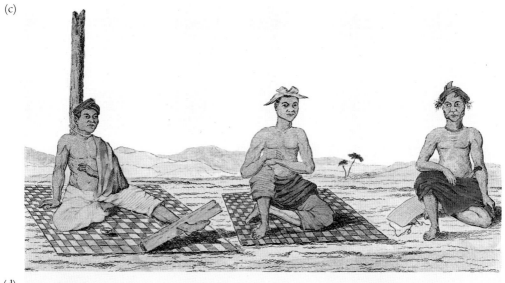

(d)

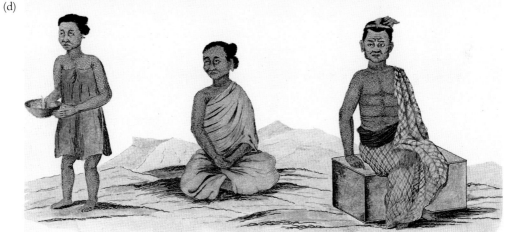

zone of silk or other cloth, fastened round the waist with a gold pinding, and a handkerchief slung over the left shoulder' (1826: 265–6).

Beside the Minangkabau are the 'Raja of Munto Panei, A Cannibal Chief', and a 'Batta Warrior from Seantar: a Cannibal'. Both of them are dressed in the Malay style. The Raja is a Batak of high standing from the Asahan area about whom Anderson wrote that, 'having associated much with the Malays, [he] is quite civilized in his manners ...' (1826: 153–4). Perhaps it is a sarong which the Simalungun soldier in the right of the plate is wearing over his shoulder in the fashion that John

Crawfurd described: 'When [they] wear, as they generally do, a kind of short breeches, they occasionally disengage the sarung from the loins, and throwing it transversely over one shoulder, use it in the manner of a Scots Highlander's plaid' (1820, Vol. 1: 209).

The sarongs depicted here and in Plate 9c may have been the Buginese sarong which was sold throughout the archipelago, or the 'kain kampong' (village cloth) woven in Deli during Anderson's time. Both were plaids.

Even the 'Tubba Slave in the Stocks' (Plate 9c) is dressed in Malay apparel. The 'Batta from the Borders

of the great Lake' further inland, however, is wearing an unstitched hipcloth of the Batak clothing tradition.

In Plate 9d, the 'Tubba Batta Woman at Assahan' has her sarong pulled up under her arms in the style worn by Simalungun women. The 'Cannibal Batta from the Interior of Batu Bara' to the right is perhaps wearing the coastal 'gubbar', or plaid. 'A stout ferocious looking fellow, with muscular bandy legs.... He had a most determined look ...' (Anderson, 1826: 122).

Table 1. Batak textiles sold at the coast in Anderson's time.

*In Langkat* (p. 264):

1 *Junjong*—'red striped coarse wiry cloth, like a shawl' [possibly the *jungjung* from the Sitolu Huta region? (Plate 10)];

2 *Ragi padang*—'a blue striped coarse cotton cloth' [a Simalungun textile worn by older men and women (Tichelman, 1938: 68)];

3 *Ragi tubba*—[possibly the *teba*, a thick, indigo blue Karo textile worn around the hips (see Plates 37 and 51)];

4 *Katmanga*—[possibly the *hati rongga*, *gaci ronga*, *gaci renga*, etc. The cloth was found in Karo, Simalungun, and Sitolu Huta (see Plate 43)];

5 *Surisuri*—[a common cloth of Toba origin, worn also by the Karo, Simalungun, and Pakpak Batak (see Plates 45 and 95)].

*In Deli* (p. 289):

1 *Ragi tiga*—[? The name translates as 'market cloth' in Simalungun. Perhaps it was simply a textile intended for sale.];

2 *Ragi surisuri*—see above under *surisuri*;

3 *Junjong*—see above;

4 *Ragi seantar*—[a textile from the Siantar area of Simalungun. Tichelman (1938: 67) has described the cloth as having dark side panels and a light centre panel with appliquéd red, white, and black velvet.].

*In Asahan* (p. 328)

1 *Mergum sisi*—[probably the cloth known variously as *simarinjam sisi*, *simarjan sisi*, *simarigan sisi*, or *pinarunjat sisi*. A Toba Batak cloth from south of Lake Toba.];

2 *Guru gundang*—[?];

3 *Surusuru*—[probably *surisuri*—see above];

4 *Rinjap*—[the Toba Batak *runjat* from south of Lake Toba? Joustra (1910: 131) refers to a *runjap* originating from Tano Hurung and the Upper Bila region of Padang Lawas which was strong and densely woven, and worn as clothing or made to serve as a blanket.];

5 *Sabila garam*—[?];

6 *Sebottar*—[? Perhaps the *Sibolang na bontar* is meant. This is a Toba version of the Karo *teba*.];

7 *Ragi sehorpa*—[?];

8 *Ragi sehoram*—[?];

9 *Tonompiac*—[?];

10 *Ragi atuanga*—[?];

11 *Iabbit*—[?—a cloth worn around the hips as *abit*?];

12 *Ragi perbouiac*—[?].

The unknown textiles in Asahan may have come from the Habinsaran, Garoga region, the textiles of which have never been studied.

10. *Jungjung* textile.
Collection: S. Niessen.

This textile was made in Sitolu Huta and was worn by people of high class. Anderson mentioned a Batak 'junjong' textile which he believed was attractive enough to merit wider marketing possibilities. Perhaps he meant the *jungjung*.

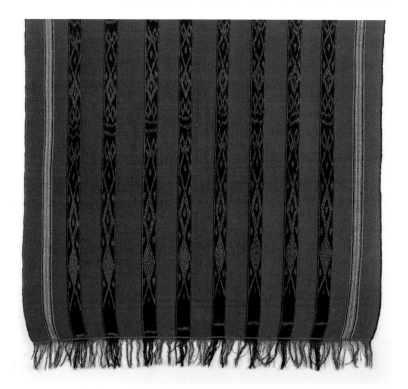

The Karo plantation workers in Langkat expressed 'evident partiality and growing taste for European chintzes, maddapollams [British imitation of Indian cloth], muslins, and handkerchiefs' (1826: 52); amongst the Pardimbanan chiefs in Asahan, he noted a 'partiality for European chintzes, and particularly for scarlet broad cloth', etc. (p. 151). Anderson's excitement is undisguised: 'Nothing but the want of means prevents [the Karo] from all wearing European cloth.... Their produce will give these people increased means of purchasing their favourite dresses ...' (p. 52). Of the Pardimbanan chiefs: 'they would have made purchases, had there been any for sale ...' (p. 151).

While Anderson's business acumen was piqued by what he saw, he was also moved by the Batak reactions to novelties. He delighted in watching them respond to European goods, such as mirrors, which they had never seen nor imagined before: 'I know nothing which it is more amusing to contemplate than the first feelings of surprise which such objects, the products of high civilization and art, impress on the minds of savages' (pp. 86–7).

It is tempting to speculate on the Batak reaction to the softness of silk. The Batak knew how to make bark cloth, a kind of coarse spun yarn from nettle, and what Anderson referred to as 'harsh and wiry' (overspun?) cotton. The conceptual impact of the softness of silk, the gleam of metallic yarn in Indian cloth, and the brightness of Indian and later European dyes, can only have been powerful. The myths of the Batak tell that Pusuk Buhit (Navel Mountain) on the western

21

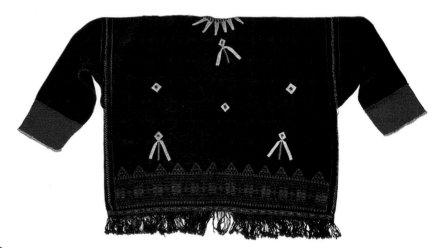

11. Karo *baju*.
Collection: Museum fur Volkerkunde, Frankfurt.

This jacket was collected prior to 1884. It is made from Batak handwoven fabric, but embellished with European import fabric. Here, too, there is the curious use of narrow strips of decorative appliqué which Anderson mentioned.

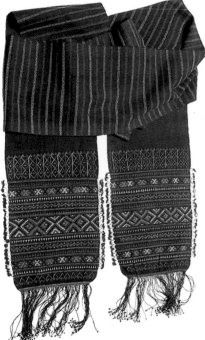

12. Southern Batak sash decorated with scarlet broadcloth.
Collection: Staatliche Museen zu Berlin–Preussischer Kulturbesitz, Museum fur Volkerkunde, Abteilung Sudasien.

The Batak of the southern regions enjoyed using scarlet broadcloth for decorative purposes. Here it is attached in combination with beads to the edges of a sash bearing the pattern of the *sadum* textile.

shore of Lake Toba is the centre of the earth, and that the Batak are the descendants of the first humans. What would it be for a Batak nurtured on such a myth to come down to the coast and discover people clothed in fabric of inconceivable softness, fineness, and brightness? Surely the sumptuousness of the foreign cloth alone would test the Batak sense of their centrality in the Universe.

What they did with their cloth purchases speaks of their admiration for it. Extrapolating backwards from items in the earliest museum collections, it appears that they made their Malay clothing for daily use from cheap and relatively coarse imported cotton. Their more extravagant purchases seem to have been used sparingly as embellishments for their own textiles and apparel. The scarlet broadcloth, for example, which so pleased the Pardimbanan chiefs, we find trimming sleeves and collars of elaborate jackets (Plate 11). Cut into short, narrow strips, it was sewn on to the edges of sashes like tufts (Plate 12), or in longer strips, was used to emphasize pattern rows of the finest textiles (Plate 13). The stuff was clearly precious as it was used so sparingly and only on the finest of the Batak textiles.

A Karo Batak textile in the collection of the Ethnographic Museum in Berlin has a small piece of a silken Acehnese *plang rusak* (a textile with a chevron motif) and imported red cotton cloth appliquéd decoratively to its surface (Plate 14 and also Plate 11). The item brings to mind a charming detail which Anderson observed in Sunggal: 'The Battas here have a curious custom of patching a little square piece of white cloth, sometimes in the shape of a cross, on their cloth which they wear round their shoulders' (pp. 71–2). Such a clothing detail is like idiom uttered for a listener with no understanding of vocabulary

13. Toba Batak *ragidup* end field.
Collection: Museum fur Volkerkunde und Schweizerisches Museum fur Volkskunde, Basel.

This *ragidup* textile is extraordinary for the use of beads to trim the edges of the cloth, and for the scarlet broadcloth stitched between the rows of supplementary weft in the end fields. The Toba Batak refer to the *ragidup* as their 'number one' textile. Its three panels are stitched together. The centre panel may contain a variety of patterning in the middle section, while the end fields always contain elaborate supplementary weft patterning.

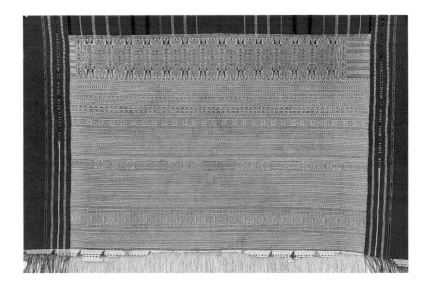

or grammar. What was the meaning of such an appliquéd cross? Who wore it and when? To have used a piece of trade cloth, and especially a piece of luxury cloth like silk, meant that the appliquéd piece was a fancy patch, indeed. Furthermore, the *plang rusak* type of cloth seems to have been highly appreciated as it inspired Batak weavers everywhere. They learned to make the same chevron pattern in cotton on their own looms and it became thoroughly integrated into their own clothing vocabulary (Plate 15).

The 'gubbar' textile which Anderson mentioned as one of the products of coastal manufacture is so similar in name to the Batak 'gobar' textile as to invite comparison. Anderson's description of the gubbar coincides with the appearance of the Batak *gobar* as we know it from later ethnographic records and museum collections. Both are characterized by their 'tartan designs', to use Anderson's description

14. Karo *kellamkellam* or *cabin*.
Collection: Staatliche Museen zu Berlin–Preussischer Kulturbesitz, Museum fur Volkerkunde, Abteilung Sudasien.

The Karo Batak *kellamkellam* or *cabin* textile is deep blue in colour and usually contains no decorative embellishments. The owner or maker of this cloth appliquéd a small square fragment of an Acehnese textile type called *plang rusak* to the centre of the cloth, and a smaller piece of red imported cotton to the side and along the edges of the cloth. The desirable silk and the bright red no doubt made the cloth the envy of onlookers.

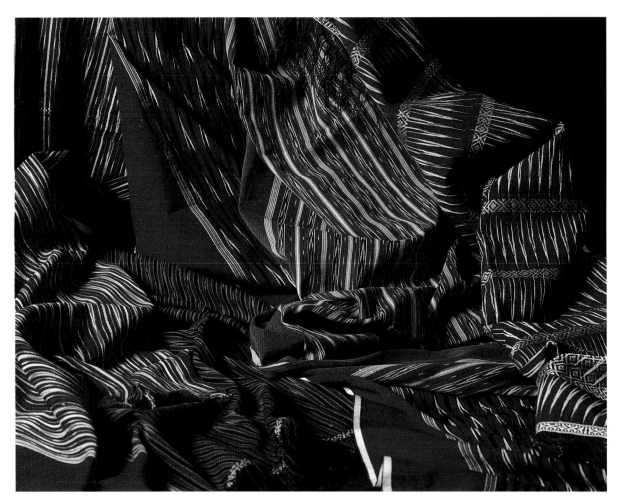

15. Chevron patterning in Batak textiles.
Collection: S. Niessen.
Photograph: Koichi Nishimura.

Batak weavers were inspired by a cloth with chevron patterning which they knew from trade with India and/or Aceh. Everywhere, variants of it were made in cotton on Batak looms. This photograph shows the Karo *uwis nipis* to the far left and right in the photograph, and Toba Batak *tuturtutur na marsuksak*, *parang rusak*, and *mangiring* from left to right between them. All are shoulder-cloths.

(stripes in both warp and weft). Both differentiated rich and poor by varying their design (Plate 16). Both functioned as blankets as well as apparel. The *gobar* was one of the textiles in the cloth repertory of the Batak of Simalungun and Sitolu Huta, while a simpler version used by the Toba Batak south of Lake Toba, again with a tartan pattern, was used exclusively as a blanket.

The Batak liked metal. Women used rings of thick brass as neck ornaments (Marsden, 1811: 37); gold and silver and tin were desirable. Neither Marsden nor Anderson mentioned the use of metal objects in Batak clothing, but the Batak appreciation of metal is evident in their earliest known fashions. Small tin cones and bells are worked into the dangling fringe ends of jackets and bags where they must have gleamed and tinkled (Plate 17). There is a light-hearted gaiety in the use of these foreign imports. They call to mind the Batak whom Anderson loved to watch discover a mirror for the first time.

Needlework, which they were exposed to in connection with the tailored clothing from the coast, seems to have inspired the Batak male imagination. They learned to sew their own jackets (women

16. Batak *gobar*, collected by D. Borr-
man, 1913.
Collection: Rautenstrauch-Joest Mu-
seum fur Volkerkunde, Cologne.

The Batak *gobar*, which may have
been inspired by the coastal 'gubbar',
has a plaid motif in the centre panel.
The supplementary weft patterning
at the end of the cloth is an indica-
tion that this cloth was for someone
of high status. Without the fancy
patterning, the cloth would have
been destined for someone of ordin-
ary status. The patterning is typically
that of Sitolu Huta and Simalungun.

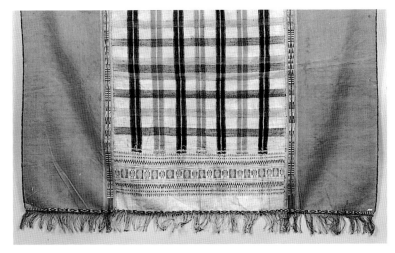

17. Mandailing bride, photographed
by Professor A. Grubauer in Pekan-
ten, early twentieth century.
Photograph: Rautenstrauch-Joest Mu-
seum fur Volkerkunde, Cologne.

The bride's jacket is trimmed with
tin bells and cones which would
have tinkled merrily whenever she
moved. She is wearing numerous
metal bracelets around her wrist as
well (see also Plate 94a–b).

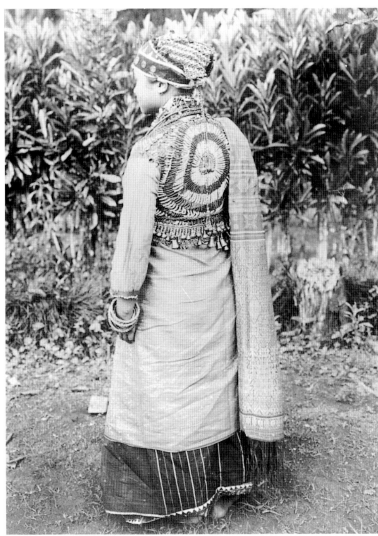

25

18a–c. Karo *baju rompas* worn by young people, collected by G. Meissner (perhaps during his journey with von Brenner-Felsach), 1880s.
Collection: Staatliche Museen zu Berlin-Preussischer Kulturbesitz, Museum fur Volkerkunde. Abteilung Sudasien.

The Karo purchased white trade cotton at the coast from which to make their jackets. When soiled, these would be dyed with indigo to freshen up their appearance. The maker of this jacket made good use of the colour of the cloth by stitching the seams with contrasting red and black yarn. Needlework was artfully done by men and served to decorate the clothing as well as to stitch it together.

(a) front view

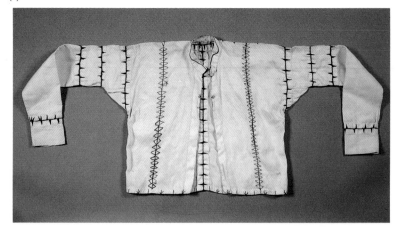

(b) back view

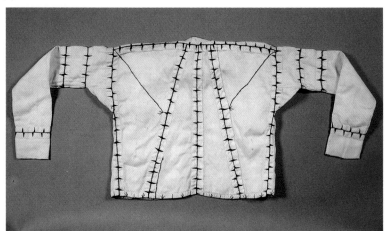

(c) detail

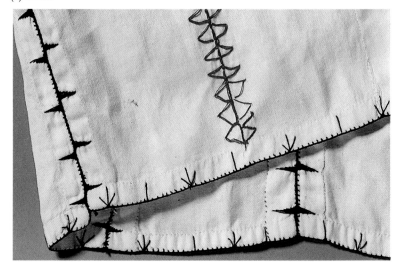

19. *Baju ungkap*, an exceptional women's jacket, collected by Professor A. Grubauer in Uluan (Toba Batak), 1913.
Collection: Rautenstrauch-Joest Museum fur Volkerkunde, Cologne.

Fancy needlework has stitched some of the same patterns as found carved and painted on Batak houses, and in the twined edges of Batak textiles. The maker has used buttons purely for decoration and trimmed the jacket with beads and imported fabric.

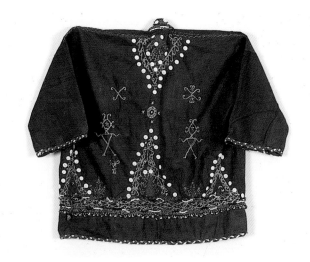

20. Karo Batak man.
Photograph: Museum fur Volkerkunde und Schweizerisches Museum fur Volkskunde, Basel.

The Karo Batak had the custom of wearing long hipcloths. To facilitate movement, the wearer had to pull up his hipcloth (*gonje*) with one hand.

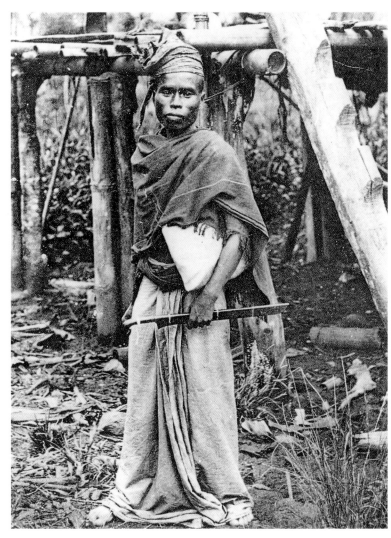

wove, but men sewed). Tailoring a *baju*, and especially the needle-work involved, developed into a flamboyant outlet for decorating clothing and another expression of delight in the foreign (see Plates 18 a–c and 19).

Anderson's descriptions are tantalizing. While he did not spend enough time in any port to develop a complete understanding of the local cloth idiom, he picked up hints of its importance and recounted them anecdotally:

In conversing with some of these people who had just arrived [from Soonghal/Sunggal], one of them informed me that he had been trading in the interior for a few months before, and lost one of his companions, who was killed and eaten by the Battas near the great lake, because he wore a short sarong, which is considered very indelicate amongst a certain tribe of Battas, and a great insult. They wear their garments down to their feet (1826: 60).

Perhaps Anderson had picked up information about the Karo Batak, as these people preferred long hipcloths (Plate 20).

The focus of many of Anderson's observations, particularly concerning the upper body coverings of women, and the extent to which their ear lobes were stretched by wearing heavy ear-rings—a habit Anderson detested—clearly had more to do with the tastes and moral proclivities of his own culture. His descriptions of local fashions are informative in the way a dictionary glosses words. But the full language is missing. What patterns were favoured and where? How widely were particular fashions known? There are limits to what can now be recovered about the clothing systems of then, but these limits have not yet been tested. The tally of specific, detailed information about coastal garb is meagre but it enables us to deduce that the fashion scene prior to the colonial era was complex. The straits communities of the seventeenth, eighteenth, and nineteenth centuries await their costume historian.

# 4 Woven Records of Batak Textile History

WHAT did the Batak textile tradition look like in the early nineteenth century when Anderson visited Sumatra's shores? Much of the literature about Batak textiles has us conceive of a full-blown set of cloths destined for the gradual decline of the post-contact. Were this indeed the case, then to piece together the textile repertory of the earliest contact would be to reconstruct the authentic, the vigorous, and the most lovely—to which we would have to turn for the most intense visual pleasure.

Reconstructing the Batak textile tradition in the early nineteenth century is not a simple matter. There are neither surviving collections which date from that time, nor complete lists of textile types, with provenance, to which we can refer. The only extant lists are found in John Anderson's report of his trade mission, in which he noted the names of cloths which Batak traders brought from the interior to trade at Langkat, Deli, and Asahan (see Chapter 3, Table 1). It is a stroke of luck for us today that a man of such great powers of observation and facility with his pen should have been chosen to visit Sumatra's shores. Although the list is meagre in comparison to the range of Batak textiles that must have been available at the time, it appears to include textiles woven in the northern regions of Karo, Sitolu Huta, and Simalungun, and textiles of the Pardimbanan and Uluan regions. However, it is not always clear—perhaps because of the orthography John Anderson used for textile names in Batak languages with which he was unfamiliar, perhaps because some of the textiles have fallen into disuse and have disappeared, and perhaps because the list includes textiles from regions which are still obscure on the Sumatran textile map—which cloth types all the listed names refer to. Nevertheless, the list is solid, written evidence of a corpus of cloth the existence of which at that time there can be no doubt.

It is to deny textiles their quality as primary sources to insist on verbal evidence of their early existence, however. Textiles can be evaluated in much the same way as Anderson's lists: extrapolating backwards using knowledge developed in later times. For example, the first soothsayings about the inevitable demise of the Batak textile tradition were written almost a full century ago. Nevertheless, a comparison of the present-day Batak weavings with those made in the

time of those nostalgia-stricken texts reveals a remarkable continuity. This in itself offers the possibility that the Batak textile tradition is not prone to rapid and fundamental change and a second rather exciting possibility that, incomplete as the first museum collections are, they encapsulate a great deal of information about the Batak textile tradition as it was 'before contact'. I believe that when the British traders arrived on the scene, they were seeing Batak textiles that looked like those in our museum collections, the earliest of which date from 30 to 50 years later.

Yet change is also a constant and fundamental characteristic of the Batak textile tradition. The tradition represents a flexible balance of dynamism and continuity. If this is indeed the case, the way the tradition has changed, and the way the tradition has remained unchanged through the past two centuries become the more interesting issues to ponder. It is fascinating to read accounts of how the tiny but proud early political units of the Toba Batak resisted attempts by the colonial power to impose a stable, unchanging administrative structure upon them. Where the Dutch wanted tidy, unchanging units, the Batak knew a system which renegotiated structure at every social gathering in which an individual made a new bid for power, necessarily re-shaping history to coincide with his vision. If political units were fluid and ever subject to change, the stable constant was found in the process of renegotiation (see Chapter 7). Textile scholars would have something in common with colonial administrators if, in taking up the challenge of characterizing the Batak textile tradition, we were simply to list the repertory of textile types. This would be to monumentalize, or render static a particular version of history, and precisely to negate and deny the fluid nature of the tradition. Could it be that a static view of Indonesian textile traditions is as informed by our own culture as the Dutch need to impose a static administrative structure was informed by Dutch ways? Museums, for instance, require tidy categories and unambiguous systems. Similarly, the printed medium hardens for posterity categories which, in the wear and tear of daily life, have less definite boundaries.

Batak weavers even now do not rest upon having learned to make a particular textile or set of textiles and then pass these down invariably to their daughters or apprentices; they often entirely change their repertory when they marry and go to live in their husband's village; they may embellish their new repertory with the motifs from home; they experiment with new colours and designs they pick up on the market. Apparel denotes the status of the wearer, and as a strong feature of Batak behaviour is the bid for higher status, women serve in the process, and well, by weaving the denoters of status and by picking up quickly on status-marking textile trends. This process would account for rapid and selective incorporation of design embellishments from outside—whether fine gold yarn from the nineteenth-century Malay coast, European baize of the brightest red colour ever seen, or little metal cones which could easily be attached to a fringe and which tinkled whenever the wearer moved.

(*Opposite page*)
21a–b. Weavers in the Karo Highlands.
Photograph: Royal Institute of Linguistics and Anthropology, Leiden.

In Plate 21a the weavers are preparing the yarn for weaving. In the background to the left in the photograph, a woman has a hank of yarn on a vertical frame. She is applying starch to the yarn to make it stiff and hard so that it will not pill and break in the loom. The woman in the foreground on the left is winding the warp on a warping frame. The warp is round and continuous. The weaver shifts it in the loom as she weaves (Plate 21b), thus ending up close to the point where she began. The unwoven section of warp is cut through, making an oblong cloth with dangling warps which may be twisted into a fringe. The man beside the weaver in Plate 21b is twisting the fringes of a finished textile.

Much of this weaving technology shows ancient Indian influence. This accumulation of foreign influence came to a rather abrupt end in the early nineteenth century. These photographs are rather special because the Karo Batak no longer weave. The only weavers left in the Karo area today are Toba Batak immigrants.

(a)

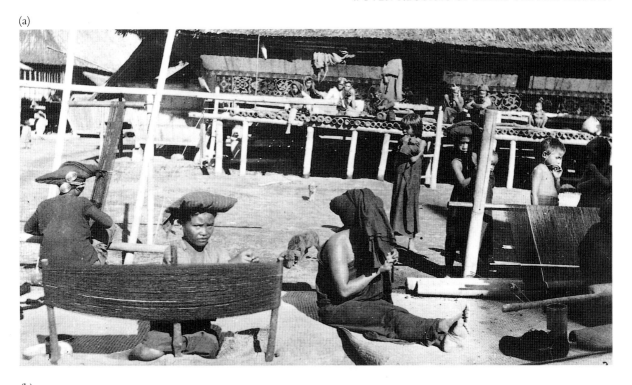

(b)

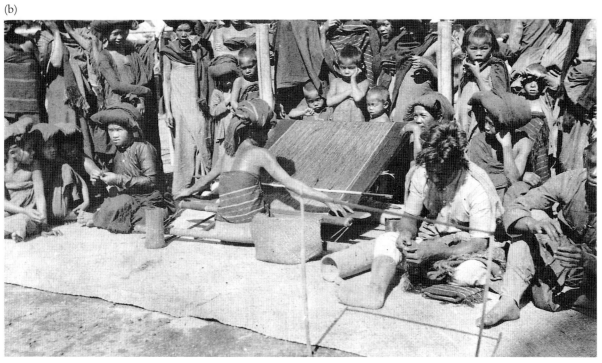

Ironically, the strongest features of Batak textile design—and this is just another aspect of the constancy of dynamism—are the result of hundreds of years of accumulation of technical knowledge and design features. The Batak area of North Sumatra, just as most of Indonesia, has been the recipient of wave upon wave of external cultural influences, all of which have left their mark on the textiles of the archipelago. If the earliest Batak museum specimens are believed to exemplify a tradition that escaped waves of foreign influence and to that extent represent 'original' Indonesian textiles (for example, Maxwell, 1990: 71, 400), this is only because that composite of external influences has coalesced into a new original. Even as the often cited 'isolation' of the Batak must be qualified with a description of the extent and sophistication of their internal trade networks (see Chapter 5), so must the original nature of Batak textiles be under-

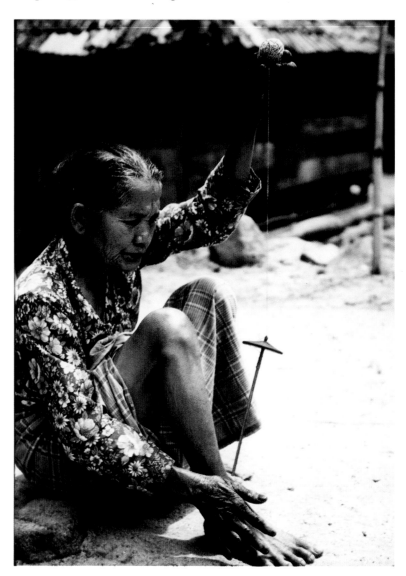

22. Ompu ni SiSihol, weaver from the western shore of Lake Toba (Harian Boho) demonstrates the use of a drop spindle to ply yarn, 1980. Photograph: S. Niessen.

Ompu ni SiSihol remembered spinning with a wheel (*sorha*) to make other kinds of yarn, and decrepit old wheels in people's barns testified to a time (World War II) when yarn was not available on the market. The drop spindle probably goes back much further in time than the spinning-wheel which is associated with the thousand-year history of Indianization in the archipelago (Maxwell, 1990: 158).

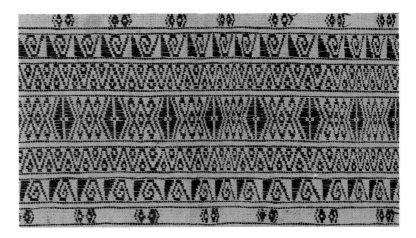

23. Detail of the end field of a *pinunsaan* textile.
Collection: S. Niessen.

The supplementary weft decorations in the end fields of the *pinunsaan* are the legacy of the Bronze Age in Indonesia. Conventional archaeological wisdom has it that metal was introduced to Indonesia around 100 BC from Dongson in Tonkin, present-day Vietnam. The impressive kettle drums found in Indonesia from that source are documents, cast in metal, of the repertory of motifs that entered Indonesia with those drums. Batak geometric motifs were selected from that repertory. Spirals, curves, and meanders are rendered in supplementary warp and weft, *ikat*, and weft twining (see Niessen, 1991b). The hook/key patterns are especially well developed. Weavers south of Lake Toba will raise the value of virtually any cloth by adding an extra embellishment of this nature, either at the ends of their cloths, or along the horizontal median line. The motifs are difficult to execute and show off a weaver's skill (see also Plate 13 of the *ragidup*).

stood as the outcome of profound early influences that came to Sumatra's shores from distant cultural origins. The earliest evidence is the most sparse—and perhaps one of the reasons why we are inclined to see an 'originality' in Batak textiles—but even here there are powerful clues of distinct layers of inspirational foreign culture contact.

In watching a Batak weaver make her cloth the observer witnesses the legacy of know-how that may go back hundreds if not thousands of years (Plate 21a–b). My seventy-year-old weaving teacher, Ompu ni SiSihol, for instance, living on the western edge of Lake Toba, in the Harian Boho Valley, used a drop spindle to ply yarn for certain purposes (Plate 22). She also remembered spinning with a wheel (*sorha*) to make other kinds of yarn, and decrepit old wheels in people's barns were not altogether rare, testifying to the time when yarn was not so readily available on the market. The drop spindle probably goes back much further in history than the spinning-wheel which is associated with the thousand-year history of Indianization in the archipelago (Maxwell, 1990: 158).

The decorated end fields of one of the most famous of all the Batak textiles, the *pinunsaan* (Plate 23), are the legacy of the Bronze Age in Indonesia. Conventional archaeological wisdom has it that metal was introduced to Indonesia around 100 BC from Dongson in Tonkin, present-day Vietnam. The impressive kettle drums found in Indonesia from that source are documents, cast in metal, of the repertory of motifs that entered Indonesia with those drums. The geometric motifs were selected from that repertory by the Bataks for their textiles. Spirals, curves, and meanders are rendered in supplementary warp and weft, *ikat*, and weft twining (see Niessen, 1991b) and hook/key patterns are also well-developed in the supplementary weft of the *bulang* textile of Simalungun Batak (Plate 24) (Niessen, 1988/89). The 'number two' textile in the Toba region, the *ragi hotang*, is decorated with supplementary weft motifs, many of which the weavers selected from the same Dongson stock (Plate 25). Weavers south of Lake Toba will raise the value of virtually any cloth by adding an extra embellishment of this nature, either at the ends of their cloths, or along the

24. Simalungun *bulang* textile.
Collection: S. Niessen.

The end field of the *bulang* has supplementary weft patterning similar to the *pinunsaan*.

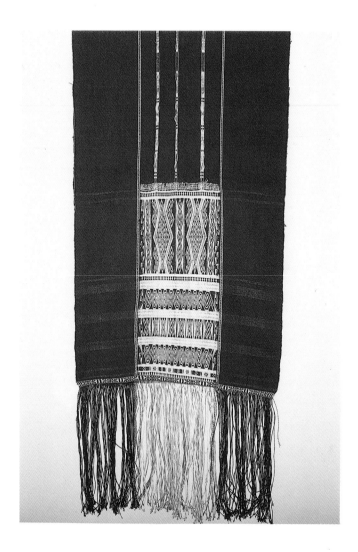

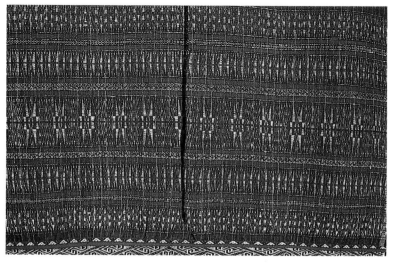

25. Detail of the supplementary weft patterning of the *ragi hotang*.
Collection: S. Niessen.

The *ragi hotang* does not have a separate panel devoted to its supplementary weft patterning, but the patterning bears strong similarities to that of the *pinunsaan*. Today, both of these textiles are only made southeast of Lake Toba.

horizontal median line. The motifs are difficult to execute; they show off a weaver's skill (see also Plate 13 of the *ragidup*).

On Samosir Island, alternatively, the visitor will find few local textiles containing the Dongson-inspired supplementary weft patterning. Instead, he or she will be struck by the simple but elegant, rich blue set of indigo-dyed *sibolang*, *bolean*, and *surisuri* textiles. Here the *sibolang* is the 'number one' textile. An inhabitant of Samosir Island, very knowledgeable in ritual affairs, told me that this triumvirate of indigo-dyed cloths (Plate 26) represented the nucleus of the Batak textile tradition and that the more than one hundred other design types within that tradition were only 'additions' to this elegant blue core. There is no reason to doubt the man's claims; Bataks are talented historians for whom it is a necessity of life to piece together the threads of their own heritage. Textile scholars also believe that the history of indigo dyes in South-East Asia goes back further than that of red dyes (Maxwell, 1990: 58) and that blue textiles may predate red textiles in that part of the world. If the Indonesians, including the Bataks, knew weaving by the neolithic age, Dongson patterning can only be a later embellishment to an already established cloth tradition.

We may assume that the Batak used bark cloth before the advent of weaving, but that cotton was preferable to this less flexible material which stands out in Batak memory as well-loved by lice. If the use of bark cloth predates Batak weaving, the nineteenth-century visitors were seeing in the bark headcloths and sashes of the common folk, results of the most ancient Batak textile knowledge. By the twentieth century, it had phased out entirely and only revived briefly during the Second World War when cloth was scarce.

These historical layers are of such antiquity that the Batak share all of them in some manner, and to some degree, with their neighbours. Certain design features, such as the organizing principle of tripartitioning—which expresses itself in the two identical side panels with a centre panel (Plate 27) in virtually every Batak textile, which divides the centre panel of many cloths, including the *ragidup*, *pinunsaan*, and *bulang*, into two end fields flanking a centre field, and which informs the placement of several decorative embellishments (Niessen, 1985a)—are features which Batak textiles share with the textiles of their neighbours elsewhere in South and South-East Asia. The principle of tripartitioning, found in textiles from India and throughout insular and mainland South-East Asia, is one of the most widespread, although each weaving tradition gives to it something unique.

Comparing the textiles of the Acehnese to the north and the Minangkabau to the south with those of the Batak, certain common features stand out which may be interpreted in the wider Asian context, while certain features are no doubt due to intense links between these neighbours. Furthermore, these two options are not mutually exclusive. On the other hand, Batak textiles also stand distinct from those of their neighbours precisely for some of their early Indonesian features. The predominance of patterning in the warp of Batak textiles (Plate 28) is symptomatic of the Batak escape from more recent

35

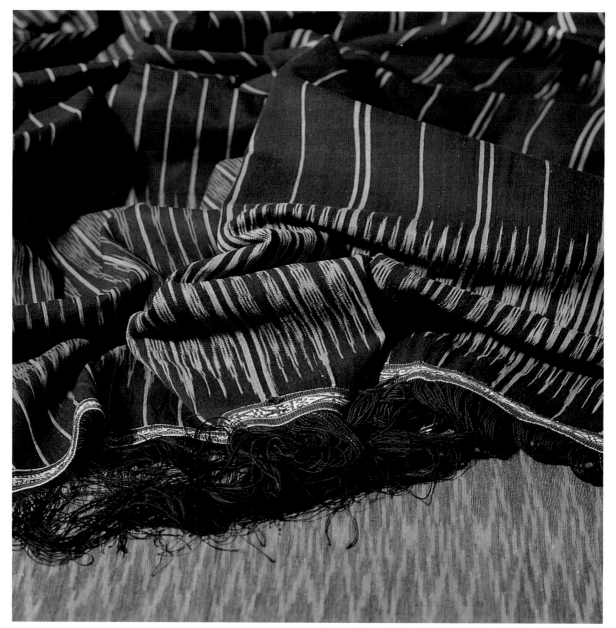

26. The Toba Batak triumvirate of indigo blue textiles: *surisuri* (left), *bolean* (right), *sibolang* (bottom).
Collection: S. Niessen.
Photograph: Richard Woolner, University of Alberta Photoservices.

On Samosir Island, the visitor will be struck by the simple but elegant rich blue set of indigo-dyed *sibolang*, *bolean*, and *surisuri* textiles. In this style region, the *sibolang* is the highest status textile. An inhabitant of Samosir Island, very knowledgeable in ritual affairs, told me that this triumvirate of indigo-dyed cloths represented the nucleus of the Batak textile tradition and that the more than one hundred other design types within that tradition were only 'additions' to this elegant blue core.

27. The principle of tripartitioning in Batak textiles.

The principle of tripartitioning, which expresses itself in the overall three-panel design of Batak cloths, and in many of the smaller design features as well, is a widespread textile feature in South and South-East Asian cloth traditions.

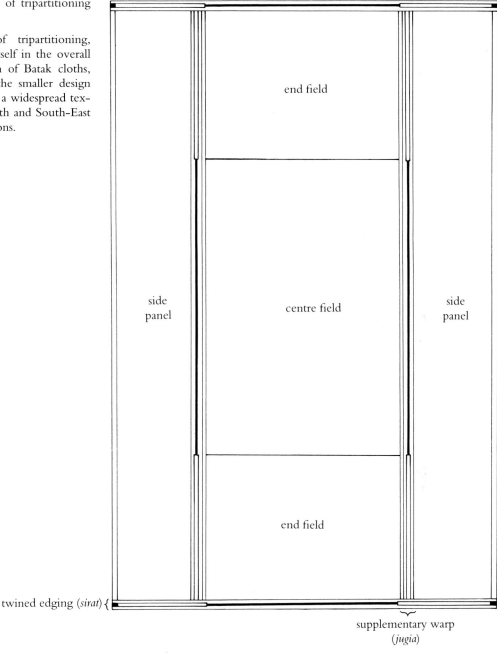

end field

side panel — centre field — side panel

end field

twined edging (*sirat*) {

supplementary warp (*jugia*)

Islamic influence. The impact of Islam is powerfully stated in silk with an emphasis on the weft patterning which typifies the textiles of the Acehnese and Minangkabau. Ample textile evidence attests to strong trade relations between the Batak and their neighbours. While not a great deal is known about trade relations between these regions, textile design similarities reveal the intensity of those links. Furthermore, many old textiles of neighbouring origin are prized Batak possessions (Plates 29, 30, and 31).

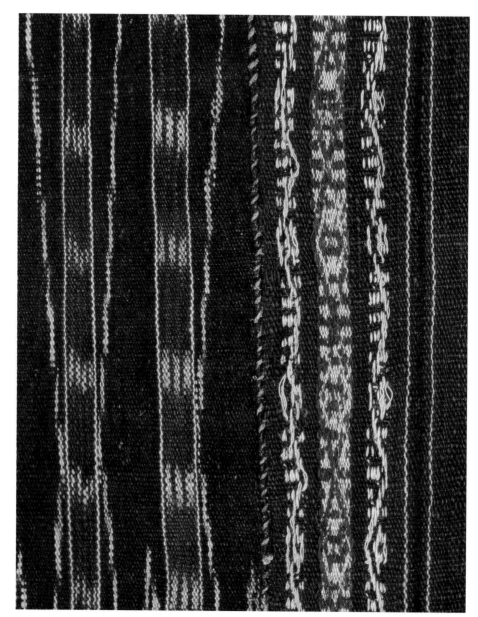

28.  Decorative warp features in Batak textiles.
Collection: Rijksmuseum voor Volkenkunde, Leiden.

While the first Europeans saw coarse primitiveness in Batak cloth, more frequently today, the warp features of *ikat*, supplementary warp, and warp striping are seen as elaborate and striking, especially in older Batak textiles. This detail of a *ragidup* textile collected in the 1880s shows all three decorative techniques. Weavers of the modern types of Batak textiles (see Plate 93) are currently in a flurry of excitement about supplementary weft patterning, however, and admire the weft features of the textiles of the Malay world.

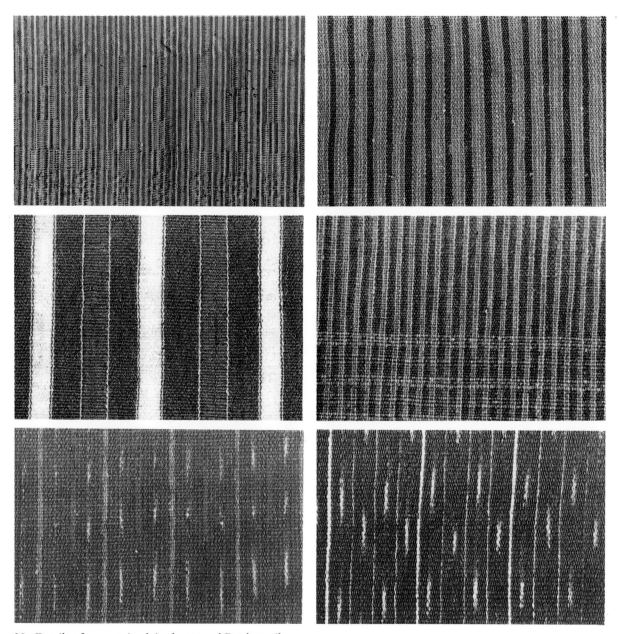

29. Details of warp-striped Acehnese and Batak textiles.
Collection: S. Niessen.
Photographs: Richard Woolner, University of Alberta Photoservices.

The Batak textile repertory includes a wide variety of stripes. It may be that the *ragi barat* of the Karo was inspired by the striped Acehnese cloth (top left). A relatively common Acehnese cloth variety—and made of silk—this one could only have been a familiar and desirable object of Batak trade. Probably the striped cloths of both the Batak and the Acehnese are reminders of an early period in Indonesian weaving history.

30. *Beka bulu.*
Collection: Haji Sibayak Suka, Kaban Jahe.

This is a detail of an old silken *beka bulu parang rusak* from Aceh in the possession of Haji Sibayak Suka, the last Sibayak of Karo. Possibly, this Acehnese cloth was the inspiration for the Karo *beka bulu*, now so popular as ritual garb (see Plate 31).

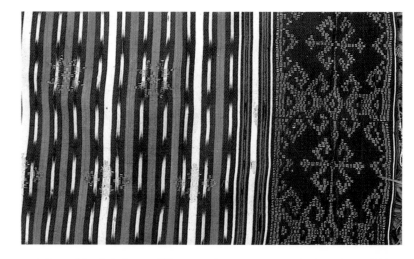

31. Karo Batak *beka bulu* textile used as a headcloth, and as a shoulder-cloth.
Photograph: Rita Smith Kipp, *c.*1980.

The *beka bulu* is woven by Karo Batak weavers on North Samosir Island.

Underneath the dancer's Malay-style red and gold sarong, he is wearing European-style trousers. The Karo textile tradition is now characterized by red and gold where it was once indigo blue.

# 5  Cotton and Cloth in the Indigenous Batak Trade

*Onan parsingguran*   *The market is a place to mingle and to socialize*
*Tigabolit parsaoran*   *Like the three colours twisted together in the headgear*

COTTON for the purpose of making cloth is no longer grown in North Sumatra, and present-day weavers are now entirely dependent on imported and machine-spun yarn, but in Anderson's time cotton agriculture was important in the Batak region. The Batak promoted and encouraged the production of coastal clothing in a very real way, by supplying some of the labour for the coastal weaving enterprises (in Batu Bara) and by bringing to the coast quantities of raw cotton and spun cotton yarn for the making of sarongs, jackets, pants, and blankets (*gubbar*) (Anderson, 1826: 289). Weavers in Deli made sarongs and blankets, and in Sirdang they made coarse *serawal* 'like the Achenese trowsers' (p. 304). It may be assumed, too, that weaving on a smaller scale for personal use occurred all along the coast.

Nevertheless, Sumatra was not a major cotton-producing island in the Indonesian Archipelago, and where there were 'significant' (from the European perspective) plantations, they were south of the Batak area. Anderson carefully documented the flow of foreign goods to the Sumatran ports (see Map 1) and the items the Sumatran inhabitants offered for sale (Map 3), but these lists do not reveal how important cotton was among Batak exports from the interior. Yarn does not appear to have been imported to the Batak area at that time either. It seems that the Batak were self-sufficient in cotton and even had a little surplus to send to the weaving operations on the east coast.

The fact that some Batak textiles were brought down to the coast for sale, even if they did not figure prominently in the international trade, also demonstrates a surplus, however small, in Batak cloth. It is clear that Batak textiles did figure in that indigenous Batak trade, and that some Batak probably relied on that trade to dress themselves.

The east coast trade that was of global significance is as emphasized by Anderson and by successive writers participant in the Netherlands Indies regime, as indigenous Batak trade is ignored. Eventually, the coastal trade expanded to the point that this bias approximated reality, but while foreign goods came to dominate the trade in North Sumatra, internal Batak trade was never fully superseded. Moreover,

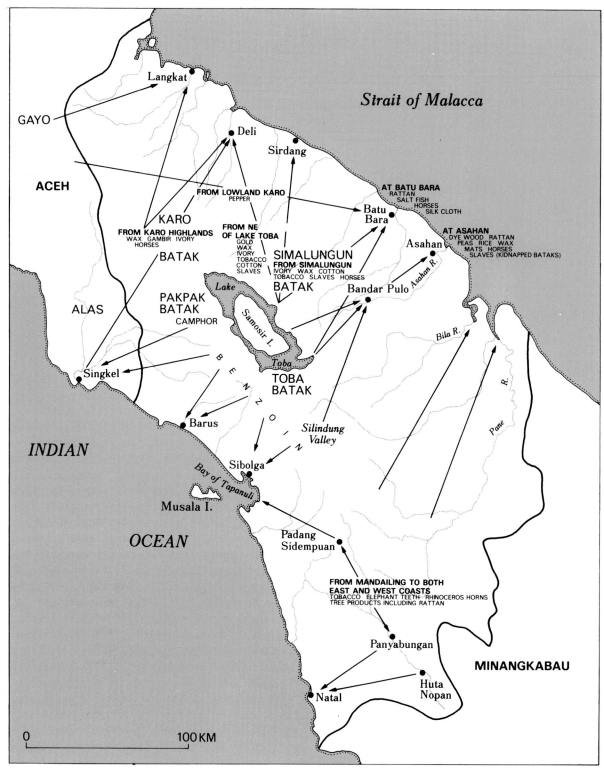

Map 3.   Sumatran exports as provided by the Batak for the coastal emporia.

it was the Batak products transported to the coast (see Map 3), and the established trade infrastructure of the Batak, which facilitated the coastal trade and its expansion. In fact, a distinction between the indigenous trade of the Batak and the coastal trade makes very little sense from a Batak perspective. Nevertheless, very little is known about indigenous Batak trade, aside from its coastal links, and equally little about the role of cotton, yarn, and handwoven Batak cloth in that trade. I have combed the early writings of travellers, explorers, missionaries, colonial officials, textile collectors, and ethnographers for chance remarks and inadvertent detail to try to reconstruct something of that trade in the interior of Sumatra, so frighteningly impenetrable to the first Europeans.

During the course of the nineteenth century, Europeans pushed ever deeper into Batak country. They hired Batak guides and porters and found themselves on jungle paths which the intrepid German medical doctor stationed on the east coast, Bernard Hagen, sensed, in awe, had been in use since Hindu times (1883: 48). No account leaves out reference to these paths and the heroism often needed to negotiate the difficult ones (Plate 32). All told, even just a tally of the paths used by the European visitors betrays an interior landscape well criss-crossed by pathways, and inhabitants used to walking. Map 4, showing some of the Batak pathways in the interior, is an extrapolation from Joustra's map of 1910 which distinguished paths from officially designated roads constructed by the colonial government—many of them, though not all, on the age-old pathways used by the Batak. The map is impressive for the number of paths it shows but it is incomplete. Many paths were too small, and too intimate to local circumstances to have been recorded on this map, and many shifted depending upon the fates of villages and the changing locations of the fields and cleared areas. Nevertheless, it is clear that pathways bound every village into an extensive network of communication. The paths were trod for reasons of trade, kinship, religion, and politics.

To numerous writers, the Batak were fearful travellers, and inferior in trading skills, surpassed by the Malays and Chinese. Other evidence—especially of the Toba Batak about whom relatively more is written on trade—offers a contrasting image of an indomitable trading and travelling spirit. Observers were impressed, if not overwhelmed, by the thousands of Batak who might gather at a principal market (Plates 33 and 34). There, not only would goods change hands, but legal cases would be decided by the community leaders, and rituals, large and small, would be enacted. The large markets were regulated by the offertory communities which have been described as among the most effective institutions of the society (Vergouwen, 1964: 120). The offertory community (*bius* in the north, and *horja* south of Lake Toba) represented the highest form of political organization of the Toba Batak and their success depended on the collaboration with neighbouring market communities to guarantee peace and safety to all market goers. The nature of Toba Batak market organization suggests an economic/trading system that recapitulated

32. Constructing a new road in Habinsaran.
Reproduced from Kohler (1926).

The terrain through Habinsaran, south-east of Lake Toba, was particularly hazardous. Here, a Dutch official in the early twentieth century has taken a picture of Batak using a colonial road that is still under construction. The women are carrying bags on their heads and are perhaps returning from the market or bringing in the harvest from their fields.

kinship ties and supported expressions of communion with the spirit world. The trade routes and the traders were integrated with the social/religious system which bound communities together. All this suggests an indigenous economic system uniquely embedded in Batak social life such that its qualities would not immediately be recognized by observers from the intellectual traditions of 'rational' economics. Whatever their form, Batak markets were effective and served to bridge the gap between needs and production abilities, in addition to their function of binding social/spiritual communities together.

What was the role of cotton, yarn, and cloth in the interior network of nineteenth-century Batak trade? Geography and climate clearly influenced circumstances profoundly, as not all regions were suitable to cotton cultivation. As weaving was a universal activity of

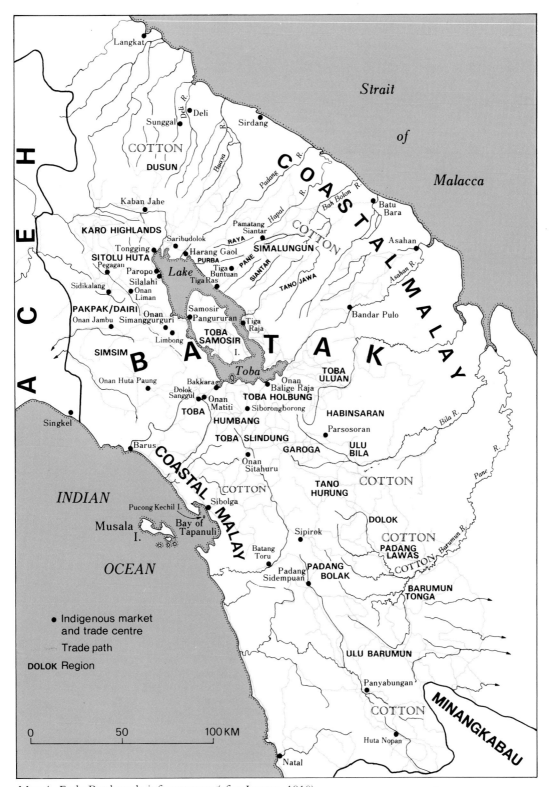

Map 4. Early Batak trade infrastructure (after Joustra, 1910).

(Opposite page)
33. Onan Raja, a major Toba market in Balige, photographed by E. Modigliani, 1890–1.
Photograph: Museo Nazionale di Antropologia e Etnologia, Florence.

Elio Modigliani, a gentleman traveller from Italy, was an avid photographer during his travels through the Toba Batak area south of Lake Toba. His picture of the market in Balige (Onan Raja) gives the impression of the 'thousands' of Batak who assembled at the Toba markets. The Balige market was the most important market on Lake Toba with links to all the territories around the lake, as well as to the south and to both coasts. Markets were held on open terrain.

(Opposite page)
34. Minor Batak market.
Photograph: Museum fur Volkerkunde und Schweizerisches Museum fur Volkskunde, Basel.

Larger all-day markets, such as the Balige Onan Raja, were dependent on agreements with neighbouring territories which guaranteed the safety of all the market goers. Smaller markets were held within the villages only in the early hours of the morning and served only the local needs. The cloths worn by these women (the child is wearing a *runjat songkarsongkar* over her shoulder (see Plate 87), and the hipcloths of the older women appear to be variants of the *ragi harangan*) suggest that the picture was taken among the Toba Batak south-east of Lake Toba. When it was taken, the Malay *baju* was not yet in common usage and it was usual for married women to bare their breasts.

Batak women (with the exception of the Pakpak), the differences had to be made up by trade.

De Haan (1875: 2–3) noted that cotton was fetched from the Dusun area to supply the weaving industry further inland in the 'real Batak' area and Hagen marked cotton fields on his 1883 map along the Buaya River near the east coast. These may have been the sources which supplied the cloth industry in Deli and Sirdang mentioned by Anderson. Hagen has written a singular account of it being transported further inland:

On my daily travels I came across several groups on the path; most of them were bringing cotton, which as I have mentioned was the crop of choice of the territories traversed so far, to the villages on the plateau, where the plant no longer grows. Generally men or boys, also young boys, carried the kapas (cotton), although I also often saw old and young women doing the same. The raw cotton was rolled in palm leaf cylinders of around 1½ feet high tied with rattan; at the front and back ends of such a cylinder, bamboo poles were fastened with ijuk [hairy black fibres of the trunk of the Aren Palm] ties and carried on the shoulders. The Batta carries all loads on these bamboo poles [Plate 35] and knows no other method of transport; also my people carried their freight in this manner (1883: 48–9).

When he reached the edge of Lake Toba at that boundary between Karo and Simalungun, he saw raw cotton and cotton yarn for sale as well as red (*Morinda citrifolia*) and blue (local indigo varieties) dye stuffs (pp. 48–9). Simalungun cotton was grown in Siantar and especially Tanah Jawa. In 1894, Van Dijk refers to these areas as having been the 'cotton barn' for Toba, a fact which points to active trade between Toba and Simalungun (p. 161). Tiga Ras and Tiga Raja, the large markets on the east shore of Lake Toba, formed the passageways between the two Batak groups (Plate 36a–b). The cotton supply in the lowland Karo region, the Dusun area, probably supported the entire northern end of Lake Toba, including Samosir Island and the west coast of the lake. Here lived—and still live—prolific weavers of cloth for the Karo and Simalungun markets.[1]

At Tiga Ras, the Simalungun sold raw cotton to the Toba and purchased, in return, spun yarn. It looks as though the Toba were specializing in spinning as well as obtaining cotton for their own weaving needs. While the Toba Batak at the northern end of Samosir Island wove some cloth for the Simalungun market, an anonymous article of 1904 indicates that the Toba were also purchasing cloth from Simalungun weavers (p. 581). Market relations seem to have been complex. Elderly Simalungun weavers whom I met in Raya could recall a day when strung looms were brought down to the lakeshore on market day and Toba weavers were hired to complete the weaving. It appears that at least some Simalungun weavers did their own dye work with available red and blue dyestuffs (p. 581).

By 1894, although cotton was still being produced in Simalungun 'in fairly large quantities', the cotton boom in Simalungun was already

[1]Archives of the State Museum of Ethnology, Leiden; Cremer Collection notes, acquired in 1883.

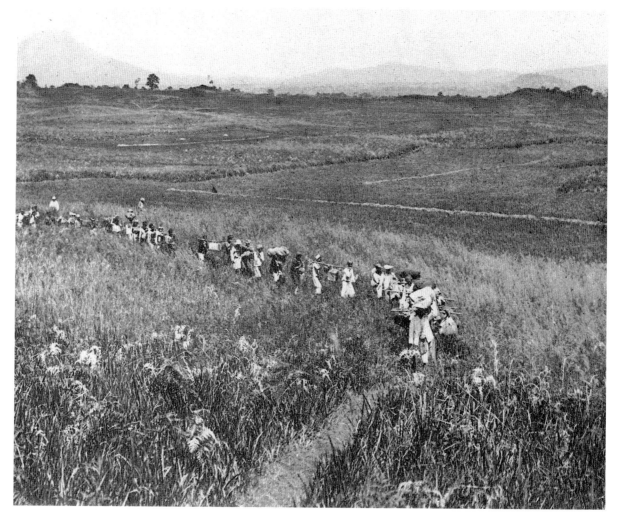

35. Karo Batak laden with goods (for trade?) follow a footpath through the highland plateau.
Photograph: Tengku Luckman Sinar, reproduced by W. Rice from Anon. (n.d.).

The *parlanja* (bearers) used bamboo poles to carry their burdens, or hoisted the object on to their shoulder. Where it was convenient, horses were also used for transportation (*hoda boban*).

a thing of the past. Van Dijk attributed this to the large amount of European yarn entering Sumatra through Sibolga, and being brought to Balige where it was shipped to other places on the shore of the lake to supply almost all the regions around the lake (1894: 160–1; Giglioli, 1893: 116–77) (see Plate 33). It appears that cotton was also at one time cultivated close to Sibolga and brought inland, and that the imported European yarn was brought in along established cotton trade routes (Henny, 1858; Veth, 1867: 38). Cotton was also an important cultigen in Padang Lawas and the inhabitants traded both raw cotton and spun yarn north to the Toba Batak and east to the Minangkabau weaving operations on the coast.

I remember with some embarrassment how, in 1979, I sought out Ompu ni SiSihol, a 'traditional' Batak weaver living on the isolated west bank of Lake Toba from whom to take weaving lessons (see Plates 1 and 22), having in my mind a rather inflexible image of how a 'traditional' Batak weaver would go about her work. The first task she set for me was to purchase, on the local market, yarn for our textile.

(a)

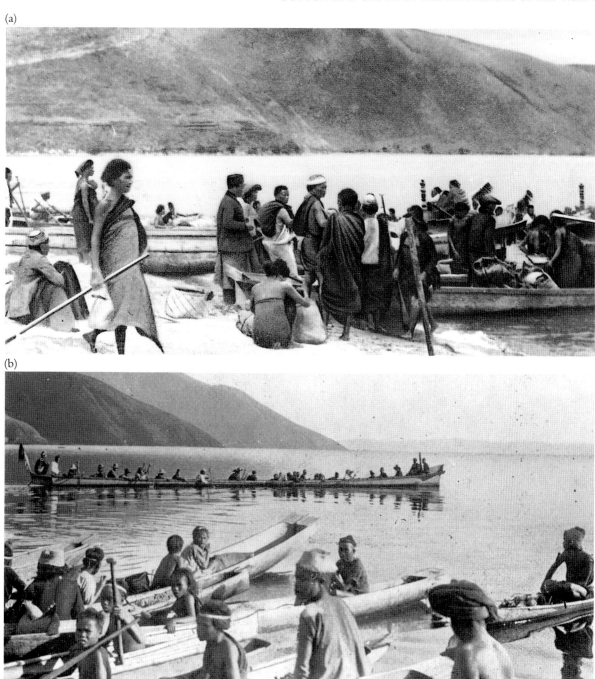

(b)

36a–b. Transportation was facilitated by Lake Toba.
Photograph 36a: Museum fur Volkerkunde und Schweizerisches Museum fur Volkskunde, Basel;
36b: Reproduced from Joustra (1915a).

The enormous dug-out canoes used on Lake Toba speak volumes as to the mobility of the inhabitants beside the lake and the Batak ability to ship their produce to market. The canoes were even used to transport Batak ponies to the eastern shores of the lake whereupon they would eventually be brought to the east coast and sold on the other side of the Strait of Malacca.

I explained that I wanted her to weave as this must have been done in the past, and that I wanted her to spin at least a little cotton for me. She claimed that yarn had 'always' been fetched from the market-place, and of course I dared argue and to duly note how much heritage had been forgotten....

Given the paucity of descriptions about Batak trade, the design evidence woven into the cloth itself is particularly important for showing contact between groups. The textiles of Sitolu Huta, woven in Tongging, Paropo, and Silalahi, show such strong similarities in appearance with Simalungun and Karo textiles that active trade between these regions, certainly in finished cloth, and probably also in materials, must be considered an established fact (Plates 11 and 16 show supplementary weft features characteristic of this region).

Sitolu Huta, the village of Silalahi in particular, maintained strong ties, in turn, with the Pakpak/Dairi area, further west. Pakpak appearance (Plate 37) was a special demonstration of the importance of cloth in early Batak trade, as weaving was not practised in this subgroup. All apparel was obtained through the market and was a mixture of textiles of different ethnic origins, many of them Karo, Toba, and Simalungun, and Gayo and Aceh to the north. Here, the names of the Pakpak/Dairi textiles as well as old photographs are clues that the current trade has deep historical roots (Manik, 1977: 214).

Some trade relations appear to have been stimulated by trade and production agreements. To cite one example, the leaders in Balige, on the one hand, and Lobu Siregar and Sianjur on the other, decided that the former would export textiles and the latter would export pigs. Furthermore, the former would not raise pigs and the latter would not weave cloth, an agreement which could only have led to more active trade and interdependence between the two regions (Sillem, 1879–80: 36).

Nevertheless, the cliché image of the independent Batak weaver growing her own cotton and working through all the stages to the finished cloth is also valid. The early British trader, William Marsden, concluded—albeit on the basis of minimal excursions into the interior—that 'In almost every part of the country two species of cotton are cultivated.... The cotton produced from both appears to be of very good quality, and might, with encouragement, be procured in any quantities; but the natives raise no more than is necessary for their own domestic manufactures ...' (1811: 157). The Toba missionary, A. Bruch, observed as late as 1895 that individual weavers south of Lake Toba engaged in all the steps of making a cloth. In great contrast are De Haan's observations two decades earlier, but near the east coast, of what may have been the first professional Batak weavers in the interior. These were the wives of (the first?) professional traders in Simalungun who owned and worked no land (1875: 38). Both spouses devoted themselves to occupations which were probably in themselves only possible due to expanding coastal trade.

The relative importance of weaving for the market and weaving for household consumption is difficult to ascertain. The problem of the

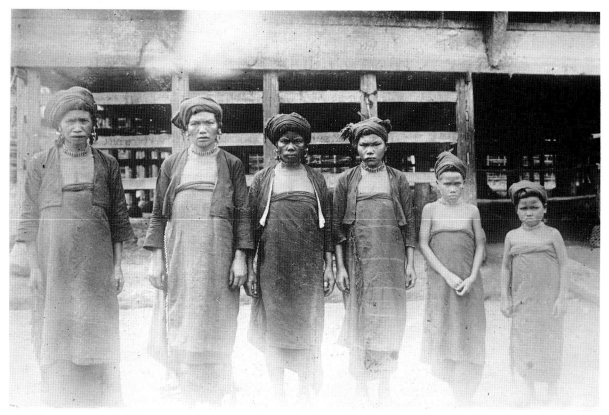

37. Pakpak Batak women's clothing (1907) demonstrates trade links with neighbouring groups.
Photograph: Royal Institute of Linguistics and Anthropology, Leiden.

This rare photograph of Pakpak women depicts the ethnic diversity of their clothing. The side panel of the cloth covering the torso of the woman on the left is relatively wide, indicating that it is a Karo, Simalungun, or Sitolu Huta textile. The woman beside her is probably wearing a *sibolang* hipcloth. The narrow side panel betrays its Toba Batak origin. The woman standing third from the right is wearing a Karo *teba* textile, or a Toba *bolean*, as indicated by the widely spaced stripes. She also has a *surisuri* on her head, probably of Toba origin. The cloth is characterized by narrow, closely jux-taposed warp stripes in a blue ground.

Pakpak clothing in the Kepas region as described by Ypes in the early twentieth century is one of the only descriptions in the literature: 'If the father of the bride is well off, then he gives along with his daughter, a *bergot* (necklace for men), golden earrings to affix to the upper edge of the outer ear (*kudung-kudung*), a silver lime box with silver chains attached to a silver gam-bir box (*para purun*) and a regular set of clothing, consisting of a sarong *abit* or *ulos* (abit = used sarong and ulos = unused sarong; these words are used figuratively for women), a headcloth (*saong saong*) and some-times a jacket (*baju*), which is tight and very short so that the belly remains bare and the shape of the bust comes out clearly. Although the wearing of a jacket is not of great vintage, one calls a virgin *Si marbaju* as opposed to *Sintua na jejab*, which means married woman. Wedding clothing is not used by a woman, but it is by a bridegroom. A bridegroom must wear a white headcloth, a *kujur sunanne* (lance), a *jenap* (a kind of klewang with a wooden sheath and a horn hilt of a peculiar bent shape) a *ucang kating-katingan*, a basket woven from pandan for sirih imple-ments, to which there is not yet a chain attached and which therefore must still be carried under the arm. Only after the consummation of the marriage may the chain—usually of copper—or the band be attached to the basket, which is then simply called *ucang* and is hung over the shoulder.

Pants are not worn by the Pak-pakker' (1907: 483–4).

51

paucity of information is compounded by the fact that the sources were written at different times, for different regions, and that regions underwent economic changes at different rates. What this composite picture does show, however, is that weaving was sensitive to market conditions, whether in reaction to activities on the east coast, or the agreements between trade leaders inland, and that the indigenous trade was a precondition for weaving to become a universal activity of Batak women.

Reliance on the market to supply the cotton yarn for weaving laid the groundwork for one of the revolutions that Batak textiles have undergone—the transference from handspun yarn to machine-spun yarn. This could only have given the wiry, regional, and personal quality of Batak textiles the first standard feature.

## A Century Later

The Batak weaving that has survived is that which has continued to adapt to the changing economic and market conditions in North Sumatra. Gone forever are those who weave for home consumption. In their place, beating wefts into their weekly cloth, are weavers for the market-place. Probably the textiles which the late nineteenth-century authors saw on the markets were symptomatic of the ever accelerating trend towards the market production of Batak cloth.

Today, weaving is concentrated in a handful of Batak regions (Map 5). Lake Toba has become the hub of Batak weaving activities, with the Silindung Valley and Sipirok also being home to prolific weavers. Everywhere else, weaving is virtually non-existent: the Karo Batak, and more recently the inhabitants of Tongging, have stopped weaving; weaving has died out in the Southern Batak area, with the exception of Sipirok where it underwent a revival (Joustra, 1910: 305); a few Simalungun villages on the shore of Lake Toba still make Simalungun shouldercloths and headcloths (Plate 38); the Pakpak/Dairi Batak have never woven. The bulk of Batak weaving is done by the Toba Batak, always the most accomplished and prolific of the Batak weavers (Volz, 1909; Joustra, 1910). At the northern end of Samosir Island and along the north-west shore of Lake Toba they weave for the Karo and Simalungun markets as they have done for at least a hundred years. On the south-east shore of the lake weavers make the coarse, wide textiles loved by Uluan consumers. On the south-west shore, in the bays of Bankkara and Muara, and scattered along the western edge of Samosir Island are the producers of the indigo blue textiles in demand by all the northern Batak (see Plate 26). Silindung Valley weavers make the modern, bright, and fashionable textiles (see Plate 93).

The markets seem to have inspired a division of textile style labour. Each region's textiles satisfy especially the local tastes and demands, but are so well connected by the well-meshed market system that they may be found and obtained virtually everywhere there is a community of Batak. The markets still work along the lines of a relay

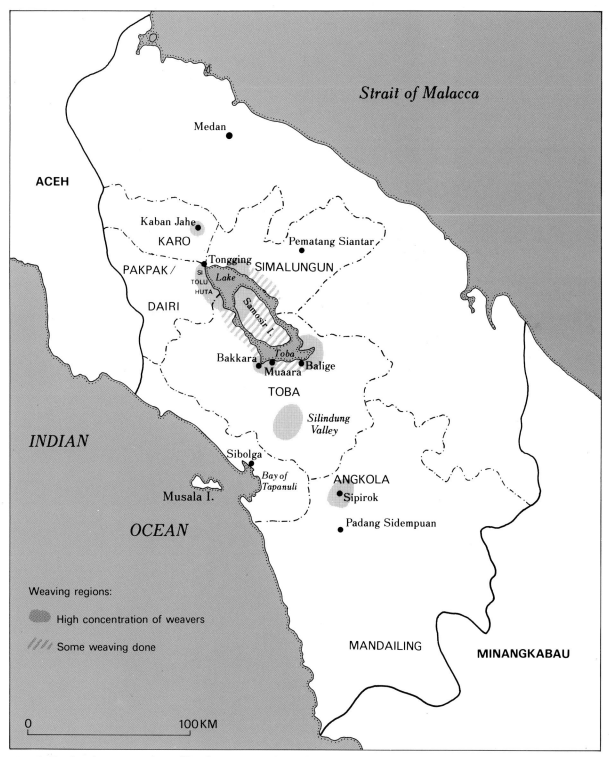

Map 5. Regional concentration of Batak weaving today.

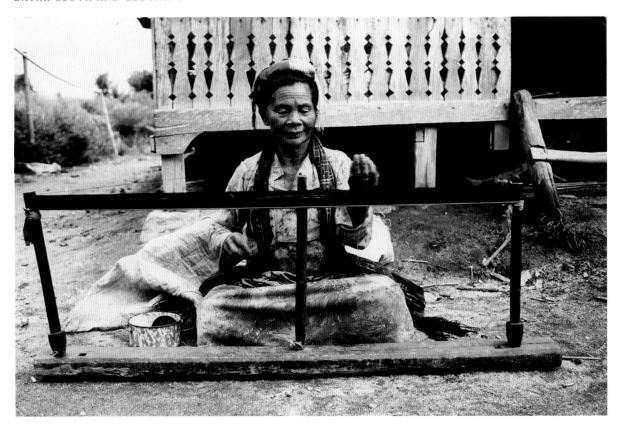

38. Simalungun weaver.
Photograph: S. Niessen, 1986.

This weaver is wearing the Sima-
lungun *bulang* on her head, and the
Simalungan *surisuri* textile around
her neck. She is wrapping the warp
in preparation for making a *surisuri*.
The Simalungan *surisuri* has different
design features from the Toba Batak
*surisuri* (see Plates 26 and 37). The
Simalungan *bulang* has features in
common with the Toba Batak
*ragidup* (Niessen, 1988/89).

system as described by Marsden two hundred years ago: once an article
appears on the market, it is purchased by traders who bring it to
the next market, where it is purchased by other traders and taken fur-
ther. Distribution occurs in a star-burst pattern from market to mar-
ket. If the first professional traders were signalled by De Haan in
1875, the larger markets now thrive on the efforts of full-time traders
who push on to a different market every day following a weekly
schedule (Plate 39). Their schedules intersect with the schedules of
traders working different, overlapping sets of markets and so the mar-
kets interlink.

Although little is known about the quantities of textiles in the early
nineteenth-century markets, textiles in the oldest museum collections
and stored in the oldest closets of North Sumatra tell that improved
transportation has transformed textile production: the range of vari-
ations in a single textile type has decreased. A textile type, especially
one that was widely known, displayed its regional origins by subtle
design features—the width of the side panels, the slight changes in *ikat*
design, for instance. The range of variations spoke of the creativity
and the relative isolation of their makers. Today, villages tend to
specialize in a particular textile type, and through market distribution
what was once only a variant becomes the standard known and used
everywhere. With continuing demand for their cloth type, and no
competing weavers, the makers are assured of part of the market.

39. Textile market in Porsea.
Photograph: S. Niessen, 1990.

Porsea, Balige, and Tarutung cur-
rently have the largest textile mar-
kets in Toba, each with more than
seventy stalls.

If Batak textiles today exist by virtue of their adaptation to the pre-
sent market, their survival is equally related to the circumstances of
their makers. When weavers cease to weave, it is because they have
found activities which are more lucrative. Probably the success of
truck cropping, the economic miracle in the Karo area in the second
decade of the twentieth century, indirectly cultivated the decline of
Karo weaving. Successful Dutch experiments in Berastagi with po-
tatoes, followed by the construction of a road from the coast to the
highlands, and collective Karo ownership of the transport (Plate 40),
brought an agricultural boom and new wealth to the population
(Joustra, 1915a: 15–20). Today, agriculture is more lucrative than
weaving. Where there are few means of making money in North
Sumatra, Batak weaving for many women, particularly those without
earning husbands, has become the buffer to hunger. The indispens-
ability of handwoven Batak cloth for Batak ritual purposes, and the
poverty of the weavers are the keys to its current survival. Who
would begrudge a weaver a less tedious and more lucrative way of
keeping afloat? The market-place represents a hidden revolution
which has shaped the character of modern Batak weaving.

The part of the weaving tradition that survived represents only a

40. 'The first freight-carrying motorized vehicle in the Karo highland plateau', February 1914.
Reproduced from Joustra (1915a).

'The export of potatoes on a large scale made it necessary to transport large quantities to the coast and to sell them there. This problem was resolved by an agreement with a trade firm in Medan which was prepared to act as an agent and provide one automobile, or two if necessary, for this purpose. The agreement stipulated that the same would be paid for the freight as had been paid until now for transportation by ox-cart. The agent held the right to transport as much freight and as many passengers as possible so that the exploitation of the vehicle would yield a profit. The profit would then, after subtracting the 6% capital investment, be put towards purchase and repair costs so that the co-operation had the means, in the course of time, to own the vehicle' (Joustra, 1915a: 18).

With time, the Karo Batak did, in fact, control much of the lucrative transportation between the coast and the highland plateau.

segment of the apparel repertory that Batak weavers once attended to. Imported cloth and clothing worked its way into the interior along the efficient Batak market routes and eventually won it over for daily wear.

On the one hand, the story is a familiar one. As roads were constructed, the transportation of the foreign goods into the interior was made faster, easier—and cheaper. It became possible to make a living by trade alone. Jobs diversified. The standardization of coin and the levying of tax increased dependence on the money economy. The needs of the people expanded (Meerwaldt, 1891: 513, 549). Lifestyles changed to accommodate the new circumstances. Handicrafts declined as they had no toe-hold in the economy; they were a free-time activity, a non-professional activity, inspired by the long slack periods in the agricultural work calendar (Joustra, 1912: 60). Similarly, the age-old benzoin trade on the west coast dried up because the Batak discovered easier ways to earn the same money (Joustra, 1915a: 88).

On the other hand, it is too simplistic to summarize the transformation of daily Batak wear in purely economic terms. These terms cannot explain the continued allegiance to ritual apparel. The cost of imported fabrics and clothing combine with numerous other factors to result in a variety of clothing transformations, some more evident and meaningful to the outsider's eye than others. Karo Batak clothing history again provides a good case in point. Anderson noted as early as 1823 that the Karo were avid consumers of cloth: 'Nothing but the want of means prevents them from all wearing European cloth …' (1826: 52). Aside from the wearing of *baju*, or little jackets, however, they seem to have put the new factory cloth to the same use which they had put their handwoven textiles. They dyed it the same colour of indigo blue and they draped it the same way around their bodies.

The only difference was in weave texture and drape (see Plates 2–5). To the observer, Karo clothing had not changed—yet the stuff from which it was made was entirely different. This subtle but fundamental transformation in Karo clothing betrayed new economic relations but refused to register new social relations with the Malay on the coast. A full century later, the clothing still had not significantly changed in style.

Clothing changed at different rates in North Sumatra and in different ways: it changed more quickly and followed different models for men than for women, and for the rich and powerful than for the poor; it was manipulated to demonstrate political and religious affiliations and allegiances. That the Karo Batak chose to fashion their own dress, rather than Malay dress, with their cloth purchases, contains a message that begs to be deciphered.

# 6 Clothing Batak–Malay Relations: Affiliation and Differentiation

THE Malay component is strong in today's *vestimentum communis* of North Sumatra. Everywhere, when the Batak began to relinquish their national garb, and even prior to that, they adopted pieces of Malay apparel (Plate 41). The *baju* was first and became thoroughly integrated with the indigenous Batak clothing system. Men's head-cloths in the Malay style (*detar*) were also quickly adopted. Hipcloths were replaced by typically plaid Malay sarongs, and also batik sarongs. Under the sarong, men may have worn Malay-style trousers (*sera-wal/seroar*), although apparently pants were the slowest component of the foreign dress to attain any popularity. Eventually, European-style pants became the dominant fashion. Toba women began to wear their hair the Malay way in a knot in the centre of the back of the head rather than in a roll on the right side of the head.

While the clothing history of the Malay of North Sumatra—as yet unwritten—needs to be juxtaposed with the clothing history of the Batak to obtain the full story of how the gap between Batak and Malay was bridged by a *vestimentum communis*, suffice it to say that local dress styles which once served to proclaim different identities, eventually served to emphasize a common identity—in which religious difference became the primary distinction. Batak and Malay were closely related: 'The "Malay" dynasties of East Sumatra were in fact moulded from varied ethnic origins, with Batak, Minangkabau, Acehnese, and Indian elements predominating over the strictly Malay blood of Melaka and Johor' and shared a long history (Reid, 1979: 2). The nineteenth century of radical social change on the east coast brought sharp, relatively sudden and painful adjustments which, on occasion, spilled over into violence; in the Southern Batak area, the Batak were overrun and overwhelmed by a warring Muslim sect from Minangkabau. While resistance to the Malay element was expressed, on occasion and by times, symbolically in clothing, the general trend was towards a common appearance that played down ethnic distinctions between the Batak groups and between Batak and Malay.

41. A return journey from Sidikalang in November 1911.
Photograph: Royal Institute of Linguistics and Anthropology, Leiden.

This photograph is important because it is dated. On it is written in Dutch, '(return) Our journey. Sidikalang. Nov 1911'. It shows a European man in his day-to-day clothing, including a jacket the same as that worn by the locals. It is impossible to know whether his carriers were Malay or Batak—and that in itself is revealing of the *vestimentum communis* that was taking over.

Note the Batak way of carrying things on the shoulder or on bamboo poles.

## The Karo, the Simalungun, and the Malay on the East Coast of Sumatra

The Karo Batak were left in the previous chapter fashioning their own, unchanged dress styles from imported fabric. By 1910, Joustra was still describing highland Karo clothing as 'fairly pure' (pp. 126–7). Presumably, he was basing his evaluation on style, as the Karo clothing tradition had otherwise certainly undergone radical changes: weavers had turned to agriculture for a living, and the society was relying increasingly on cloth purchases to make up their wardrobes; handspun yarn by that point had almost entirely been superseded by the imported commercial variety. Pure was hardly the word to describe Karo clothing, but the impression of purity was significant and curious. Except on the coast, stylistically it was registering little to no impact of Malay culture (Plates 42 and 43), although much of it was made from materials purchased on the coast, with the means earned in the service of the Malay and through a trade carefully managed by the Malay. Karo clothing styles did not alter until after their

59

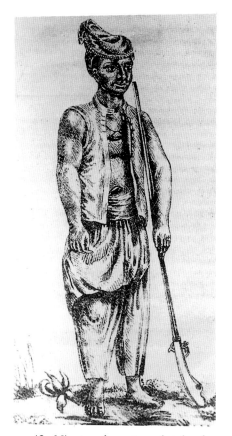

42. Nineteenth-century sketch of a Batak on the east coast.
Reproduced from Bastin and Brommer (1979).

Batak on the coast altered their dress to the Malay style. This Batak is wearing the headcloth, *baju*, and *serawal* of Malay affiliation. The print suggests that the artist came across his subject in the Malay coastal region.

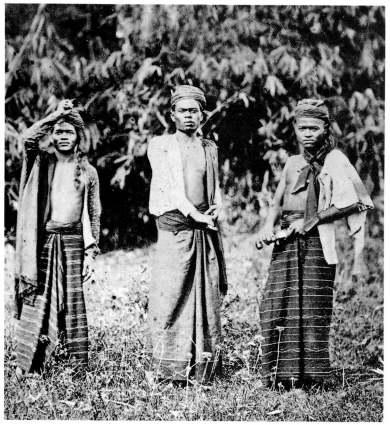

43. Young Karo men in (fairly) 'pure' dress.
Photograph: Royal Institute of Linguistics and Anthropology, Leiden.

The men to the left and the right in the photograph have the *ikat*-decorated *hati rongga/kaci rengga/gatip ampar* wrapped around their waists as hipcloths. The man in the centre is wearing a wide blue hipcloth called *julu* around his waist, the Karo variant of the Toba Batak *sibolang* (see Plate 26). All are wearing jackets (*baju rompas*).

territory had been annexed by the colonial regime (1905−6). Then change was radical and rapid.

Much earlier, it appears from the very scanty information available, the Simalungun Batak began wearing Malay garments (Plates 44 and 45). If the clothing of the Karo represented differentiation and the clothing of the Simalungun represented affiliation, it mirrored the respective relations the two groups had with the Malay. These relations were much informed by the respective social structures of the groups. Simalungun Batak social structure was exceptional in the Batak world for its emphasis on hierarchy. The raja, or chiefs, had great autonomy; even their affines had little say in their decisions. These raja were inspired by the influence and power of the Malay sultans, and attempted to make their lands available for plantations as did the sultans (Tideman, 1922: 48). Not surprisingly, very early on these raja affiliated themselves with their ambitions by dressing themselves

44. Muslim evangelists in Simalungun.
Photograph: Vereinigte Evangelische Mission, Wuppertal.

Islam came to the Batak territory with a motley array of clothing, if this photograph is an indication. Here there are gentlemen wearing batik, *ikat*, and European trousers, and a Malay sarong. On the upper body they wear a mixture of Malay and European elements. They appear to be proud of their umbrellas and watch chains.

45. Family of Tuan Anggi Dolog, Dolog Mariah, 1938.
Photograph: P. Voorhoeve.

The upper garments of this Simalungun family have all changed to the Malay and European style. While most of the women are wearing plaid Malay sarongs, two of them are still using the indigenous hipcloths. Three of them have the local *bulang* or *surisuri* textiles as headcloths, while the man second from the left is wearing the Malay fez-like *kupiah* on his head.

in Malay clothing and speaking the Malay language (Van Dijk, 1894: 153–4; Anon., 1904) (Plate 46). John Anderson's draughtsman depicted such a Simalungun Batak, who had been 'civilized' through his long and intense contacts with the Malay, dressed in Malay clothing (see Plate 9d). Unfortunately, it is not clear how the other classes of Simalungun expressed their relations with the Malay—and with their own leaders—through their clothing. The Simalungun population closer to the coast appears to have adopted Malay clothing faster than the Simalungun closer to the shores of Lake Toba (Van Dijk, 1894: 153–4), and one Dutchman noted that the same Simalungun might dress as the Malay in Malay territory and as the Simalungun in Simalungun territory (Kroesen, 1899b: 277), in what seems to have been an attempt to play down their ethnic distinctiveness (Plate 47).

The Karo, by contrast, seem to have used their clothing to emphasize their distinctiveness. They adhered to their own clothing styles, regardless of changes in the material from which it was made. The clothing itself suggests self-awareness, stubborn adherence to identity, as well as pride. Events along the east coast during that period corroborate such an interpretation.

It is possible to imagine a situation of cultural symbiosis between Malay and Batak on the east coast. The Malay were especially adept at mediating in the Sumatran trade between foreign buyers and Batak producers, playing, in other words, a complementary role to both. They recognized Batak sovereignty and power to the extent that they

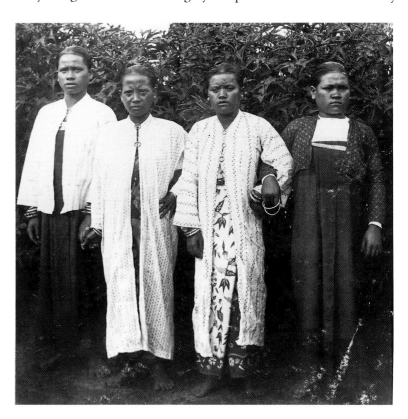

46. Daughters of the Raja of Raya, Simalungun.
Photograph: Vereinigte Evangelische Mission, Wuppertal.

The Simalungun leaders were the first to adopt Malay clothing. This photograph was probably taken earlier than Plate 42, but already there is nothing in the Malay garb of these women that suggests their Simalungun origin.

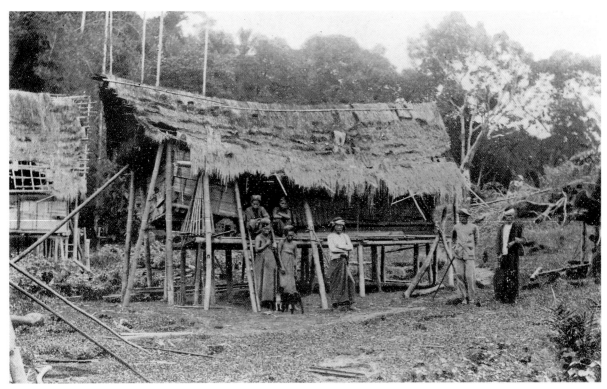

47. Poor Simalungun Batak. Reproduced from Joustra (1915a).

The gap between rich and poor was wide in Simalungun and social hierarchy was rigid.

married strategically with the daughters of Batak chiefs to ensure strong and safe trade ties. While the ethnic gulf was wide between the Karo and the Malay, in genetic and circumstantial terms, the gulf was bridged by a continuum. Many of the Malay were assimilated Karo and many Karo had been incorporated into the sultans' domains.

Whatever balance there was in the relative powers of Batak and Malay changed to the advantage of the Malay as trade picked up. When the first planters arrived on the east coast, in 1863, they appealed to the Malay for land grants, just as Anderson had appealed to them as controllers of the trade. The power of the Malay sultans snowballed through the nineteenth century. Land, unlike trade, however, was not the legitimate province of the sultans. Historians now believe that the Batak had once lived much closer to the coast, but that they gradually withdrew inland as the power of the Malay expanded. The principle of land ownership was a central point of divergence between Malay and Batak culture. Batak land was communally controlled by the lineage (*marga*) and individual members had use rights only. The Malay, by contrast, recognized individual rights of possession. During the east coast plantation boom in the latter half of the nineteenth century, Malay leaders were able to line their pockets by ceding to the planters land over which they had no legitimate power of disposal. Thus, they encroached on Batak territory.

Eventually, the patience of the Karo Batak wore thin. In 1872, and repeatedly thereafter, it exploded in violence. They burned barns to draw attention to and avenge their plight. These were long-lasting,

simmering conflicts. Economic circumstances militated against any resolution to the advantage of the Karo. A source of great bitterness and distrust to the Karo, the Dutch colonialists sided with the Malay by putting down the Karo rebellion of 1872 using military force—before conducting an investigation into the legitimacy of the Karo complaints. The Karo became notorious to the Dutch colonial authorities for the depth and virulence of their bitterness and distrust (see Plate 54).

Karo clothing co-operated with those feelings as a badge, and an expression, of their difference from their neighbours. The simple and sober indigo blue cloths of the Karo reflected the egalitarian nature of their social structure. Everyone wore the same clothing with apparel distinctions marking gender and age, but not, on a daily basis, social rank. Before the society began to register the effects of expanded trade to the coast, access to wealth was equal, even for the chiefs, and achieved through agricultural labour. The clothing of the Karo did not co-operate with the principles of authority and hierarchy

48. Karo dye pots carved in volcanic stone.
Photograph: Royal Tropical Institute, Amsterdam.

A century ago, Joachim Freiherrn von Brenner-Felsach visited a Karo Batak market and he was disappointed by its uncharacteristic (for 'India') drabness. The clothes of the people were to blame, he wrote. They were blue: light blue, dark blue, just blue (1890: 283). Throughout the Karo countryside, women and men wore blue hip-cloths; blue shouldercloths were slung over their shoulders or pulled tight for warmth around the upper body. Women wore enormous blue headcloths that shaded their eyes and faces from the tropical sun. Even the hands of the dyers were blue from the indigo. If they wore the Malay blouse-like jackets (*baju*), they preferred the dark blue-black ones. The only bit of colour was in the men's headcloths, wrapped turban-like around their heads; and these cloths were probably Malay, Acehnese, or Javanese imports.

To perk up a stained and dirty blue cloth, the Karo would over-dye it and also treat it with a red liquid (*cina*) which gave the blue cloth a coppery-purple sheen.

64

endorsed by the Malay and colonial establishments. Furthermore, the blueness of Karo dress emphasized their distinctiveness. The Karo were, and still are—at least for the time being—experts at the indigo dye pot (Plate 48). They used it to colour their social position. Any cloth which they purchased they could transform by committing it both to the style and the colour of their own clothing tradition. No early traveller to the region failed to remark on the blueness of the Karo (Plates 49 and 50).

What was the 'national' Karo clothing? As elsewhere in the Batak territory, the Karo wove cloth into oblong-shaped lengths (see Plate 21a–b) and draped them, one around the hips and one around the shoulders, and wound and folded them around the head. The hipcloth was wider than the shouldercloth; its width stretched from waist to feet, and it was inappropriate for it to be so short that it revealed the ankles (see Plate 20). The women's version was called by the generic name of *abit*; men used a *gonje*. It had to be pulled up with one hand to facilitate movement. A short cloth extending only to the knees was worn by men when working in the fields. It was rolled up

49. *Batu jala* textile.
Reproduced from Loeber (1914).

Loeber claims that this cloth was collected in the Karo region. It is the most elaborate example of the Karo *tritik* technique that I have seen and when I told Karo dyers about the pattern in 1986, it was not (no longer?) familiar to them. *Tritik* is a resist technique in which a yarn is basted through a fabric and then used to gather the fabric. When the cloth is submerged in the dye, the gathered section does not absorb dye and the result is a pattern on the cloth. That such a technique should only be found amongst the Karo Batak is another demonstration of the importance of the indigo dye pot in their textile tradition. Other examples of the *batu jala* textile are found in Plates 3, 4, and 52.

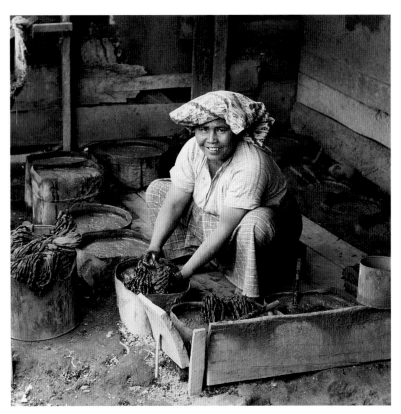

50. Karo Batak indigo dyer, 1986.
Photograph: S. Niessen.

Nande Pulung of Kaban Jahe is one of the last of two indigo dyers in her village. The other one, Nande Indra, has recently decided that it would be more lucrative to sell textiles on the market than to continue to dye. Nande Pulung combines her natural dyeing with chemical dyeing.

around the waist (*menting*) and sometimes fastened with a belt (*gendit*) (Joustra, 1910: 126) (see Plate 65). This must be what Genep, an impoverished fictional Karo character in J. H. Neumann's autobiographically based novel, was wearing: 'He did not have a wide choice in clothing because aside from a blue cloth around his hips reaching to the knees, and ditto around his shoulders, I have never seen [him wear] anything else' (1916: 34–5). Women wore theirs tied around the waist—with their breasts exposed if they were married—or tightly wrapped around the breasts if they had not yet had a child (Plates 51 and 52).

On public occasions men wore another blue cloth, called a *cabin* (pronounced chabin), thrown over their shoulder like a shawl (see Plate 20). A thick, handwoven variety, it also served as protection against the cold. It appears that this item was eventually forfeited for the wearing of jackets (*baju rompas*) made of imported material (see Plate 43), but interestingly, the *cabin* did not lose its status. Well into the twentieth century, older men were still wearing a 'shawl' in com-

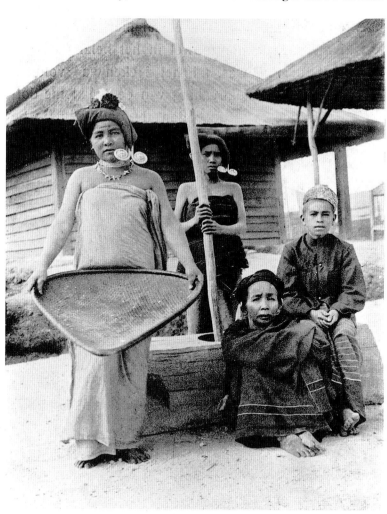

51. Karo women pounding rice. Reproduced from Joustra (1915a).

The woman on the left is wearing an undyed cotton *abit*. The Karo would wear white clothing until it was soiled, and then dye it and wear it again. The woman holding the wooden pounder has a *teba* textile wrapped around her upper body. The young man on the right is wearing what is probably a *kaci rengga* around his hips.

52. Karo women in 'pure' dress, photographed by E. Paravicini. Photograph: Museum fur Volkerkunde und Schweizerisches Museum fur Volkskunde, Basel.

This photograph depicts married and unmarried women.

The *batu jala* textile is being worn as a shouldercloth by the young unmarried woman (on the steps) and by the boy (far left). The cloth is characterized by subtle white lines at the edges and middle of the cloth (see Plate 49).

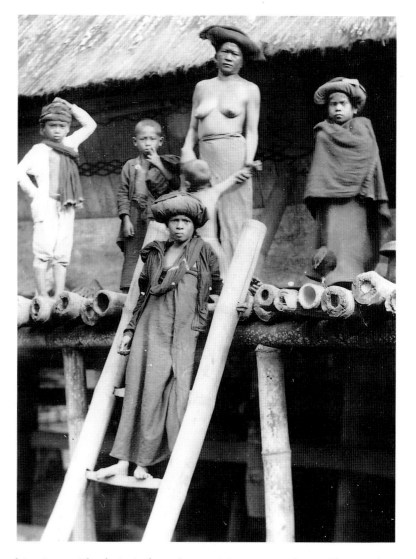

bination with their jackets (J. H. Neumann, 1916: 49). In 1910 Joustra remarked that they were worn only by the rich as ritual clothing. Presumably, this is the extra piece of finery over the shoulders of the Sibayaks in Plate 69 and of the assembled Karo chiefs in the palace on the east coast (Plate 53). Joustra refers to it in this context as *uwis kadangkadangan*, a generic name meaning, simply, 'shouldercloth'. Various cloth types could fit this purpose. The kind of cloth used by women to cover the upper body distinguished the unmarried from the married (see Plate 52). It could also serve as a carry cloth to transport a child on the back.

The jackets or tailored upper body garments (*baju*), although borrowed from the Malay clothing tradition, I include here—as Joustra did—as part of 'pure' Karo dress. Already popular clothing items when Anderson visited the east coast in 1823, they became a standard item of dress for both men and women. They were usually made

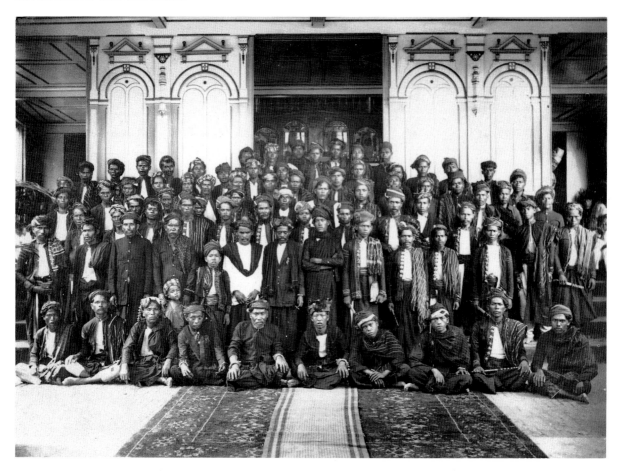

53. Karo and Simalungun leaders assembled in the palace of the Sultan of Sirdang, 1928.
Photograph: Tengku Luckman Sinar, reproduced by W. Rice from Anon. (n.d.).

It is interesting to see that most of these Batak leaders wear a shoulder-cloth over their *baju* which is a handwoven indicator of their ethnicity. Note the splashy buttons some of these gentlemen sport on their *baju*.

Unfortunately, not enough information is available to allow us to distinguish the dress of the Karo and Simalungun in the lowlands from that of their clan mates in the highlands.

of imported silk or cotton. When Hagen journeyed inland and met Karo raja, white jackets were among the gifts he was instructed to honour them with and thank them for their hospitality (1883: 46–7). Plate 53 of the Karo leaders at the east coast palace depicts them all wearing jackets. Jackets were worn also by women. The wives of Pa Mbelgah in Plate 54, and the wives of the five Sibayaks in Plate 69 are wearing such jackets.

The *bulang*, or headcloth, of men of status on ceremonial occasions was frequently an Acehnese silken import gleaming with metallic yarn. Otherwise a 'heavy woven fabric' was used (J. H. Neumann, 1916). Women's headcloths were—and still are—extraordinary for their size and shape. One, or in some areas, several layers of hand-woven cloth are wrapped around the head to jut out in a large over-hanging fold in the front and a horn shape at the back. A distinctive Karo feature was the *padungpadung*, or enormously heavy ear-rings, weighing up to 10 kilograms each; the largest and heaviest were worn on ceremonial occasions when the most monumental headcloths were worn. Far too heavy to be supported by the flesh of the outer ear, the *padungpadung* were supported in the folds of the headcloth (see Plates 3, 4, and 54).

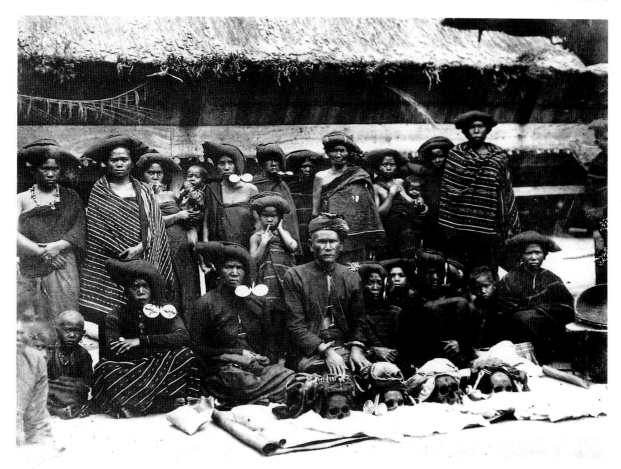

54. The Karo chief, Pa Mbelgah, and his family—including the skulls of his ancestors, photographed by Tassilo Adam.
Photograph: Royal Tropical Institute, Amsterdam.

The photographer wrote that 'the former cannibals treated me with friendship ... they did not see in me one of those Europeans who had taken their land from them by force and ruled them according to foreign laws and customs' (Adam, 1930: 138).

This 'fairly pure' clothing tradition, as it was described by Joustra, clearly contained its foreign elements.

When the style transformation occurred in Karo clothing, scraps of information suggest that it only took one generation. So little is written about this transformation that it is not possible to describe it in detail, but we know that in 1910 Karo men were still expressing a reluctance to wear trousers, although there was an increase in the popularity of European jackets. By 1916 the ritual garb of a bridegroom on his wedding day included white European trousers and a European jacket (J. H. Neumann, 1916). Within a single decade, once eschewed, European clothing had become a sign of status.

So, too, Malay clothing. The importance of the indigo dye pot for colouring Karo identity becomes especially vivid beside the red and gold clothing which were subsequently worn. When the Karo switched their political direction, they switched both their clothing styles and colours. Their current red and gold ritual garb is Malay in design and in how it is draped around the body. Underneath, pants and trousers in the European style are worn by men (see Plate 31); women wear Western dresses and blouses, as well as Malay sarongs and *kabaya* (a blouse-like garment for the upper body) (Plate 55). Blue

55. Karo Batak dancers.
Photograph: Rita Smith Kipp, *c.*1980.

The dancer is wearing a red head-cloth with a gold fringe stitched on (*jujungjujungan*). Around her waist is the *pengalkal*, a narrower cloth wrapped over the top of her sarong, Malay style. Both cloths were handwoven on Toba Batak looms. The men in the background are wearing European trousers, shirts, and jackets, with Malay cloth in red and gold on top. These textiles were made by Malay looms on the east coast. The headcloths are all handwoven by the Toba Batak.

Malayo-Islamic influence is still making its way into Batak textiles. The rise of gold and silver coloured supplementary weft, even in the most Christian area of the Silindung Valley, is replacing *ikat* as the foremost weaving speciality of the present-day Batak weavers. The Toba Batak who weave for the Karo also are using metallic supplementary weft to decorate their textiles. They are taking their inspiration from the metallic brocade textiles of the Islamic regions: South Sumatra, Aceh, and Minangkabau. The weft is used to decorate side panels, the whole cloth, or in a discontinuous fashion, to add bursts of colour to the body of the cloth.

Karo textiles, the clothes of differentiation, are a rarity today, even in the ritual setting. Now they mark only adherence to the most intimate Karo ritual procedures (Plate 56).

Karo clothing underwent an inversion. Where once the people used foreign cloth to make up their own clothing styles, they now use much of their own—transformed—cloth to make up the foreign clothing styles which they have adopted. The Malayization that crept into the Karo garb, in other words, also crept into the Toba Batak looms that produce(d) the cloth for the transformed Karo needs. Even the strongest apparel marker of Karo ethnicity, the enormous head-cloths worn by the women, are now woven in red rather than blue (see Plate 56). Karo dress, and particularly ritual dress, now claims with European undertones, affiliation with the Malay world, and only subtly, quietly insists through handwoven cloth varieties, on Karo distinctiveness.

56. Karo women gathered around the deceased covered by a hand-woven, indigo-dyed *julu* textile. Photograph: Rita Smith Kipp, *c.*1980.

Only in the ritual context are indigo blue textiles still found. The deceased in this photograph is covered with the handwoven *uwis julu*. The women are wearing head-cloths—now predominantly red as they once were predominantly blue—woven by Toba weavers of North Sumatra. The textiles are called *sigaragara*. The *ikat* patterning is in narrow indigo-dyed stripes, which, combined with the background red, lends the cloths a purplish appearance.

## The Southern Batak and the Malay

Karo insistence on their sovereignty had a long history which resulted in a new balance of the endorsement of Malay forces and their own cultural values. The Southern Batak in Angkola and Mandailing, including Padang Lawas, had a shorter and more intensely turbulent run-in with the Malay world and their subsequent endorsement of that world was much more complete; their own had been shattered.

The clothing of Angkola and Mandailing resistance to the invading Muslim Malay forces could only have been the sad tatters of war. Beginning around 1820, the *padri* (Plate 57), a fanatical Muslim sect, invaded the Southern Batak region, looting, burning, killing, and pressuring conversions to Islam. Mandailing leaders resisted to the best of their ability, but eventually requested help from the military forces of the Netherlands Indies administration. These forces in Minangkabau had allied with the non-*padri*, pro-*adat* Muslims to contain the *padri* in that region. The Dutch recognized a window of colonial opportunity in this Batak request for help; they had already subjected West Sumatra to their administration and they wished to spread northwards. After they helped push back the *padri*, they simply stayed in Mandailing (1838). The Padang Lawas region drifted into

the lawlessness and chaos of internal feuds after the invasions. Repeatedly after 1830, it requested Dutch military assistance, and after several operations and short periods of occupation, the Dutch finally occupied Padang Lawas for good (1879).

Life in the aftermath of the *padri* invasions was different. Ironically, perhaps, it changed in a way that impressed the Southern Batak that social status would forthwith be written in Malay and Islamic terms. Ironically, too, the colonial power which had helped them resist the fanatical Islamic *padri* invasions was a prominent force in underwriting the Malayo-Muslim directions of the future. In any case, there was a wholesale abandonment of their national clothing by the Southern Batak. When the first cameras arrived on the scene (in the latter decades of the nineteenth century), they were too late to capture any of it (Plate 58a–c); by that time, few people even remembered what

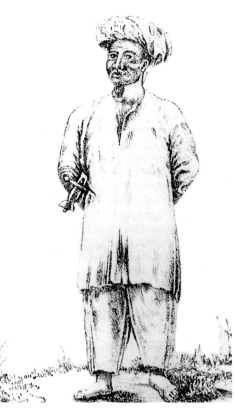

57. A *padri*.
Reproduced from Bastin and Brommer (1979).

The *padri* were a fanatical Muslim sect from Minangkabau which invaded the Batak area as far north as the Silindung Valley and wreaked much havoc and destruction.

58a–c. Van der Tuuk's records of Mandailing clothing.
Reproduced from Van der Tuuk (1861).

The indigenous garb of the Southern Batak area disappeared before cameras arrived to record it. We are lucky to have Van der Tuuk's records of this clothing in his Batak dictionary. His lithographer has depicted only women's clothing.

Plate 58a shows the long and the short *baju* worn by the Mandailing bride, as well as the woven straw bags she carried. Her bracelets are to the left of the *baju*.

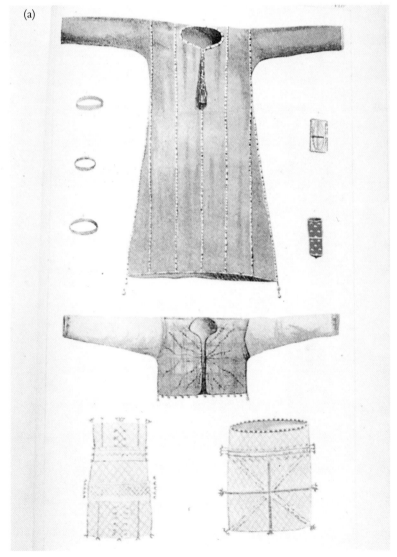

(a)

(b)

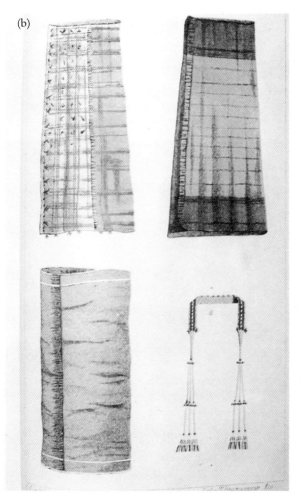

(c)

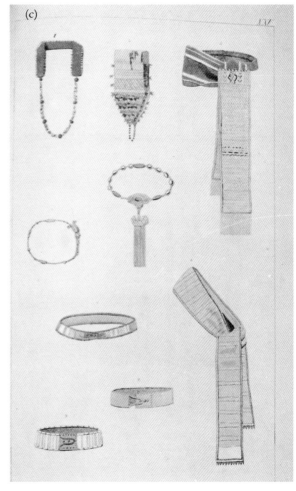

Plate 58b shows three types of hip-cloth worn by Mandailing women. The beaded piece in the bottom right corner is the *gotonggotong simata*, worn on the forehead of a Mandailing bride.

In Plate 58c, items 1 and 2 are head ornaments. The illustration also shows two sashes, three belts, and two pieces of jewellery.

that clothing had been. As early as 1846, the Dutch colonial administrator, T. I. Willer, observed that 'The large majority of the leaders have completely or partly put aside the old national clothing and taken on the Malay' and that European cloth was in 'great demand' (1846: 162). The chiefs were followed by all the men of the society, and to a lesser extent and more slowly by the women. By the latter decades of the century, J. B. Neumann was able to report that 'the clothing of the present-day Batak of this area differs little from that of the neighbouring ethnic groups …' (1887: 266). Even the inhabitants of the isolated Dolok region had taken on Malay dress: cotton jacket, pants (Acehnese or Chinese), headcloth, and a sarong around the hips on top of the pants. The women had taken to wearing an upper body garment in the Malay style to cover their breasts on dress-up occasions, and continued to wear jewellery, as did Malay women, even after marriage. Only the Batak of the isolated Garoga and Parsosoran regions persisted in wearing their 'national' dress. The clothing is an indication that the people of the Southern Batak region had quickly committed themselves to a self-concept borrowed from their neighbours; they were eventually to refuse to be called Batak, a pejorative

term, they felt (learned to feel), for the uncivilized people to the north.

Probably this extreme self-despising reaction was confined to South Tapanuli, where the pagan order had been fatally shattered by the Padris. By becoming Muslims, the South Tapanuli Batak, especially those of Mandailing, began to rebuild their self-respect on a new basis. The government schools, and Batak success in them, seem to have been important here (Castles, 1972: 180).

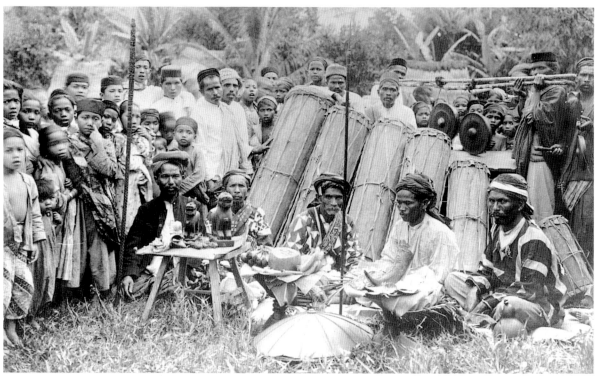

59. Pekanten agricultural rite, photographed by Professor A. Grubauer. Photograph: Rautenstrauch-Joest Museum fur Volkerkunde, Cologne.

The photograph reveals the prevalence of Malay dress on all the observers of the rite. Note the batik pants on the child in the front left corner of the photograph, and the general use of Malay jackets and headcloths. The ritual dress of the dignitaries of the rite, now in the possession of the Ethnographic Museum of Berlin, is of interest. When Marius Buys passed through Pekanten in 1886, he had occasion to experience the rituals with which these jackets were connected and

wrote the following: 'Held in great respect is the begu [spirits of the dead]-feast, which is celebrated when the padi [rice] is planted to make the spirits well-disposed. The entire population comes together then. Hundreds of chickens and several water buffalo are slaughtered. One of the priests dresses in a flashy suit, for example of black material with red and white diamonds, a sort of harlequin costume, with which to attract and fix the attention of the begus. There would be no chance at all of the spirits leaving their normal locale if they did not make use of this medium to move them. Then the priest begins to call the begus in a ceremonial fashion, usually follow-

ing a formula written up in the bark-books....

After one or more calls, a particular begu enters the priest and occupies his spirit completely, so that everything which the latter says and does is believed to be said and done by the spirit. The priest functions then as an oracle. One of his lesser colleagues acts as a representative of the people and speaks to the spirit, who expresses himself in the described fashion. The spirit, 'by mouth' of his medium, richly honours the food which has been offered. What he leaves is eaten by the other priests and leaders, and if anymore is left, then the crowd is free to eat it ...' (1886: 146–8).

Even before their exposure to *padri* wrath, the Batak chiefs had been reading the writing on the wall. Sandwiched between Malay-dominated east and west coasts, with which they were well connected by trade, and bordered by the Minangkabau Malays to the south, the Batak were exposed, often sorely exposed, to the status and power hierarchy of the Malay world—a hierarchy which they found themselves at the bottom of. But they wanted to compete in the dominant terms of the day. Mandailing chiefs converted to Islam before, after, and in spite of, the *padri* onslaught (Castles, 1972: 20). Islam and Malay were a synonymous, compound concept. By wearing Malay clothing, these chiefs were proclaiming for all the world their assessment of social forces, and the nature of their commitment to the future, social and religious (Plates 59 and 60).

What was the national dress which the Southern Batak were forfeiting (Plates 61 and 62)? It is true that the appearance of the women had changed little. Their dress remained simple: a dark blue or white cotton hipcloth reaching to the knees, or, if a woman was of higher class, reaching to her ankles and trimmed with a bright colour to proclaim her status. Apparently, she wrapped it cleverly with a pleat that revealed her lower leg as she walked. (Willer, 1846: 160–1). A white or blue headcloth (*undungundung*) kept the dust and dirt out of her hair as she worked. J. B. Neumann was taken by the coquettishness of how it was tied (Plate 63), but generally, European writers were dismayed by the ragged appearance of the women: 'What a Batak [male] could invest in the appearance of his wives and daughters, he prefers to lavish on his own appearance' and 'Generally the men are better dressed than the women and this largely due to the labours of the latter who must spend all their free hours weaving the heavy indigenous

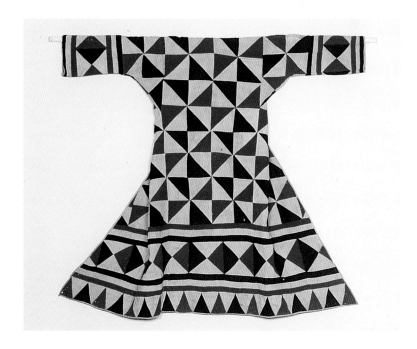

60. Pekanten jacket.
Collection: Staatliche Museen zu Berlin–Preussischer Kulturbesitz, Museum fur Volkerkunde, Abteilung Sudasien.

This patchwork coat of imported commercial cloth is probably the same as the one worn in Plate 59.

61. Detail of the *tonun patani*, Mandailing.
Photograph: S. Niessen.

There are few textiles of 'national' Southern Batak style remaining in Sumatra. The strong Minangkabau influence in this Mandailing textile is clear. It is no longer made locally. This was pulled out of storage in a private home in 1986 to show me an example of a ritual cloth.

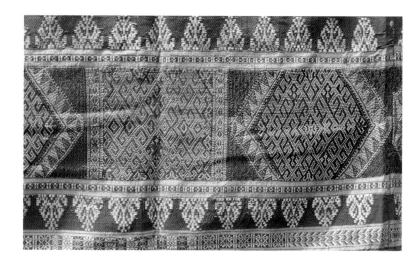

cloth' wrote Willer by way of explanation (pp. 160, 162). Marius Buys, a preacher, was not as generous:

Already in Lima Manis and Muara Sipongi we had seen various women whose upper body was completely bare and who had no other clothing on than a sarong tied around the waist.... Also her sarong of a doubtful blue colour, formed no pleasant contrast with the brown skin. A more beautiful garment would not fit these women in their daily lives. Even as her Malay sisters she has much work to do ... (1886: 135).

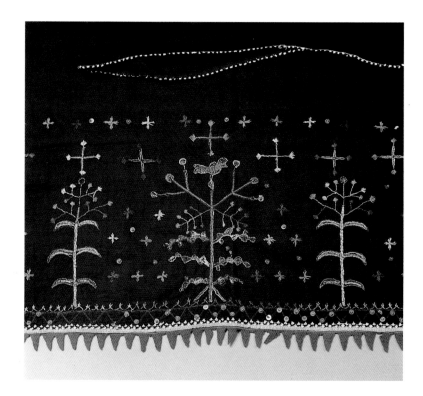

62. *Parompa*, Angkola.
Collection: S. Niessen.
Photograph: Richard Woolner, University of Alberta Photoservices.

About seventy years old, this fine carry-cloth for a child was used ritually. Made of commercial cotton, with woollen trim, it was embroidered locally. It is no longer made.

63. Women pounding rice in Pekanten.

Photograph: Rautenstrauch-Joest Museum für Volkerkunde, Cologne.

Although these women are completely dressed in Malay attire including a long *baju* and sarong, their headcloths are reminiscent of that 'coquettish' white or blue *undung-undung* that Neumann remarked on. Before women adopted Malay clothing, they went bare-breasted and wrapped a handwoven cloth around their hips.

Clothing of the slaves does not seem to have inspired detailed passages in these early writings. We know that only the nobility was entitled to own slaves and that they were required to provide for their clothing needs. They did this either by giving them cloth/clothing or the time to make their own clothing from tree bark (Willer, 1846).

Bark seems to have been a commonly used fabric in this region amongst those of lesser means prior to the influx of cheap import cloth. Men and women of the isolated Dolok region, as late as the 1830s but before their conversion to Malay garb,

wore just a piece of tree bark which served only to cover the perineum. The bark of a tree (though not of all trees) was boiled and beaten, after which a

64a–b. Old Mandailing textiles: *Rungga tolang*? *Bauran*?

Collection: Staatliche Museen zu Berlin–Preussischer Kulturbesitz, Museum fur Volkerkunde, Abteilung Sudasien.

These museum pieces are the closest in name and appearance to what was described by Willer for the Mandailing/Portibi (Padang Lawas) area as a shawl for men of high social position 'in which the Batak has invested all his taste, of a very heavy cloth with a black background colour.... When the centre field is open and thus remains black, the fabric carries the name *sadon*; if it is decorated with narrow stripes, then it is called *rungga tolang*, and with wide stripes, *bauran*; this last type is the most expensive. The patterning of the edges consists of a large diversity of hooks, diamonds, crosses, dots and other geometric figures; they never represent a living object. The colours which are used are confined to a dull red, white and light blue. At first glance, the edging has the appearance of coarse tapestry work; by closer inspection one discerns in design and colour more taste and harmony than originally seen. The width is embellished with a fringe made of the warp yarns of the cloth. The length flaunts bundles of fringes with coloured beads, on the ends of which are attached narrow strips of scarlet, and on the outside edges are serrated with diamonds. This durable piece of clothing, in which the local inhabitant, without a second thought, dresses himself tastefully, is very valuable; one makes none for the market, and if there is one offered for sale from time to time, it costs from 16 to 32 gld copper and sometimes more. Only the nobility is entitled to wear it; someone of lesser rank who availed himself of such, would receive a fine and the shawl would be confiscated' (1846: 163–4).

piece of a fathom long and an elbowslength wide served as clothing (*tangki*). The material is less coarse than one would think. When the tree bark is well prepared, it is much more flexible than thick wool. This clothing is not even worn by the most uncivilized Batak in the area anymore (J. B. Neumann, 1887: 267).

The sophistication of the woven cloth worn by the men, especially men of high status, in the Southern Batak region reveals deep historical roots, however (Plate 64a–b). In Willer's day, the national garb of the Southern Batak region was still to be found albeit only on elderly men of high class. Their appearance contrasted with that of the younger leaders.

(a)

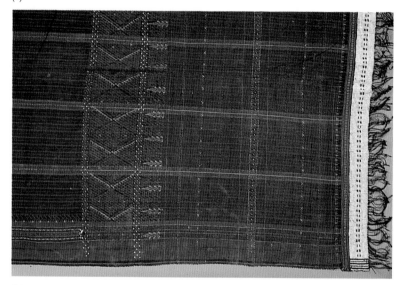

(b)

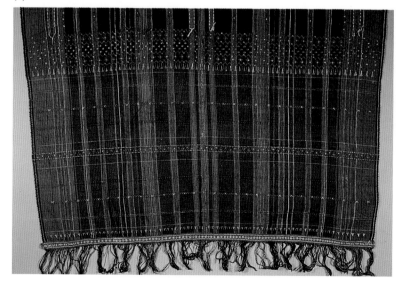

Amongst the elderly and in the isolated villages, far from the capital cities, one still finds aristocrats who continue to dress in the old way; it is simple, functional and not unattractive, consisting of a cloth which covers the lower body, in which a heavy cloth with coloured stripes is used; a sash, which fastens the cloth on the hips, and which is furnished with ivory rings on the ends which can serve like gold as a medium of exchange; a cape or shawl, in which the Batak has invested all his taste, of a very heavy cloth with a black background colour ... (1846: 163–4).

Why did the chiefs go after a Malay appearance and not the power and status represented by European shirts? The colonialists, after all, ruled the Malays of West Sumatra. Another half century was to go by before these features began to appear in Southern Batak clothing. The answer in the early part of the century probably had much to do with the alliance between the Dutch and the pro-*adat* Muslims in West Sumatra, an alliance which the Dutch were loath to jeopardize by flying Christian flags. In the eyes of many frustrated Europeans, the Netherlands Indies administration even managed to appear pro-Islam. Van der Tuuk, who was working in Barus, complained in 1853 that it may as well have been Netherlands Indies policy to support Islam because the effect was the same: the administration did not allow its officials to spread the gospel although there were no missionaries there at the time, while Muslim leaders were permitted to settle anywhere; Batak leaders at the end of the year were given a pack of Malay clothing; the Angkola region, which had not yet accepted Islam was being brought under Mandailing administration where almost all of the leaders were already Muslim; Arab prayers were being taught in the government schools and the children were taught to respect Islamic fasts (1962: 67). Probably Van der Tuuk was referring to the fact that the colonial administration was importing petty officials and teachers from Minangkabau to help them in the Southern Batak area (Joustra, 1921: 26).

By adopting Malay clothing and Islam, the inhabitants of the Southern Batak region were answering the expectations from both Malay and European powers. Clearly, Willer's observations that the chiefs had adopted Malay dress makes sense in this social climate; and it was logical, too, that the chiefs would be the first to express the need to look like Malays: 'They [the chiefs] wear headcloth, jacket, vest, sash, pants and sarong, such as one sees on the coasts, and use for this, according to their means, cotton, silk, *grijnen*[?], woollen cloth or velvet materials' (1846: 162–3).

Van der Tuuk made another critical point. He believed that not only should the Netherlands Indies administration support Christianity more actively, but that it should also actively support distinctive Mandailing culture against what he considered to be the eroding, monocultural tendencies of Malayo-Islam. He was appalled by the execrable treatment the Toba Batak endured from the Malays when they came down to the coast for trade; he saw, too, how they were culturally alienated by the support the Netherlands Indies administration was giving to Islamic factions, support that would further serve to

diminish Batak pride in, and knowledge of, their own culture. Long after Van der Tuuk had left the region, Buys, passing through, was sensitive to these same themes. He described what he saw:

The influence of Islam, a power which so emphatically makes itself felt throughout the Indies and which forms such a block to the spread of Christianity,—this influence was also very powerfully at work here, and little by little this religion also began to count its followers in Pakantan in masses.... In any case this [Southern Batak] folk expresses a lively desire to change their religious beliefs and all which goes together with that, especially where they have come in contact with the Malays and Europeans. This desire may not be attributed to a deeper and purer religious need rising up in them ... but it is the result of the denigrating way they look at themselves and their past. They are ashamed of this past, of their nationality ... and will therefore gladly change their religion. The name Battak or Batta counts as a curse and they never use it when they speak about themselves. Mandailing, Angkola, Toba; they prefer to be called after the territory in which they live. The leaders and others of status prefer to speak Malay if they have the chance to learn this language, and like to present themselves as Malays in the areas where [the Netherlands Indies] administration has been set up....

... by accepting this [Islamic] religion, they come in closer contact with the Malays, yes, and in their eyes become as good as Malays and in such a way pass outside the circle of their denigrated nationality.

The leaders like to relate themselves through marriage with high status Malays, while their own authority and influence increases not a little through this. If the Batak become Christians, then there still remains between them and the Europeans always a wide gulf, and as long as they comprise only a small group, they become isolated in the midst of their Mohammedan and heathen clan-mates (1886: 139–42).

The Batak ego was a sensitive barometer by which to predict directions of change in Batak society. Most Batak groups may be characterized by their vigorous striving after success—in whatever terms this might be defined. By the beginning of the twentieth century, Dutch missionaries and teachers alike were amazed at the zeal with which the Batak strove after *pangkat*, the status associated with white-collar employment. They were not to be dismissed or put down, and they did what was necessary—including change their clothes—to achieve their goals (Castles, 1972: 70).

# 7 Dressing for Success under Colonial Rule: A Batak Men's Story

ALL social relations in Batak society are vertical. Always there is a party who is entitled to the superior role by virtue of age, clan affiliation, or life achievement. But it is also true that Batak society is—or was (except in Simalungun)—egalitarian. Hierarchy expressed itself according to the situation; it was not absolute. It shifted with the circumstances and responded to new bids for power. The Dutch administration changed that by skimming off a portion of the indigenous Batak élite and co-opting it into their own administrative corpus in which the rules of hierarchy were well-defined and the expression of hierarchy, in contrast to the Batak way, anything but fluid. The egalitarian Batak clothing (Plate 65) may have still fit the physical body, but it no longer fit the social body. It had to be altered to suit the new hierarchy.

While Batak social organization differs from subgroup to subgroup, the differences are as variations on a theme and certain generalizations can be made: all the Batak subgroups organized themselves into patrilineal clans, and resided in smallish villages. These were under the leadership of a raja. When Anderson used clan or village affiliation to identify the Batak he met on the east coast, his words reflected the political reality of the time. The Batak had not developed large state organizations, and even the ethnic subdivisions marked on Map 6 are a reification of much fuzzier transitions between ethnic groups. The political unit of the Batak was the village, or the larger entities built for specific purposes through intervillage co-operation.

The Dutch knew that their own administrative system had to work through larger units to be effective. They could not deal with hundreds of chiefs and political units which were in constant flux. They thus superimposed a hierarchy of powers on the Batak villages, uniting groups of them into larger units. In each case, they attempted to work as much as possible within the administrative terms already familiar to the Batak, hence the great variation, throughout the territory, in administrative structures. The Karo highlands were divided into five main units, each under a Sibayak, with the Dusun area falling under the administration of the coastal sultanates; the kingdoms of Simalungun were of a convenient size and were simply kept along with

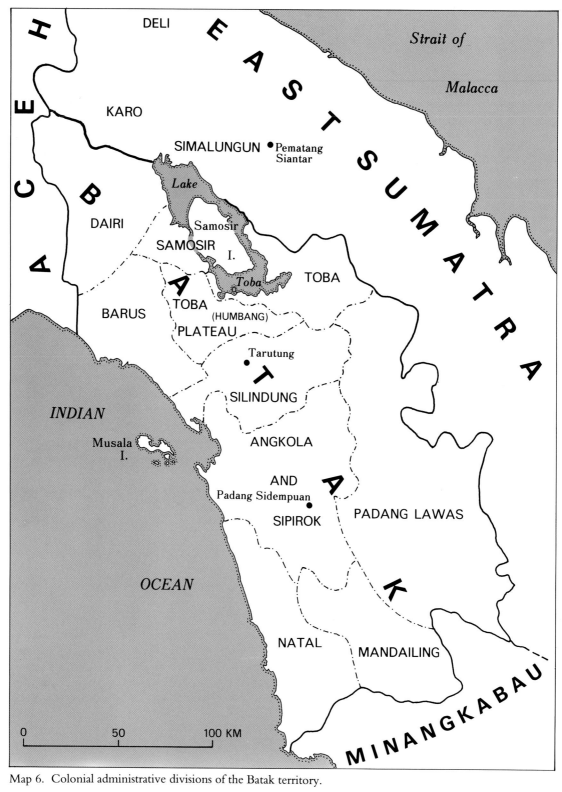

Map 6. Colonial administrative divisions of the Batak territory.

65. Preparing to work in the fields. Reproduced from Bruch (1925).

A shortened version of the hipcloth was worn for working in the fields. An example of egalitarian Batak apparel, it was worn regardless of the rank of the wearer.

their rulers provided they were amenable to the Dutch administration; and the Toba and Southern Batak underwent several administrative experiments to parcel their territory into regions and districts of manageable proportions (Joustra, 1910: Ch. 5). At each level except the highest, Batak were assigned to the administrative positions and the Dutch ruled indirectly through them.

Gradually, the Dutch were giving Batak society the requisite structures to entrench the colonial version of social hierarchy. Simalungun political structure worked in harmony with Netherlands Indies economic goals; their case is instructive of what the Dutch form of hierarchy was in service to achieve—and which under the indigenous form of hierarchy in all the other groups, was never even an option. The Dutch required stable social institutions, where Batak society had focused on principles of operation which were manipulated according to the situation and the characters involved. The Dutch penchant

to codify the 'correct' version of Batak kinship history, laws, territorial boundaries, rules of succession, and so on, had the effect of remoulding Batak society in the image of their own political understandings. They experienced interminable frustration, especially with the Toba Batak, who greeted every policy change as a stimulus for further re-negotiation and controversy. But slowly, by teaching the chiefs, and by setting up schooling, the Dutch understanding of social structure took inalienable root.

The revised administrative structures required that the village chiefs hand many of their powers to the authority above them, and that each level of authority have carefully prescribed boundaries. When the chiefs agreed to collaborate with the Netherlands Indies administration, above all by acknowledging it as a higher authority, their autonomy was supplanted by the requirement to be obedient. Whereas once they had to be responsive to their people, their position was now assured by responsiveness to their employers, the Dutch. Also the wife-giving and wife-taking affines, who had always played a significant role in the chiefs' decision-making process, lost administrative power.

The nature of indigenous Batak political leadership conjures images from the archival literature of dignified chiefs with flashing eyes, exercising their well-honed powers of oratory in the presence of an assembled group. A chief's powers lay in his insights and ability to transform those insights into convincing speech. He lived by his wits. Power was jockeyed for; it could be achieved but never secured, and its defence was its maintenance. Kohler witnessed the pride of such chiefs when they gathered in Habinsaran and wrote about it in admiring terms:

In their various costumes, the raja presented a very picturesque scene. Those from the northern areas made the best impression, wearing only their own cloth, consisting of many-coloured or darkly coloured sarongs and wide shouldercloths which half-covered the upper body, leaving the arms, decorated with wide ivory rings, completely free. They were remarkable for their strong frames, their flexible movements, and dignified stance [Plates 66 and 67].

Later it appeared that these were also the leaders who had the most authority under their subjects....

One saw in their stature and behaviour that one had to do here with the nobility of the Batak folk ... (1926: 27–8).

So taken was Kohler with the dignity with which the Habinsaran chiefs accepted colonial rule, that he believed this dignity to be a sign of breeding, hence immutable: 'And the mightiest amongst them, who until now have feared no opposition, bowed for the much greater power, the strength of which they had learned to respect. It was no shame to bow for the ruler' (pp. 27–8).

Time proved, however, that to subject the chiefs to the colonial power was to subdue much of their exuberance and to chain their wits to duty. It is not difficult to imagine that the eyes of the chiefs dulled and their powers of oratory rusted as they learned that the new

66. High-class Toba Batak couple, photographed by E. Modigliani. Photograph: Photoarchives Museo per l'Antropologia e Etnologia, Florence.

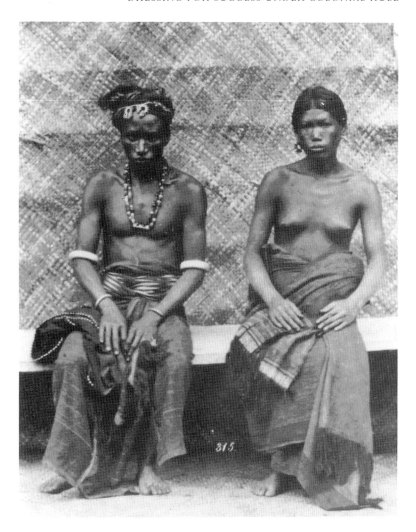

There are many indications in the clothing of this couple that they are of high social status, probably a raja. and his wife who have dressed up in their finery for the camera.

The man has hung his golden ear-rings (*duriduri*) around his head-cloth—probably a silken *parang rusak* from Aceh. He has also used a *parang rusak* as a sash around his waist. His *abit* is striped and looks like the Toba *ragi harangan* (see Plate 29 (bottom, left and right)). His wife appears to be wearing the wide blue *sibolang* around her hips. Both are using the *ikat*-decorated *ragi hotang* as a shoulder-cloth. The man's is trimmed with beadwork. He is also wearing two strings of large (imported glass?) beads around his neck, ivory or bone bangles around his upper arm (*rutis*), as suiting a person of high status, and metal bracelets (*loyung peoter*) around his wrists. Up to nine could be worn of yellow and red copper and iron worked together. The woman is wearing one ear-ring in her right ear. She is considerably less embellished than the man.

terms of success resided in obedience more than craftiness.

The indomitably compelling colonial power engulfed Batak society by awarding opportunity, remuneration, and prestige to those who co-operated with it. Batak employed their wits to jockey for recognition in the new administrative machine. Supporting the administration was economic opportunity. Those who were not involved in the administrative avenues of success could exploit unprecedented opportunities in trade. A middle class developed (Castles, 1972: 72). The Batak who remained loyal to the pre-colonial terms of social success, saw their chances for social prestige diminish. They could not stand aside from the times. They either worked within the changing social order, or they lost out.

Summaries of clothing trends indicate that everywhere, except the Southern Batak area (see below), the leaders were the first to adopt European styles and they were followed by the rest of the male populace. Malay clothing also made further advances under the colonial administration and slowly the garment blend was achieved which I

67. High-class Batak family.
Collection: Rautenstrauch-Joest Museum für Volkerkunde, Cologne.

This photograph depicts a man, woman, and child, probably a family, standing under an elaborately decorated Batak house. The times are evident from the generation gap; the child is dressed in pants and *baju*, while the older generation are wearing 'national' Toba Batak attire. The man has a *bolean* textile over his shoulder and a *sibolang* around his hips. The woman has a *ragidup* wrapped around her torso, and is also wearing a *baju*. The bag under the man's arm is made from the skin of an animal.

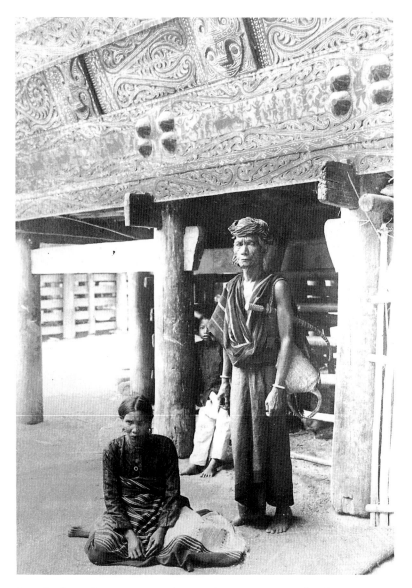

described at the outset as the *vestimentum communis*, the common clothing which all the Batak subgroups shared, and which made them indistinguishable in appearance from neighbouring ethnic groups. The missionary, Meerwaldt, wrote in 1894 that in areas which had come under Netherlands Indies administration, men switched to wearing a 'shirt, pants, often of the Acehnese type; a "mandar" (a sarong) and a "detar" (headcloth), with which they hang one cloth or another as the "sapœtangan" [shouldercloth, literally "towel"] over the shoulder' (p. 522). Twenty years prior, pants were completely unknown in the Toba area (Schreiber, 1876: 264). These written descriptions are interesting to compare with the archival photographs which so rarely show a turn of the century Toba Batak male wearing Acehnese pants with sarong. Perhaps Meerwaldt's statement was less

applicable to the Toba than to other groups, or perhaps there is evidence here of the bias in the photographs, almost all of which are carefully posed with the people dressed up in their finery and do not show the daily norm.

Nevertheless, the archival photographs offer more information than the written records of how the times were influencing peoples' raiment. Plate 68 shows the Raja of Simalungun, probably in the 1930s. Plate 69 depicts the Sibayaks of Karo; probably it was taken a

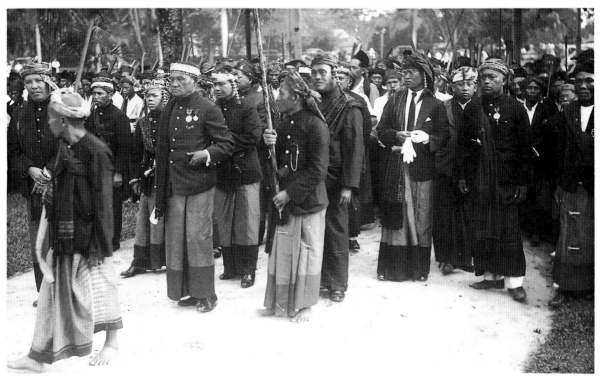

68. Parade of Simalungun leaders, c.1930.
Photograph: P. Voorhoeve.

'Some kind of ceremony in Pematang Siantar. In the front row from left to right: the Raja of Tanoh Jawa, at an angle in front of him with turned head is an attendant, behind him a district leader (perhaps Tuan Gaib from Silou Kahean, but I am not sure of this), then the Raja of Raya (with golden 'beads' (Sim. doramani) hanging from the tip of his batiked headcloth), at an angle in front of him with two medals, the Raja of Siantar, at an angle behind

him the Raja of Panei (also with doramani), an umbrella carrier, the Raja of Dolog Silou (also with doramani), the Raja of Purba (with white gloves), at an angle behind him Tuan Distabulan (district leader of Bandar) and to his right (with a medal), if I am not mistaken, the district leader of Dolog Panribuan (the district in Tanoh Jawa where Parapat is located). Of the seven Rajas of Simalungun only the Raja Silima Kuta can't be found in this photograph' (Voorhoeve, pers. com., 1983).

These men are wearing blue hipcloths of the *ragi pane* or *ragi sapot*

variety. The Simalungun provenance of these cloths is evident from the width of the side panels and the absence of a stripe between side and centre panels. The attendant, second from the left in the photograph, is wearing a Toba Batak hipcloth, recognizable from the narrow side panels and the *ikat* patterning. The men of higher status are wearing shoes, while their attendants are not. Their jackets are of the European variety with lapels worn with shirts, or more frequently, of a military appearance with a stand-up collar and reaching only to the hips, with no shirt required underneath.

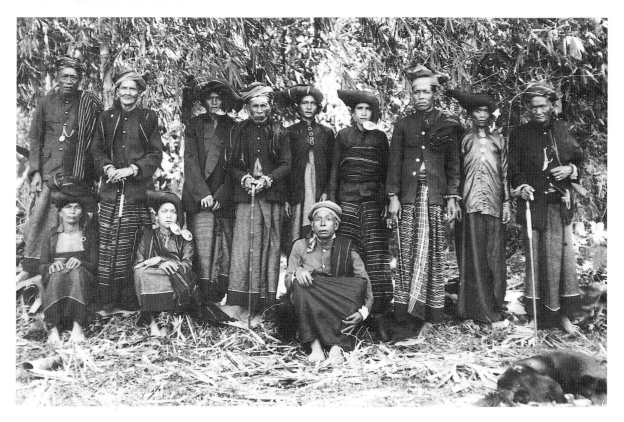

69. The Karo Sibayaks and their wives in the early twentieth century. Photograph: Royal Tropical Institute, Amsterdam.

The *baju* or tailored jacket became a standard item of dress for both men and women. The European jacket made easy inroads into the Karo dress tradition. Trousers did not follow suit until the second decade of the twentieth century. One woman is wearing an elaborate European jacket in which she looks awkward. Perhaps she pulled it on to cover her breasts for the photograph. The woman furthest to the right is probably wearing a silk *baju* as befitting her station. Several, if not all, of the men appear to be wearing silken headcloths, probably imported from Aceh, as appropriate to their social status.

few decades earlier than the Simalungun picture. The similarities and differences between the pictures are interesting. Both groups of leaders are dressed in handwoven hipcloths, European jackets, and indigenous head coverings. However, the Karo leaders wear neither shoes, nor trousers under their hipcloths. The one sign they show of the changing times is their European jacket. They give the impression, which Hagen offered in 1883, of a certain pride in combining foreign status garments with their own finery (Plate 70). The Simalungun rulers, by contrast, give the impression of having wrapped a hipcloth around their fully colonial-establishment outfits, for the purposes of the parade. Their own clothing has become a ceremonial item; the clothes of the colonial bureaucracy reflect their daily lives. Where the Karo were still attempting to fit the European way into their own lives, the Simalungun had pulled on their 'national' clothing just for temporary display—like Batak everywhere do today on ritual occasions.

Plate 71 of the Toba Batak leader of Parmonangan and his family was taken in 1906. This photograph presents an interesting hodge-podge of men's clothing styles. Elements of Malay, European, and Toba Batak attire are combined without consistency. The odd mixture presents, nevertheless, a sense of authenticity. The men are wearing what has caught their fancy and they can show off a diverse array of trousers, head coverings, jackets, and belts. Here there is experimentation, and a not always clear sense of the meanings of the clothing

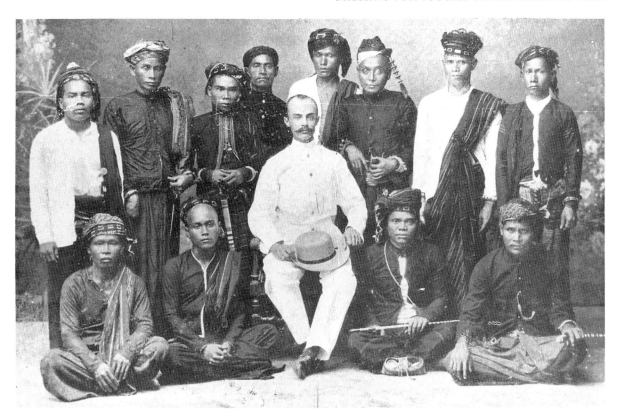

70. Simalungun and Karo leaders. Photograph: O. J. A. Collet, 1925.

This photograph still gives the impression of selective incorporation of foreign elements into an indigenous clothing system.

items; it gives the impression of the wearers' delight with novelty and with status categories. Plate 72 of Albinus Lumbantobing, by contrast, shows us a Toba Batak who is fully aware of the power of his garments and who flaunts an earnest intention to exploit them. He is a person who no doubt lives closer to a centre of colonial power—and to a regular income. He has picked up not just the clothing of the colonist, but also the stance. Spontaneity and experimentation have given in to adherence to precise rules. Propriety has taken on a new meaning and a new look.

## The Southern Batak under Colonial Rule

In the Southern Batak area, as described in the previous chapter, the impact of the *padri* had been so devastating that a wholesale rejection of the national ways followed in its wake. This was illustrated in part by the rejection of national garments and the acceptance of Malay garments. The clothing transition was a complex affair if examined in combination with the changed premises of Southern Batak existence. It was not simply a matter of which clothing replaced which other clothing, but also of when and how particular garments were worn. The expression of status and hierarchy was not the same in the new social order as in the old.

Just as their Northern Batak neighbours, the Southern Batak had

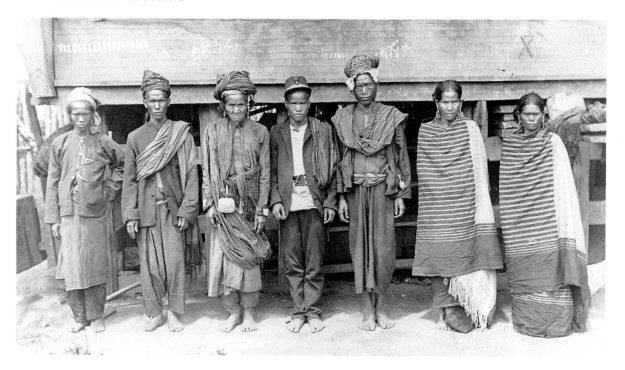

71. Chief of Parmonangan and his family, 1906.
Photograph: Vereinigte Evangelische Mission, Wuppertal.

The chief and the male members of his family are wearing spontaneous, in-consistent combinations of Batak, Malay, and European clothing.

72. Albinus Lumbantobing, nephew of Raja Obaja (Raja Pontas).
Photograph: Vereinigte Evangelische Mission, Wuppertal.

This young man is on his way to social success in Dutch colonial terms, with-out a single marker of his Toba Batak ethnicity. The inhabitants of the Silindung Valley were exposed the earliest of all the Toba Batak to the colo-nial regime, and also the most intensely.

Men who worked their way into the ranks of the colonial administration showed it in their dress. These uniforms of acculturation underscore the kind of hierarchy brought by the Europeans. Worn on a daily basis, and so sharply contrasting with the standard folk garb, they proclaimed, by association, that social level was now supported from above rather than below, that it was more rigid where once it had been more fluid, and that it was now based on vocation where once the vocational range had been limited to farming with a few subsidiary activities which showed up usually only on ritual occasions.

dressed themselves in communal egalitarianism—even though hierarchy was more pronounced here than amongst their Northern Batak neighbours—the Simalungun excepted. The display of hierarchy was reserved for ceremonial occasions, and this confused missionary Buys:

… the son of the village leader did not look particularly princely. It happened several times, by the way, that we were mistaken in the quality and the rank of the Batak. It is crawling with raja amongst them; each village, almost, has its own. Most of these highly placed persons do not distinguish themselves in their daily dress walking in the sight of their subjects, although they often have the means, and only take on a more formal appearance on ceremonial occasions. …

In general the Batak does not appear to enjoy showing to the world his status or his relative wealth through his clothing, lifestyle, his home and other externalities. Many of them, who live in a small hut, lacking in almost all conveniences, and walk around with a naked torso, without any other clothing than dirty short pants of coarse blue cotton, are owners of a not unimpressive herd of cattle … (1886: 174–5).

On ceremonial occasions, the regalia of hierarchy was trotted out so that especially the nobility could point out, in fine detail, the status differences amongst themselves and between them and the commoners and slaves. They wore specific capes, hipcloths, and headcloths, and also reserved the colour yellow for themselves. While more specific details of rank are lost to us, we have inherited a clear indication that the expression of rank was something reserved for the ritual occasion.

The nineteenth century was an experimental period of transition during which the old and the new ways of life and of dressing vied and collaborated with each other. In 1846, Miller wrote that the highest official, the Yang di pertuan of Siantar, and a few kuria (small administrative district) leaders, still wore their old style headpieces on ceremonial occasions. Reluctant to give up their old social distinctions, some of them fastened their characteristic, status-defining fringe to their Malay headpiece. Having the most to gain by adopting the status of the Malay, they also stood to lose the most by relinquishing the status features once due them in their own society. Not only were social categories weakened by a new mode of dress that did not recognize them, but the use of the colour yellow illustrates that old rules of dress were defied or no longer heeded. The use of yellow became common, 'much to the annoyance of the leaders' (J. B. Neumann, 1887: 173). It appears that they no longer had the means to enforce the old social rules, or to garner the respect from their subjects that they had once enjoyed. Perhaps Neumann's use of the word 'leaders' was already a trifle anachronistic (Plates 73 and 74).

The missionary, Buys, could be counted on for critical statements about Batak appearance, but if the following description contains a grain of truth, by 1886 the wearers were still struggling with the new terms of their clothing—and probably their existence:

One may be sure, if one travels in the company of an administrative official, that in his entourage will be not only rajas, but even maharajas—great

73. Kuria leader in lower Mandailing wearing an *ampo*.
Reproduced from Joustra (1915a).

'The leaders appear in their official suit, a jacket of blue wool with a stand-up collar, stitched with gold … some keep a fantasy-suit, even more beautiful than the official one, which is to say even more richly decorated with gold and silver … these people are crazy about wearing shoes, indubitably because it gives the status impression of a European' (Buys, 1886: 127).

His dress is similar to the official dress of the administrators in Rao (Minangkabau highlands on the border with Padang Lawas).

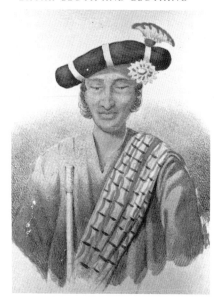

74. Minangkabau penghoeloe. Reproduced from Bastin and Brommer (1979).

The headcloths marking social leadership in the Southern Batak area seem to have been inspired by those of their Minangkabau neighbours to the south.

princes, or, if you will: kaisers. On such occasions these leaders dress up in their official clothing that many of them do not wear half as well as their Malay counterparts. I have seen one who made me think of fat, round bakers or farmers from the outback, who had pulled on a braided jacket and made a comic appearance in it (1886: 175).

Even the highest status Batak were not able to shake their reputation of being uncivilized. Woe the clumsy dresser! The Batak would achieve no success without learning to dress for it!

While a middle class was developing elsewhere in the Batak territories, which allowed the enterprising to compete with the inheritors of power, in Padang Lawas trade was something that men devoted themselves to before they married. The inhabitants of Padang Lawas had not been keen traders in the pre-colonial era because social rules disallowed it—except for young, unmarried men, and in exceptional and limited circumstances, for leaders in debt.

Under the colonial regime, trade expanded considerably, and it is easy to deduce that it would have had a profound impact on such a trade-shy society. The clothing of the young men who 'embarrassed' themselves with making money in this way, are a document of just how profound that impact was, and how it was perceived locally. When Willer was writing mid-century, those young men would 'dress as close as they can to our [civil?] servants, and make use of nothing but European cloth, of which they select the most brightly coloured' (1846: 162). In other words, clothing was defining generation and occupation. Malay clothing dressed the established social ranks, and European garb clothed the young men of trade. When J. B. Neumann wrote forty years later, the flamboyance of the youth had developed to new extremes, and although he was not entirely appreciative of it, he otherwise provided an excellent description:

Amongst the youth the desire is great to imitate our clothing. One sees them with pantalon collant of wool or white cotton, with a black or white jacket and shining 'fantasy-buttons'[?] of silver or gold plate, sometimes also with Williams-buttons [golden with an embossed crown, symbol of Dutch sovereignty] which are worn by the ruling administrators, with a vest, under which their blouse/jacket is worn as a shirt. Some have even purchased a shirt. The sash is then folded as narrowly as possible, so that it is barely visible under the jacket. That the white which they wear is anything but bright, but always a dirty colour, scarcely needs to be said. Instead of the headcloth, a cap or fez with golden trim, is worn, or a cap without the rim, trimmed with gold or silver.

One sees them on horseback; then there are even those who wear socks and gloves. This, however, is only the case in Ulu Barumun, where the people are the most advanced, and where they have the opportunity to see the styles of the Mandailing kuria leaders. Some wear slippers, as if to lend them an air of refinement. The use of shoes is becoming more and more common (1887: 267).

Trade, and the gap between what the Malay world and European power represented, led Southern Batak society to depict their generation gap in clothing style. It would be interesting to learn whether the

activities of the flashy youth outshone the power of the elders of the society, just as the development of the middle class elsewhere in Batak society could compete with the powers of the traditional chiefs.

Eventually, the European look made its way into the upper ranks of the society, however, to combine with the Malay look (see Plate 73). Joustra noted in 1910 that 'Leaders and local administrators are usually dressed in half-European clothing (English shirts, shoes, and socks!). The mixture even included bits and pieces of the old, national clothing which only came out of the closet at the most official of events' (p. 131).

## Toba Batak Hierarchy under Colonial Rule

Indigenous Toba Batak hierarchy was a holistic phenomenon. At its apex was SiSingamangaraja, the great Batak hereditary leader whose authority pulled together the political, social, spiritual, and economic domains of Batak life. He presided over the *bius*, the highest annual ritual complex, the enactment of which was believed to be the maintenance of every dimension of life itself. He was known as the origin of markets and received tribute in this capacity from far away. He was believed to be the creator of the Batak political system. Symbol of Batak power, spiritual and social, there was no one more affronted by the intrusion of the colonial regime than he, and no one more burdened with the responsibility of repelling it. In 1907, when the Dutch killed the twelfth SiSingamangaraja, they dealt the mortal blow to Batak opposition, and then the still independent regions of Habinsaran and the west coast of Lake Toba were finally annexed. The *bius* had been banned; the raja system and Batak territorial system had been transformed to meet colonial bureaucratic needs; the SiSingamangaraja was dead. In the photograph of SiSingamangaraja's family, the eyes are downcast and the people look disconsolate. The men have been dressed in the uniform of conformity and co-operation with Dutch rule (Plate 75). They are stripped of the symbols of their own beliefs. The children were placed in the care of a Christian guardian (Plate 76).

British visitors to the Silindung Valley in the early nineteenth century downplayed the authority of the SiSingamangaraja as 'only nominal and imaginary', and it is sure that he was not able to muster many troops to fight the Dutch (Burton and Ward, 1827: 512). But his power would not have been strong had it been simply based on physical might. Only upon the death of SiSingamangaraja XII was the Dutch colonial regime to learn the power of 'mere' myth. As a myth, SiSingamangaraja could only die if he disappeared from the mind. His greatest power was conceptual; his spirit was believed to be eternal. To be effective, the Dutch set about trying to kill his mythical existence:

People were afraid to say that Si Singamangaradja still lived; whoever dared do that would surely be arrested, imprisoned and banished, even if he were a

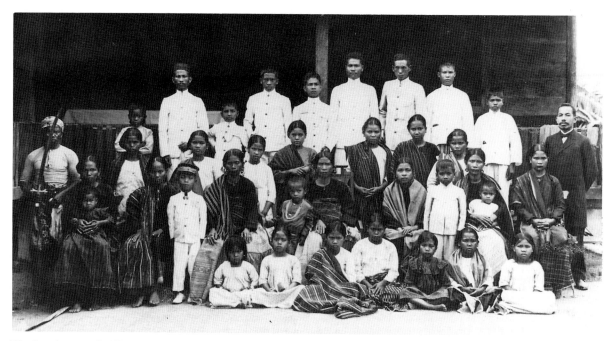

75. Survivors of SiSingamangaraja in 1911 (on the occasion of their baptism?).
Photograph: Vereinigte Evangelische Mission, Wuppertal.

Christianity worked hand in hand with the colonial regime. To dispel the power of the SiSingamangaraja, his descendants had to be stripped of their beliefs. This began by stripping them of the symbols of their beliefs. On this occasion, four years after the death of SiSingamangaraja, the young men have been dressed in the clothing of affiliation with the colonial regime; their heads are bare, and their hair is short. The young children are dressed in Western-style clothing—in the villages they would still have been running around naked. The women have their torsos covered by *baju*, but their shoulder-cloths have been permitted. Perhaps the potency of Batak textiles as symbols of beliefs was not understood by the Dutch.

76. Three sons and three daughters of SiSingamangaraja XII in 1907, the year of their father's death.
Photograph: Reproduced from Tampoebolon (1944).

Initially, the upbringing of the children was entrusted to Missionary Henoch. The children were separated from the 'heathen' element in their own culture so that they would not inherit the spiritual legacy of SiSingamangaraja.

94

Pastor (pandita) or other person of rank. Lots of people acknowledged that Si Singamangaradja had died, that there was no longer anyone higher than the Kompeni. If Si Singamangaradja were truly higher than the Kompeni, he would certainly not have died. Therefore the Kompeni could not any longer be driven from the land; the kingdom of Si Singamangaradja would fall because no-one witnessed any longer that he lived ... (Gaius Hutahaean testimony, in Castles, 1972: 81–2).

To this day, the myth of the invincibility of this leader has not been wiped out. The Toba Batak still expect his spirit to return in another corporeal form. The Karo Batak maintained their own clothing styles to resist the encroachment of the Malay world; the Toba Batak clothes of opposition are vestments in the tradition of the SiSinga-mangaraja. Lost to and by the secular world, these garments are still the clothing of the spiritual core of Toba society. The most fervent believers belong to cults which offer to his spirit on a regular basis. Various such sects exist, each defined by its own combination of syn-cretist borrowings from Christianity, Islam, and Batak religion and myth, creative and spontaneous attempts to fill the spiritual void left by the colonial cracking of Batak society and the secularization of Batak political power (Castles, 1972). All of them share the centrality of SiSingamangaraja in their beliefs, and equally, a loyalty to Batak law and religion (Plate 77). On ritual occasions, the cult garments are carefully selected to represent the spiritual beliefs held by the SiSingamangaraja. The leader of the Parmalim sect, one of the sects

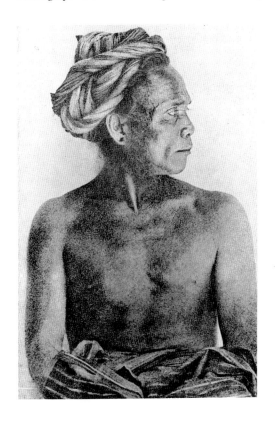

77. Guru Somalaing.
Reproduced from Modigliani (1892).

Guru Somalaing was one of the first Batak to ponder the spiritual void left by the intrusion of the European power. He began a new religion based on a disparate pantheon of spiritual mentors from Islam, Christianity, Batak mythology, and history.

78. Raja Mulia, Parmalim leader.
Photograph: Sitor Situmorang.

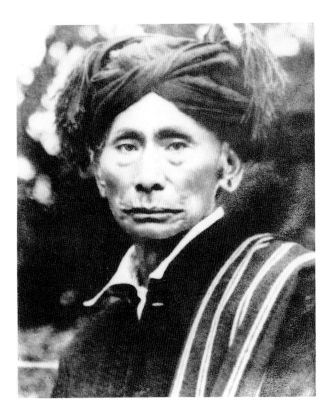

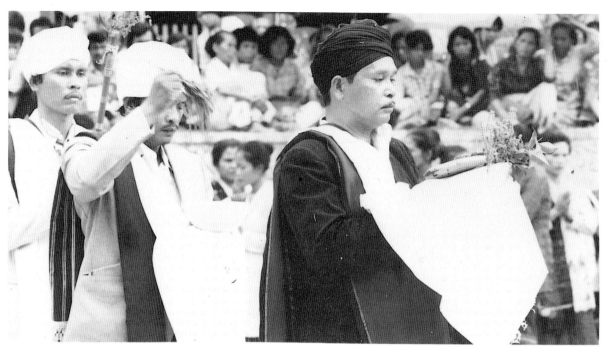

79. Parmalim rite.
Photograph: Sitor Situmorang.

The leader of the Parmalim is wearing a black headcloth. The others are wearing white to symbolize purity. The leader is consecrating an offering.

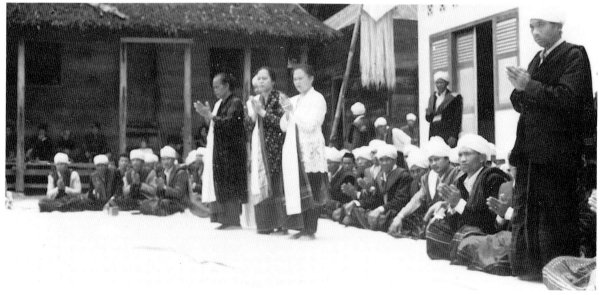

80. Paniaran, dancing at a Parmalim cult ritual, 1990.
Photograph: Sitor Situmorang.

The participants in this ritual are wearing white to symbolize purity. The women are wearing handwoven hipcloths—something that is otherwise no longer done by Toba women, even on ritual occasions. Foreign apparel is rejected here in an attempt to preserve the authentic nature of the ritual.

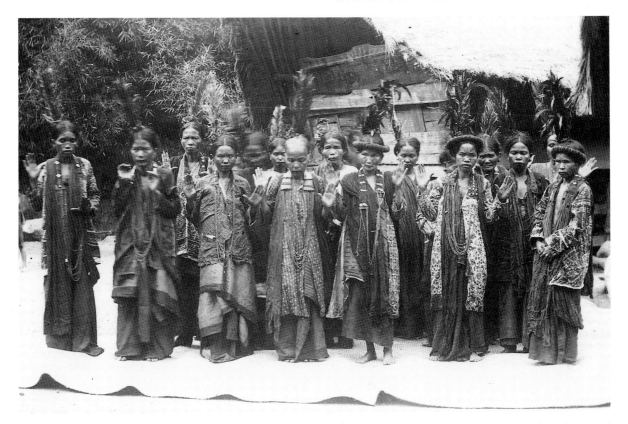

81. Paniaran, *Bius* festival, SiHotang, 1938.
Photograph: J. A. Honinge, Royal Tropical Institute, Amsterdam.

The crowning annual *bius* ritual was forbidden by the Rhenish missionaries, but allowed again in 1938. This photograph was taken in the SiHotang valley, a more isolated region of Toba. With their hands, the women are making dancing motions. They are dressed primarily in handmade textiles, and they have chosen imported fabrics to render their *baju* particularly fancy. This was a time when foreign dress was still admired and bestowed status in a ritual context.

which follows SiSingamangaraja, wears a black headcloth in his ritual role as temporary representative of the spirit of the SiSingamangaraja (Plates 78 and 79) following the belief that the SiSingamangaraja used a black silk or cotton headcloth to symbolize his supreme spiritual power on earth. The other members of the movement wear white to symbolize purity (see Plates 80 and 81). None of the spiritual leaders wears golden jewellery or brightly coloured cloth (Sitor Situmorang, pers. com., 1972).

Where once the Batak incorporated, with delight, foreign trappings to express status in their dress (Plate 82), now their indigenous trappings are worn with loyalty and solemnity on special ritual occasions to remember the spiritual essence of their social origins. The spiritual component that once participated in the holistic political workings of the Toba Batak has been extracted from it and splintered off.

# 8   The Donning of Christianity

## A Split Characterizes the Toba Batak Universe

WHEN I first visited the Toba Batak in 1979–80, Mr G. M. Panggabean, businessman and newspaper editor, had developed one of the highest public profiles in the North Sumatran capital, Medan. He was adept at displaying his success in a variety of trappings, and the trappings he selected are telling. The familiar ones are standard around the globe to denote the modern, rich urbanite, but to these Panggabean added something quintessentially Toba Batak. He gave his newspaper the popular Toba Batak voice by devoting special columns to customary pre-Christian, pre-colonial social rules. He stirred the appreciative Toba Batak populace still more by resurrecting memories of their most sacred and powerful leader, SiSingamangaraja XII, who died defending Toba Batak territory from the encroaching colonial power. In the way Panggabean promoted this most potent of folk heroes, he promoted himself as folk hero. He even appeared at folk rituals dressed in a way reminiscent of the times of SiSingamangaraja: a simple, wide *abit* wrapped around his hips, another textile over his shoulders, and one tightly bound around his head. All his selections denoted high social station. What was exceptional was that he did not wear a European-style suit underneath his Batak textiles. There was no familiar underlying layer of acculturation; his appearance did not convey the 'it's-ok-to-participate-in-this-ritual-because-I-am-a-civilized-Christian-underneath' message. It spoke instead of an unequivocal and irrepressible Toba Batak ethnicity, complete with religious connotations. It came across as daring, and it appealed strongly to Toba Batak nostalgia. The Toba Batak remember well their priestly leader, SiSingamangaraja; they heed many customary laws, they continue to enact certain rituals, and they still weave and wear, on occasion, their pre-Christian clothing. Nevertheless, the Batak are aggressive and successful participants in the modern Indonesian world, known for their astute dealings and their hunger after success. A split characterizes their Universe. They identify with both sets of G. M. Panggabean's trappings....

## The Clothing of Christianity

The Rhenish Mission shifted its operation to the Silindung Valley in 1863. That the first missionaries survived Batak opposition to their intrusion is little short of a miracle, but then they and their long

fought for and hard won converts were isolated from the rest of the community of Batak. This fact must be understood in Batak terms. As clan members, Batak are members of offertory communities of various sizes, the largest being the *bius*. Logically, a Batak who no longer participated in the offertory community fell short of true membership. Isolation was excommunication. Short of killing the nonconformists, isolation was a most drastic measure that could be taken by a community that valued the solidarity of the family. This was one of the reasons why Nommensen, the famous early Christian missionary who was active in the Toba Batak area during the second half of the nineteenth century, urged a ban on the *bius*, the highest ritual expression of the community (Korn, 1953). The *bius* was not just an annual festivity, but a regular culmination of tasks and duties of a complete calendar cycle of rituals which knit the community together. Probably, Nommensen was fully aware of the profound social ramifications such a ban would have.

The tenuous position of the Christians gradually strengthened, partly through their own bravery and dedication. In addition, their influence had a chance to make inroads in the Silindung Valley because the society was in chaos subsequent to the *padri* invasions. Furthermore, there were crucial Batak contacts of whom Raja Pontas, who assisted the missionaries, was the most remarkable (Plate 82). Ironically, even the spiritual beliefs of the Batak assisted the missionaries in unexpected ways. Still uncomprehending of the spiritual might (from the Batak perspective) of the Christians, many Batak were afraid to simply do away with them. Missionary accounts such as Van Asselt's (Plate 83) of their adventures make exciting reading (1905). What began as a grudging and fearful belief that some powerful force was behind the lives of these missionaries, grew into a desire to share in that force through association with them (Schreiber, 1899). While missionaries were concerned, when great flocks of people followed their leaders to the new religion, that the conversions were not being made on the appropriate grounds, the missionaries nevertheless enjoyed a success amongst the Toba Batak as they enjoyed nowhere else in the Batak homelands.

At first the missionaries, who were Dutch and German by origin, denied that they were associated with the colonial power, though the colonial administration had more to gain by admitting that the mission was paving their path. The co-operation between the two establishments became increasingly apparent as the Dutch military stood on the alert to back the missionaries at critical moments, and the Netherlands Indies administration was willing to support mission schools. In turn, the mission often mediated between the government and the people. It made its wishes known, as well, regarding which Batak should be selected for administrative appointments (Castles, 1972: 43).

When piecing together the Batak perspective of the new European elements in their midst, the co-operation between mission and colonialist grows strikingly evident. The Batak were exposed not just to the Christian dogma and a new administrative style, but, in a much

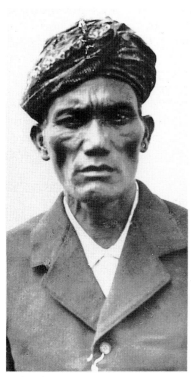

82. Raja Pontas Lumbantobing, one of the first Christian converts. Photograph: Vereinigte Evangelische Mission, Wuppertal.

Raja Pontas Lumbantobing was a man of great intelligence and courage, highly influential in the area. He died in 1900 (see Van Asselt, 1905: 229–38). He is dressed in a European coat of the kind worn by the missionaries, and probably a European shirt. His headcloth is a Javanese batik worn in the Malay style.

83. Missionary Van Asselt and his wife.
Reproduced from Van Asselt (1905).

While Batak Christian leaders dressed like the European missionaries, Batak women did not adopt European dress until many decades later. Women were of little consequence in Van Asselt's accounts of missionary life; he even neglected to disclose his wife's name.

profounder sense, to Europeans and European ways. They were introduced, not to compartmentalized religion and administration, but to cultural changes with all-permeating ramifications. There is no other way to explain the profound lifestyle changes that attended the intrusion of the Europeans. Church and state were confounded by the Batak, and, in retrospect, correctly so. The chiefs and their followers either set themselves to operating within the new terms of success, or, like SiSingamangaraja, they opposed those new terms and those who promoted them, church and mission alike. This was an early stage of the still evident cultural split that informs Panggabean's two sets of trappings.

Church hierarchy was another social ladder that became available to the Toba Batak. Men who climbed through the church did so by taking up teaching and preaching and participating in church meetings of various levels (Warneck, 1932: 95) (Plate 84). While new status terms were developing, some indigenous positions were in decline. The *datu*, Toba Batak spiritual leaders and healers whose

84. The church elder, Simatupang, and his family.
Photograph: Vereinigte Evangelische Mission, Wuppertal.

Europeans did not appreciate children running around naked until they were about eight years old, as was the Batak custom. The boys in this photograph appear to be dressed in Chinese-inspired suits and have their hair neatly cut, just as their father has.

The daughter is wearing a *baju kurung* as a blouse, and a locally made *ragi botik* over her shoulder. Her mother has a *mangiring* textile over her shoulder. Her hipcloth is an elegant *jobit*.

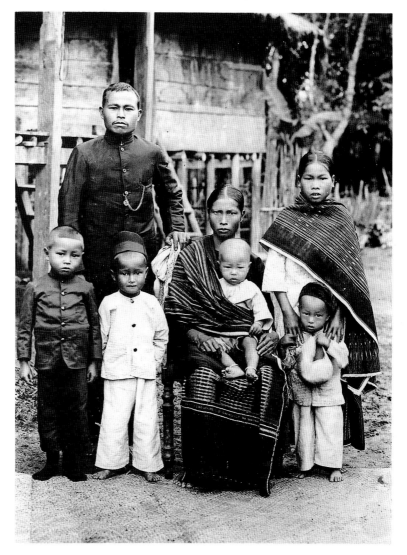

power depended upon their followers' belief in the Batak spirit world, saw their positions becoming weaker and less central. This was exacerbated when the mission started to include European medical personnel in their Tapanuli teams. Further, the mission actively discouraged aspects of Batak customary life where it was seen as conflicting with the principles of Christianity (p. 93). There were spin-off effects: the market system was changed to leave Sundays 'free' for worship; single family dwellings became the architecture of the day; 'purchasing' brides with a bride-price was discouraged; even Batak music was discouraged and German hymns were learned in church (p. 97).

A specific clothing image was adopted by the Batak as a strategy and a statement of commitment to the new goals of acculturation. Women learned to cover their breasts with Malay-style *kabaya* and *baju kurung* [tunic-like garments], whether they were married with

85. Missionary Ginsberg and the elders of the Batak church.
Photograph: Vereinigte Evangelische Mission, Wuppertal.

Batak learned to remove their headcloths as a sign of respect and to adopt the clean-cut look by cutting off their long locks. Buys wrote in 1886: 'The Christian men and boys among the Bataks have, in imitation of the Europeans, adopted the custom of being bare-headed in church and school and to cut their coarse black hair very short....

In addition it happens that the Christian-Batak, out of respect or a feeling of decency, takes off his headcloth, also a demonstration of the influence which the change of religion can have on folk customs. Among the Malays and the Javanese though, as among the non-Christian Bataks, it counts as disrespectful to appear without a headcloth in the presence of their superiors' (p. 257).

children or not. Men learned the clean-cut look: they cut their hair and shed their headcloths. Doffing the headgear was now a sign of respect (Plate 85) where covering up had previously been the norm, as it still was in the Malay context. The bare head was a sure sign of conversion to Christianity. The nakedness of children was not appreciated by the Europeans, and even the little ones had to learn to cover up, little girls like their mothers and little boys in *baju* and pants, often of Chinese cut (see Plate 84).

Graduates of the mission schools who went on to teach were expected to present the same example to their students as had been presented to them by the European missionaries. To this end, the men dressed like their European cohorts (Plate 86). In missionary Warneck's seminary in Pansur na Pitu (Silindung Valley), Schreiber was met in 1898 by the 'lieblicher Unblick' of white pants and red jackets worn by each of the students (1899: 64). It seems that part of showing one's Christian religion was to outwardly show association or affiliation with the immigrant Europeans. It may have begun with a display of being in the good graces of the missionaries: Missionary Van Asselt's wife (see Plate 83) sewed clothing and gave it to the villagers for Christmas (1905: 192); missionary Heine was known for giving jackets and pants to his house guests, who loved these mementoes of their sojourn and his affection and were not hesitant to ask for them (Warneck, 1911: 47).

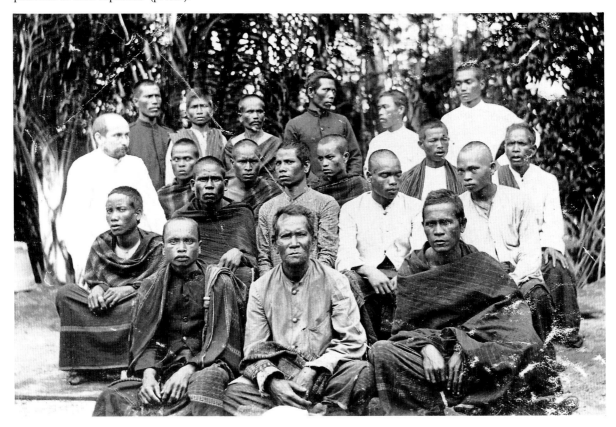

86. Three ordained Batak mission-
aries, *c*.1870.
Reproduced from Van Asselt (1905).

Batak teachers in the mission dressed
like their European cohorts.

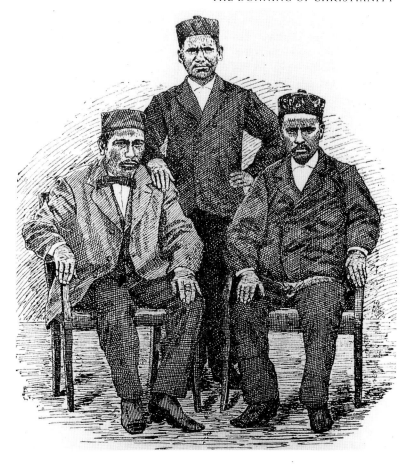

The picture I have sketched so far is of enthusiastic, forward-
looking people going after whatever it took to compete in new terms,
within new spheres. The negative side of this optimistic image is the
abuse and embarrassment which the Batak suffered from being
labelled uncivilized, dirty, and heathen. Often this was not overt, but
always it was present to some degree. Buys' disparaging description of
the men who tried so hard to conform by cutting their hair is illustrat-
ive of what appears to have been a no-win situation for the Batak in
which they had done their best to win: 'As ugly and sloppy as the
Batak wear their headcloths, which is sometimes no more than a dirty
rag, in contrast with the Javanese and Malays, who as a rule are neat
and tidy, they nevertheless look better with such a headcloth than
with an uncovered head' (1886: 257). The pejoratives in Buys'
descriptions, as they represented the common attitude of a probably
not too unkind man with an attitude typical of the European of the
time, could not have been easy for the Batak to bear. They reacted to
comparable slights in the Muslim area by wearing Malay clothing.
They reacted to them in Christian areas by putting on Christian
clothing. Even when patronized kindly, the European presence could
only have inspired resistance or rekindled the efforts to conform.

Today, G. M. Panggabean can probably only get away with his

87. *Runjat songkarsongkar.*
Collection: S. Niessen.

This shouldercloth originates in the Uluan area, south-east of Lake Toba. It is one of several variants of the same textile type (see Plate 34).

'heathen' look because he has been exceptionally successful in creating his wealthy, modern look.

## Christianity in the Cloth

In the pre-acculturated Toba Batak thought world, yarn and cloth had powerful connections with the spirit world and the gods. According to one myth recorded in several variations, the creator of the earth and the ancestress of the entire Batak peoples was a spinner who came down from the upper world on her yarn (Voorhoeve, 1977; Niessen, 1985b). For the Batak, a shouldercloth protects against the elements and is correct formal apparel, but also it is indispensable in prayer to recreate that original link with the spirit world (Plate 87). Cloths decorated the pre-Christian Batak altars (Warneck, 1915: 368), wrapped the bodies of the dead, covered the coffins, cradled the bones upon reburial. Cloths were bestowed upon the sick to appease their souls, thereby strengthening them and healing their ills. Bestowed upon nuptial couples they promoted unity, longevity, and fertility. The cloths themselves both comprised and accompanied offerings. As gifts between affines, they represented the ongoing, unbreakable spiritual ties created by marriage between two clans. Analogous to time, the warp manifested the cyclical nature of regenerating, unfailing life (Niessen, 1985b).

Inevitably, Toba Batak conversions to Christianity were woven into their textiles. The secularization of weaving is one way to describe the effect of the religious conversion, an ironic, though, upon closer inspection, logical outcome of contact with European values. Despite frequent missionary complaints about the lack of religious feeling in the ever competitive and status-seeking Batak, we know that contact led to a secularization of many economic and material aspects of their lives where once they had come together in a spiritual/religious unity.

Women were the makers of Batak cloth, and even if this cloth was intended merely as a body covering, it participated in colouring and design in the larger corpus of textiles, permeated with ritual and religious significance. While European eyes characteristically saw carelessness and sloppiness in Batak dress, Batak eyes read in their textiles carefully encoded messages of social order. Batak textiles, of numerous set designs, are like community shares. Each textile has a value relative to the total repertory, and a specific role to play within it. This is what Batak eyes read. They take in messages about age, marital status, social position, and occasion. A portion of the cloth/clothing repertory played in the common and familiar (to the Batak) manner of the day-to-day context, and another portion was used on ritual occasions when people would dress themselves up in their finery. Social order or status hierarchy would be displayed then as at no other time. Furthermore, the clothing worn by the participants were pledges to the spirit world, proclamations of belief, expressions of an intense desire to please by living the order which the spirit powers sanctioned, and which resulted in the propitious flow of life. By

wearing the appropriate garb, in daily life or in the ritual setting, individuals, like their textiles, represented their belonging and their participation in the larger community, that whole which myth and ritual conflated with the Universe. This changed gradually as weavers used new colours of yarn and changed aspects of their textile design, in short, created textile neologisms which made sense only in the new, Christianized, syncretic textile vocabulary. The split that characterizes the Toba Batak Universe was being woven, as could be expected, in their cloth.

The archival photographs show this transition occurring. The tidy, serious young women in Plate 88 are wearing clean and ironed *baju kurung* with Malay sarongs around their hips, and a textile—usually

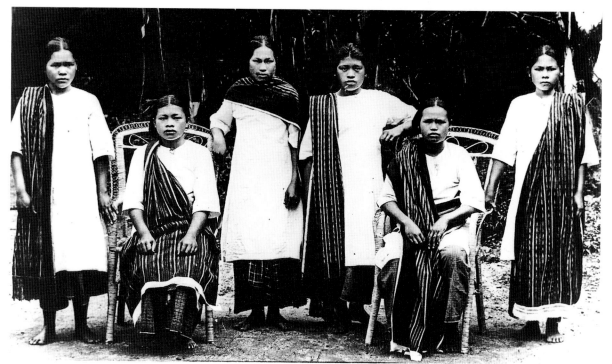

88. Young mission pupils (?). Photograph: Royal Tropical Institute, Amsterdam.

Probably the young women depicted are mission school pupils. Their clean and tidy clothing gives an impression of missionary influence. All are wearing *mangiring*-type shoulder-cloths. Several of these are embellished with a lacy fringe rather than a twined border.

Missionaries taught the Toba to express their conversion to Chris-

tianity in specific ways, so that gradually a Christian Batak became recognizable on the basis of appearance alone. This had to do with adopting European ways. Buys was impressed by this when travelling through a small Christian enclave in the Southern Batak region: 'When we approached Pekanten, we met a few groups of women, who had a somewhat more pleasant appearance than the others.... They wore their hair neatly parted and were appropriately dressed in a clean *sarong* and

*kabaya*. They surprised us with a friendly good morning greeting, something very unusual in these areas, where the European only seldom from the inhabitants, least of all from the local women, receives a greeting. Soon it appeared that they were Christian women and girls and the more pleasant appearance, by which they distinguished themselves, was partly due to the civilizing influence of the missionaries, under whom they had stood' (1886: 137).

the *mangiring* variety and often with a lacy fringe rather than a twined border—over the shoulders. The textile hangs there tidily like a refined embellishment of dress, like a scarf: decorative. The *mangiring* is the appropriate shouldercloth for a young, unmarried Toba Batak girl to wear, but the textile in this setting is purged of its 'heathen' associations; otherwise it would not be worn by a girl in a mission school, least of all for a photograph.

Weaving and needlework occupied a particular status in the minds of the missionaries, reminiscent of the sober role of needlework back home in Europe (Parker, 1989). In fact, the mission schools taught the young girls stitchery and macramé in the second decade of the twentieth century. Weaving was considered, like needlework, an excellent way to teach the young girls diligence and orderliness. Both labours were time-consuming, exacting, and demanded hours of quiet, concentrated labour. The missionaries saw in weaving a character-building technique which would inculcate the young girls with the values of obedience and self-control and render them appropriate young spouses of the schooled Christian males—a far cry from the thought-world which has gone uncommitted to paper although woven into old cloth, which must have belonged to the pre-Christian weaver (Joustra, 1914; 1915a: 60) (Plate 89).

89. Weaving school in Laguboti. Photograph: Vereinigte Evangelische Mission, Wuppertal.

The mission taught young women to weave so that they would be able to provide well for their families. The missionaries also believed that the tedious labour of weaving would teach the girls diligence and obedience. The mission seems to have failed to recognize the Batak belief system bound up in Batak weaving. Note the macraméd edging on the shouldercloths of the two girls on the far left of the front row.

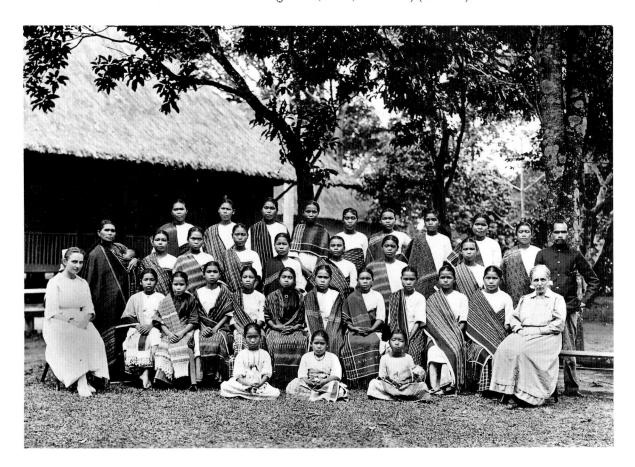

The profound impact of the new Euro-Christianized thought-world on Batak weaving can be further appreciated through learning more about the curriculum which the missionaries devised for the female pupils. Several decades after their work in the Toba Batak region began, the missionaries were troubled by the fact that there were still fewer female children benefiting from missionary schooling than male children, and while they knew that the wives of missionaries did their best to engage Batak women in discussions and teach them by example, formal education was necessary. When the Deaconess, Lisette Niemann, joined the Batak mission, she set up a series of girls' education programmes. While boys were being prepared to fill European shoes administratively and in the Church, the hope in girls' education was to not alienate them from their culture and to replicate the pattern of their village lives as much as possible at school, with the addition of values and skills which would make them superior wives and mothers. The girls were taught sewing, cooking, washing (with soap!), obedience, orderliness, and cleanliness. Van Bemmelen has researched the rigour with which these pupils were indoctrinated:

A part of the Western character shaping comprised instruction in the awareness of order and punctuality. When the girls came to school, they had to learn to sit still, to listen. They were forbidden to walk through the classroom....

If a new student came dirty to the classroom in the girls school in Pearaja, then without pardon, she was put in the tub and vigorously scrubbed and afterwards put in clean clothing. There was a store of clothing especially reserved for that. The next morning, the girl got back her own clothing, washed. In the day-school in Laguboti the little ones had to wash themselves during the break with water from a large reservoir on the lawn and comb their hair and the girls from the evening school did the same in the morning before their departure. Bodily hygiene was emphasized in ingenious ways: at the annual public last day of school, the best students received soap, hairpins and combs as rewards for their diligence and good results ... (1989: 31–2).

While the impact of the girls' school must originally have been minimal because of the meagre number of students they could accommodate, this impact gradually expanded as schools for girls were opened, not just in Laguboti where Deaconess Niemann worked, but also in Pea Raja (Silindung Valley) and Balige during the early decades of the twentieth century (Plate 90).

The girls taught in the weaving school adjoining the girls' school in Laguboti were between six and twelve years of age. They could hardly have been conscious of the elaborate associations their textiles had with their parents' pre-Christian beliefs in a spirit world. One wonders about the initiative that led to the forfeiting of some indigenous motifs for new designs which made their way into the textiles. Twined edging, for example, once exhibited the same decorative patterns as those found on Batak houses to ward off evil spirits and protect the inhabitants/wearers. Later, Latin characters exhorting well-being for the wearer (Plate 91a) or proclaiming a belief in

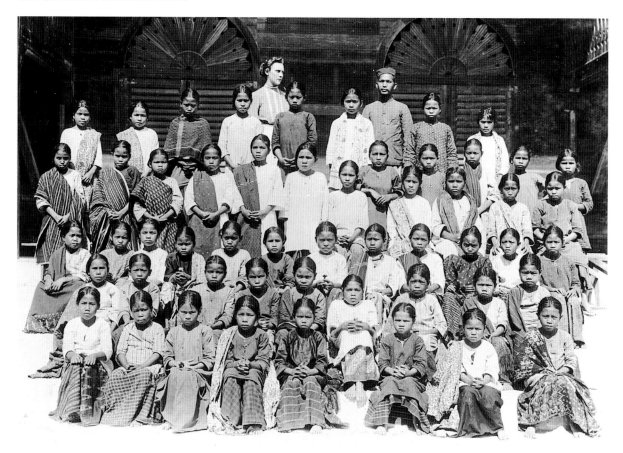

90. Pupils in Pea Raja's Girls' School, Silindung Valley.
Photograph: Vereinigte Evangelische Mission, Wuppertal.

Girls' schools were not as numerous as boys' schools, but several opened in the early decades of the twentieth century. The pupils were taught skills to make them good wives and mothers: sewing, cooking, washing (with soap!), obedience, orderliness, and cleanliness. Here, they are still wearing some Batak handwoven clothing. By 1925 the children no longer wore Toba Batak textiles, but rather dresses in the European style, shoes, and hair in braids (Van Bemmelen, 1989: 35).

Jesus Christ (Plate 91b) were twined into the textiles instead. The message of the patterning was comparable, in other words, but expressed through the particular avenues of the different religions. Were these missionary initiatives, or were they instinctive purges Christian Batak weavers were effecting on their own textiles to make them suitable for Christian contexts (Niessen, 1985a)? Was this kind of transformation the inevitable outcome of the loss of knowledge about the weaver's own religion, and her accommodation of a new thought-world in her cloth? Was it because the missionaries were oblivious to the significance of the Batak weaving arts that they forbade the weaving of foreign motifs by their pupils and insisted on them learning, by medium of samplers (Plate 92), the full range of supplementary weft patterning that they were able to collect for preservation, posterity, and scientific research, from all the corners of the Batak homelands (Joustra, 1914)? In their attempt to 'improve' the weaving arts by expanding the Batak colour palette with imported, chemically dyed yarns from Europe, were they aware that the textile products that they were encouraging did not fit in that closed repertory/community of Batak ritual cloth?

There is a sense which springs out of early mission photographs (see, for example, Plates 84, 88, and 89) that the missionaries' under-

91a–b. Twined patterning in Batak textiles.
Collection: S. Niessen.

The patterning in these twined edgings reads 'Well-being to the Wearer' and 'He is Jesus Christ'. This patterning reveals the effects of both a Western education and of Christianity.

(b)

standing of the Batak weaving arts has been self-fulfilling and has produced decorative, Christianized objects: lacy, tidy, fashionable. Today, an entire genre of Toba Batak textiles is woven in this fashionable, feminine mood, especially in the Silindung Valley where the colonial and missionary presence has the greatest vintage and the deepest roots. Their textiles are all the hues and tones of the rainbow, made of the finest imported yarns, decorated primarily in supplementary weft, and useful only as shoulder embellishments for the modern, acculturated rituals of Church and activities in Malayo-Javanese Indonesian society. These textiles do well when judged by the criteria of modern Indonesian society, but they are meaningless for Batak ritual and they are never worn by men (Plate 93).

If the sociological and intellectual aspects of religious conversion so

92. Detail of a sampler woven in the Laguboti weaving school, *c.*1910–20. Collection: Royal Tropical Institute, Amsterdam.

The children in the mission weaving school in Laguboti were taught to weave typical Batak supplementary weft patterns which the school collected from different Batak regions.

This detail from a sampler shows the motifs (from top to bottom): *sigumang, salungsalung, matamata lombu, iponipon,* and *sanggulsanggul.*

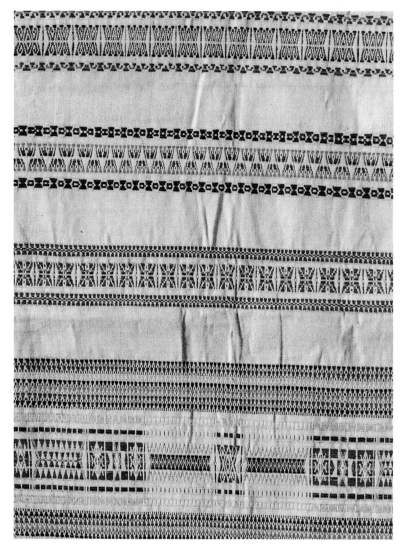

influenced Batak textile design development and indigenous use of Batak textiles, we might well ponder the impact on the Batak weaving arts of both the lack of education and the type of formal education girls eventually received. There is the simple fact, evident today, that when Batak women are educated, they do not weave, but strive after employment in office jobs and the like. Weavers are stuck with the pejorative evaluation of being poor and uneducated and the nature of their work second class and undesirable. Did the missionary shortcoming in providing education for women at first, and later in providing an education that emphasized only the labours of the wife and mother, give weaving a reprieve from the onslaught of modernity, and time to find a niche in the changing social milieu? Other Batak crafts (male) quickly and totally met their demise towards the end of the nineteenth century (Joustra, 1912: 58). The more esoteric query concerns the impact of literacy on Batak aesthetics and the

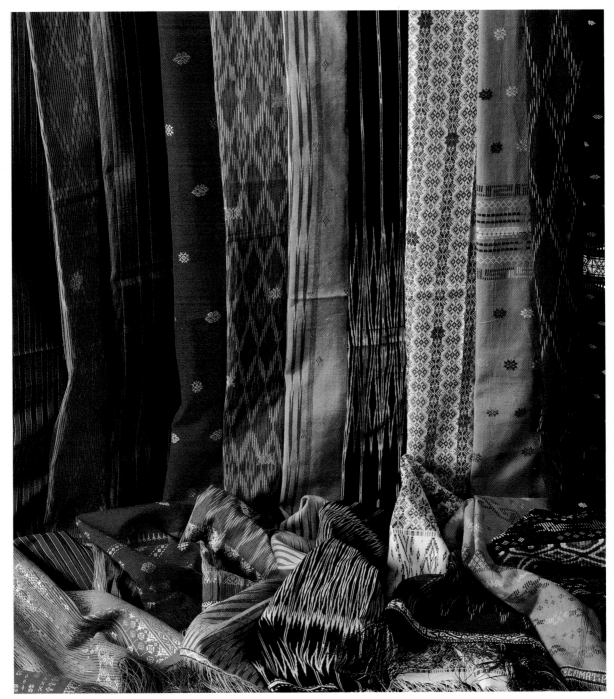

93. Modern Silindung Valley textiles.
Collection: S. Niessen.
Photograph: Richard Woolner, University of Alberta Photoservices.

These textiles represent some of the range of colours and designs that are currently woven for fashionable, and not ritual, purposes in the Silindung Valley—although the distinction between the two categories grows ever more vague with time.

epistemological underpinnings of weaving. Does the enduring strength of Batak textile design have to do with the historical oversight in providing education for women?

On the reverse side of the coin, and ironically, the survival of the Batak weaving arts might have much to thank from missionary influence. Whether oblivious to the power of the Batak cloth or actively purging it of this power, the missionaries sanctioned the weaving of cloth and weavers received approval for their work from an authority to which they were very sensitive. Despite the introduction of Christianity to the Toba Batak, they have retained much of their indigenous ritual life, and for virtually every ritual some use of their indigenous cloth is prescribed and indispensable. The tolerance of the Christian influence in the region may be part of the reason why there is any market left for the traditional designs. Ultimately, the survival of Batak ritual life spells the vitality of the Batak weaving arts.

The split that is diagnostic of the Batak thought-world and their social and ritual life, is given plastic expression in their textiles. The fine, bright, decorative, feminine, fashionable cloth of the modern world of Christianity and the Indonesian nation may be laid beside the sombre, brooding, serious ritual textiles of customary law. The former can hold their own in the critical light of Malayo-Javanese judgement. They take their cues from Malay cloth and are embellished brightly with metallic coloured supplementary weft. They are *slendang*, the Malay term, much more than they are *sampesampe*, or *handanghandang*, the Toba Batak word for shouldercloth. Now, Malay clothing design has begun to inspire Silindung Valley weavers; they have begun to weave sarongs—not the hipcloths of the past, but stitched cylinders of cloth, which also compete in design and fineness with Malay varieties. They are fond of saying that Ibu Tien, President Suharto's wife, has purchased two of them. Batak cloth was out-competed for the market of daily dress early in this century; it adapted, with missionary guidance, to the ritual demands of the modern world; and now it is pushing through to compete again on the clothing market. It is competing within the terms of the national economy and the products command a high price, but they are exceptional and high-quality products. They are forging ahead. They have changed their character, yes, but they have survived by virtue of that transition. The quality of the *adat* pieces, on the other hand, is declining. They have become 'tokens' of what they once were. To compete on the market they have to be woven faster, more loosely, sloppily.

G. M. Panggabean must commission his ritual textiles to get good ones, and he does so in the Laguboti/Porsea area where the weavers still eschew the modern Silindung Valley cloths and extol their own conservative weaving. The split that characterizes the Toba Batak Universe also informs Toba Batak weaving style regions.

# 9 Transforming Fashions of Batak Femininity

ON her wedding day, the early nineteenth-century Southern Batak bride (Plates 17 and 94a–b) would sing her tearful *andung* (mourning) song while setting off from her parents' house for her husband's house. All through her (numbered) carefree days of blossoming womanhood, she wore jewellery which jingled and tinkled as she moved, but upon her arrival in her residence of married life, this pretty freight, that was her wealth and symbolized her value, was stripped from her to become her husband's property, as she herself had become, and she would quietly begin the years of toil that would occupy the rest of her life (J. B. Neumann, 1887).

As a married woman she had no right to own property, no right to divorce except when childless, no right to keep her husband from having co-wives. Her only powers were her wiles, and her husband was her master. If he were to die, her ownership would devolve to his (male) next of kin who, if he claimed her as his wife, was allowed by customary law to force conjugality on her—a dubious 'right' also allowed a chief who desired the daughter of one of his subjects.

The contrast in her life before and after marriage startled the Dutch. They found the young, nubile woman almost shockingly free. If she did not live in a separate home for young women, she still lived with her parents, but was free to entertain interested young men in whatever way she pleased. She was free from responsibilities other than fetching a little water, cooking the occasional meal, and weaving mats. Her father would indulge her from affection if she wished to break a betrothal that did not suit her, or encourage an engagement of her choice. If Neumann was taken aback by her morals, he was delighted by her expressions of personality and her coquettish talents. Contrast this with his view of the married woman:

Is it thus incomprehensible that the Batak woman turns ugly very quickly; that deep wrinkles mark her forehead; that the once soft and downy skin is wrinkled before its time, and scorched and cracked by the heat of the out-doors where most of her work is done; that the once beautiful limbs with attractive pure curves become quickly angled; that the most beautiful woman a few years after marriage, especially if she has already borne a child, is almost unrecognizable; that a beautiful old Batak woman does not exist, but that in her old age is like a skeleton, from which one automatically recoils, from which one shudders for fear of being touched? (p. 246).

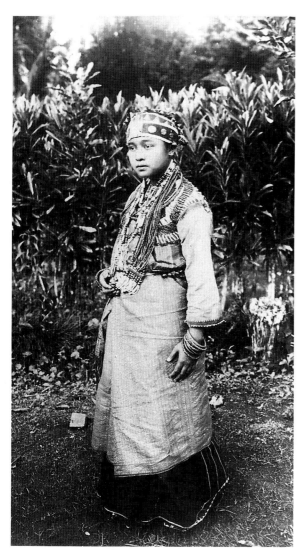 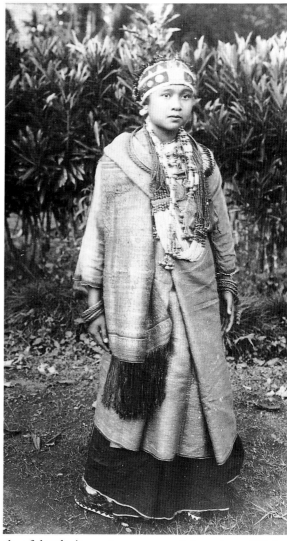

94a–b. Pekanten bride, photographed by Professor A. Grubauer. Collection: Rautenstrauch-Joest Museum fur Volkerkunde, Cologne.

If covering up was the mode of youthful childlessness, the jewellery in such abundance served this end: '... in the ears they wear rings of copper, bronze or tin, often in such great quantities that not only are the holes obviously enlarged, but also the earlobes are rather stretched. In Parsosoran there are also holes made in the upper edge of the ear to pull yarn or metal wire through and on which a small bunch of beads is strung, called *antinganting*, *udeng-udeng*, *pangkutan*, and *parsahutan*. The neck is further decorated with false pearls and beads (*pongkal*), nowadays also of fake corals (*morjan*) of shell and fishbone (*hompas*, *kima*), in which case they are called *songka*. Necklaces composed of fishbone and beads in strings of three or four, are called *si mata ribana*. Other girls, nowadays only the girls of lower class and almost exclusively in Dolok, wear instead of the necklaces just described, large rings of bronze or copper wire (*loyang*). Sometimes there are ten of these rings, differing in size, and they form a fairly heavy cargo, especially considering that an equally great quantity, if not more, are worn on the wrists and forearms (*loyang di tangan*) and on the ankles and lower leg (*loyang di pat*). But this jewellery ... is slowly beginning to disappear. Was it once a sign of wealth and class, now it signals less refinement ...' ( J. B. Neumann, 1887: 270–1).

Included in this bride's finery are a very elegant silk Minangkabau shouldercloth and sarong.

Yet, marriage was a desirable achievement for a woman. Just as for her husband, it was her passport to participation in the rituals of customary law. It was better even to marry low than to not marry at all! A woman's lot in life was to perpetuate the clan of her husband and to look after the home front. Upon marriage, she could advance to the next levels of social achievement: bearing children, and then acquiring grandchildren and great-grandchildren. A woman's social success was largely judged by her fertility and ability to perpetuate her husband's clan. The wedding ceremony marked a significant threshold in her life cycle (Plate 95).

In other regions of the Batak world the ceremony was not as dramatic as stripping a huge freight of carefully acquired jewellery from a humbled bride, but the transition from being an unmarried girl to a respectable married woman was as important. When the *baju* caught on, it was used to let the whole world know, at a glance, a woman's marital status: she would cover her breasts before marriage (*na marbaju*

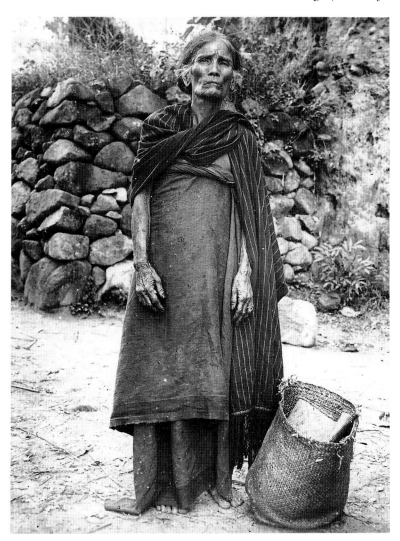

95. A Toba Batak woman, twentieth century.
Photograph: Royal Tropical Institute, Amsterdam.

The life of a married Batak woman was difficult in all the subgroups, and it took its physical toll.

This woman is wearing a *sibolang* textile around her torso, and a *surisuri* over her shoulder.

refers to a woman who covers her breasts/an unmarried girl), and after marriage and childbirth she would *buka baju*, open her *baju* and leave her breasts exposed (Plates 96 and 97). Following the Christian imperative of covering the breasts for the sake of 'decency', and the adoption not just of the Malay garment, but also of the Malay custom of always wearing an upper body garment, Batak women lost this relatively new means they had devised of announcing this transition. Furthermore, when the Southern Batak women began to follow the Malay way of wearing jewellery, that is, by wearing it even after marriage, they were muting another expression of the same social transition. They gave up their own ear-rings to wear the Malay forms. Malay ear-rings were not rings, but rather ear-plugs (*karabo*, *subang*) made of gold, *suasa*, or copper. The lower-class way of following the Malay style was to plug the hole in the ear lobe with a roll of leaves or a piece of wood (*sebong*, *ombongombong*). Where the local forms of jewellery of the Southern Batak were still worn in more isolated regions, by 1887 they were already associated with old-fashionedness.

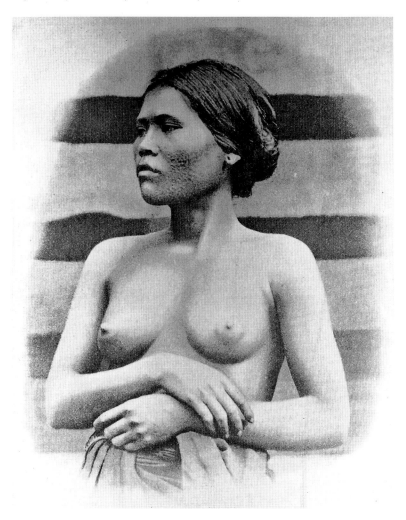

96. A Toba Batak woman, Nai Muara.
Reproduced from Modigliani (1892).

When the *baju* became accepted dress, Batak women used it as a marker of social position. Unmarried women would cover their breasts where married women were allowed to open their blouses. Modigliani took pictures south-east of Lake Toba where the use of the *baju* was still not yet common, but it did not take long before naked Batak torsos no longer appeared before cameras.

97. Karo Batak mother with two children.
Photograph: Tengku Luckman Sinar, reproduced by W. Rice from Anon. (n.d.).

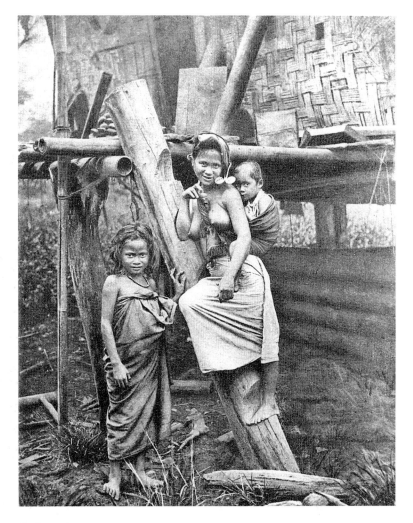

If Batak women, by changing their clothing and adornment, were sacrificing vocabulary by which to express a critical moment in their lives, they recovered their voice by utilizing, for the same ends, some of the new clothing categories available to them. The evidence I have for this is from current Toba Batak women's fashions, and archival photographs, and I suspect that it represents a common trend throughout the Batak area. Above, I recounted how the unmarried men of the Southern Batak area who 'sullied their hands with trade' wore racy European garb, yet when they became respectably married participants in their own society's workings, they wore the Malay garb of the establishment. It appears that Toba Batak women recognized similar associations with these two types of apparel and they, too, distinguished Malay clothing as appropriate for the ritual setting, and European garb as appropriate for the non-ritual setting. By extension, women who, by virtue of marriage, had entered the ritual spheres of Batak society could now characterize their status by wearing Malay clothing. Their younger, unmarried sisters could dress in

the flouncy, frilly European dresses of the schoolgirl, or more recently, the serious suits of the working woman. For married women, the European blouse or dress may not be amiss in the non-ritual context, but she alone has the prerogative of dressing up 'in *adat*'—sarong, *kabaya*, Batak shouldercloth, hair in a tidy bun at the back of her head—for ritual. While the Toba still use the expression *na marbaju* for unmarried girls, a different clothing vocabulary has been fitted to the concept.

If one were to randomly open Toba Batak clothes closets in North Sumatra, it would be clear that women's wardrobes present a greater allegiance to Malay than to European clothing compared with men's wardrobes which are filled with shirts, trousers, and suit jackets. Even on ritual occasions, the Batak textile is something which men temporarily pull on for a particular prayer or speech or dance. While women will dress up 'in *adat*', men's clothing association with *adat* is more limited (Plate 98). Even though men, in principle, bear the primary responsibility for *adat* ceremonies, only *adat* leaders will go

98. Toba Batak burial ritual in the Silindung Valley, 1986.
Photograph: S. Niessen.

The women gathered around the coffin are dressed 'in *adat*': sarong and *kabaya*, a Batak shouldercloth, and hair in a bun. The widow has a mourning cloth (*sibolang*) over her head. Only the men who will speak at this ritual, the closest male relatives of the deceased, are wearing shouldercloths. Men pull on a shouldercloth temporarily at ritual moments, such as for dancing or praying.

'full dress'—and keep it on throughout the rite. It seems that women are more participant (except for the shouldercloth, they wear '*adat*' throughout the ceremony) but less empowered in *adat* (they wear Malay rather than Batak styles). Men, in principle, are more empowered but only the key participants among them exhibit the extent of their responsibility by wearing handwoven Batak textiles—and not Malay clothing items. Malay clothing will suffice quite nicely for the ritual setting, but Batak cloth is indispensable for the most intimate core of Batak ritual expression. European clothing, on the other hand, is fully secularized and 'modern'; it belongs not at all with the intimacies of Batak culture.

Gender is one of the most fundamental distinctions in Batak society and permeates its every level and aspect (Niessen, 1985b). The fact is expressed in clothing: Karo women were the primary wearers of thin, imported European cotton throughout the nineteenth century (see Plates 2–5); Southern Batak women dressed miserably compared with the peacock males of their society. Yet, how alike the dress forms of pre-colonial society for both genders: hipcloth, shouldercloth, headcloth! The gender distinction revealed itself in details and not in the basic wardrobe. Since the nineteenth century, however, the basic wardrobe has diverged, and it suggests that the gap between the genders widened during the colonial period.

The colonial era was a time of opportunity for men and very little corresponding opportunity for women. Men took up trade and travel and office. They pulled on trousers and shirts and jackets. They learned to wear shoes, go to school, read watches. They learned about absolute authority. The life of women was life more or less as usual. They tended the gardens and rice-fields, tended the children, tended the meals, tended the home (Plate 99). When doing it in handwoven cloth proved expensive and backward, they did it in sarongs. When doing it with naked torso proved shameful, they pulled on a blouse. No opportunities pulled or seduced them from the home front. When schooling finally came, it emphasized their efficiency in the home and their supportive role. They continued to guard the home front (Plate 100).

Plate 71 could hardly be more revealing of the respective worlds of the genders under colonial rule. A row of five men have their bodies draped in a diverse combination of Malay, Batak, and European dress. To their left stand two women, straight as statues, hidden underneath the textile called *ragidup*. They are as though incapacitated, having no arms. Were they wrapped this way to hide their breasts? Presumably, they 'were wrapped'—by the photographer?—and did not wrap themselves. In this photograph they stand dutifully. Their role is adornment. Their ears are hung with gold and their bodies draped in the highest class of cloth. They are showing off the chief's wealth. They are part of his clothing. The photograph gives them no other social definition. If the finery of the men is a spontaneous and creative combination of the spoils of their social environment, the women represent class in conservative Batak terms. Except for their covered

99. Karo Batak women pounding rice.
Photograph: Tengku Luckman Sinar, reproduced by W. Rice from Anon. (n.d.).

Karo society was more egalitarian prior to colonialism, although the Dutch described women as an 'exploited class'.

The egalitarian multi-family dwellings depicted here eventually gave way to single-family dwellings, and diversification in the economy led to greater economic differentiation amongst the people.

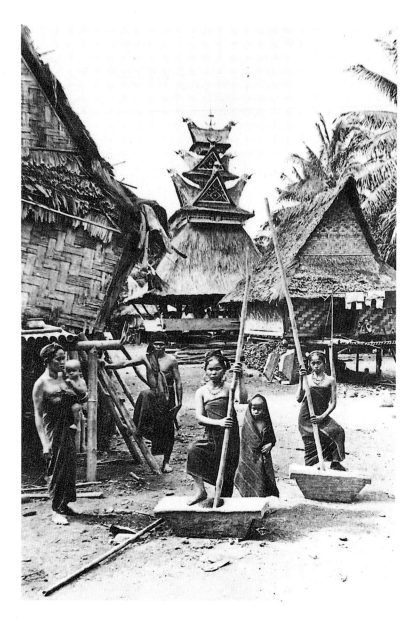

(*Opposite page*)
100. Women in Pekanten picking lice, photographed by Professor A. Grubauer.
Photograph: Rautenstrauch-Joest Museum fur Volkerkunde, Cologne.

A domestic scene.

(*Opposite page*)
101. Toba Batak welcome dance. Reproduced from Collet (1925).

I expect that this photograph dates from much earlier than Collet's publication because the dress of the dancers reveals a fundamentally different concept of dress from that in the early twentieth century. These women do not have the 'washed, ironed, and neatly folded' look of Christianized, Europeanized, modernized Batak.

breasts and their tidiness (contrast this with Plate 101), there is no hint on their bodies of the changing times.

There is no hint either from the archival photographs or the literature that women made conscious political statements through their clothing. Politics was not their purview. What is striking about Plate 102 of SiSingamangaraja's captured mother, wives, and children taken just after his death, is that their clothing shows nothing of the nature of his strife. It appears, to my eye at least, no different from the fashions worn by any Batak women and children at the time. The women are dressed in *baju kurung* and hipcloths. Two of them are wrapped in Malay sarongs, perhaps borrowed, to keep them warm on the chilly plateau where Siborongborong is located. The point is that

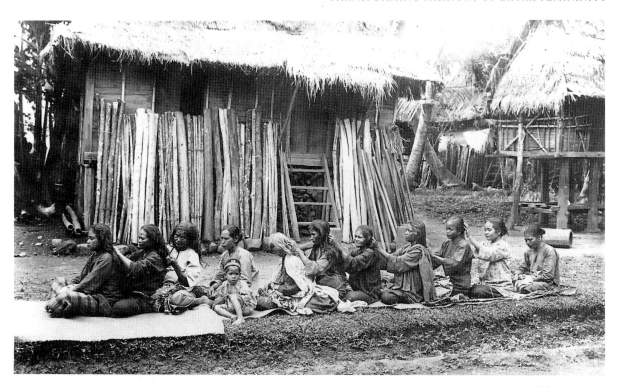

102. The captured mother, wives, and children of SiSingamangaraja, Siborongborong, 1907.
Reproduced from Tampoebolon (1944).

Br. Situmorang, the elderly Batak in the wicker chair, has just lost her son, SiSingamangaraja. The other women are his widows; the children are now fatherless. They are shown here in Siborongborong on their way to their lives of captivity in the Silindung Valley.

There is nothing in the clothing of this unfortunate group which is out of the ordinary with their times. Batak women do not seem to have consciously used their clothing to make political statements.

they and the children have gone with the times; they make no statement through their clothes of their affiliation with unchanged Batak beliefs. Perhaps this kind of clothing statement was of later vintage for men as well. Unfortunately, we do not have a photograph of the SiSingamangaraja himself. If the women make a clothing statement at all, it is one of submission. Neither in this plate, nor in any other that I have found, is there anything brash or politically audacious in women's garb. There is no female counterpart in the photoarchives to Albinus Lumbantobing (see Plate 72).

A woman's success was measured largely by the productivity of her womb, and by tending to the home front. This was her statement, and she used the successive items of clothing available to her to make it and reiterate it.

# 10 Conclusions

THE study of Batak cloth has eclipsed the study of Batak clothing. With our gaze fixed steadily on authenticities of the past, such as 'ancient textiles', we have missed (and still miss) the sartorial realities of Batak daily life which parade across the historical stage. Unlike the proverbial Emperor whose importance ranked so high that even his nudity was interpreted as splendid raiment, the Batak have developed fully elaborated, meaningful clothing traditions, virtually none of which has been inspected in detail by onlookers. In this book, I have tried to stitch together a few remnants of the Batak sartorial past.

The Batak have entertained a long and profound history of adaptation with their clothing. The wearers have, by times, jealously guarded their own clothing, eagerly adopted foreign apparel, creatively adapted imported styles and fabrics, boldly experimented with shoes, wool, braid ..., diligently applied their talents at embroidery needles and sewing-machines, and coming out for the final bow, have all clad themselves in the same *vestimentum communis*. The above chapters have thrown spotlights on a few moments in this clothing history. We know from these moments that Batak clothing has accumulated a rich store of cultural significance. Much of it is a thoughtful achievement of acculturation.

The Batak clothing history in the chapters above is an aspect of a social history of ethnic encroachment. The process of fashion change in a colonized society undergoing fundamental social transformations can only be a highly complex matter deserving of careful scrutiny by costume historians. The variety of Batak clothing possibilities in the late nineteenth century can only be matched by a plethora of processes by which the clothing was changing. Several ethnicities were involved, and a range of conceptions of hierarchy and status; factions were vying with each other not just for social control, but for the terms in which control would be understood and attained. The impinging ethnicities, Malay and European, were spurned and emulated, alternately and simultaneously. They represented status and anti-status, the hierarchical heights which the Batak could achieve, and the hierarchical depths to which the Batak could sink. The social infrastructures supporting the foreign understandings of hierarchy were, by times, misunderstood, manipulated from the outside, capitulated to and operated within, or transformed. Simplistically, clothing substitution is a dualistic process of affiliation with the origin of the

newly adopted styles and differentiation from the styles that are thereby rejected. The spontaneous, creative act that makes fashion the challenging social barometer that it is, however, implies that what occurs is not simply mimicry and rejection. Which clothing features and items are selected, rejected, and combined in new ways, are the considered statements of the times. The Batak consistently sought status and how they covered their bodies was one expression of this striving.

There are two major phases that Batak fashion underwent during the critical century discussed in this book.

I have argued above that the initial process of Batak clothing change had early roots, beginning long before Anderson's time. To incorporate the foreign seems to have been a Batak penchant; this was not a process catalysed by Western intrusion. In the chapters above, Batak textile design was presented as material proof of both the ability of the Batak to incorporate the foreign and the time depth involved. We are lucky that our written records go back just far enough, and work sufficiently in tandem with early collections, to give us evidence in historical times of this process of innovation and adaptation, so that we are not forced to rely entirely on the archaeology of textile design. Examples may be found in the way the Batak incorporated red wool trim into their finished weavings, in the way *baju* were elaborately stitched, in the way fancy imported Acehnese silks were worn at important Batak rituals. I would hesitate to label these clothing imports 'imitations', as the word suggests an accuracy of understanding of the original purpose of the cloth and clothing items on the part of the recipient. Diffusion is the better word, especially given the accuracy with which the Batak later learned to imitate European and Malay garb and by which they learned to entirely forfeit any sartorial hint of their own ethnicity (see Plate 72 of Albinus Lumbantobing). The kinds of borrowings in the early days elaborated the Batak clothing systems in vogue at the time. They embellished the indigenous styles.

In the pages above, indigenous Batak trade in cloth and weaving materials were described, to the extent that the data allowed. The indigenous Batak trade network provided the framework by which the foreign was able to penetrate the interior. The review of trade offered an insight, too, into the cognitive status which the Batak may have given to foreign imports. Ompu ni SiSihol, for instance, knew that yarn had always been imported to her valley on the west coast of Lake Toba. For her, Egypt, Japan, England, and the Southern Batak area were all mythically 'far away'. What mattered to her was that the yarn came through on the market, and not whence it had come.

I have also outlined the indigenous Batak trade network in order to demonstrate the limits of an economic model for explaining the process by which the Batak retained or shed their clothing traditions. National Batak dress was not forfeited simply because cheaper imports eroded indigenous production—although undeniably this occurred. Juxtaposed with the succeeding chapters which have documented the

cultural and creative subtleties of clothing change, Batak economics and trade can be left, unexaggerated, in their place.

The second phase of clothing change occurred in the context of social trauma, when the Batak groups were beginning to sense, and experience in often very harsh ways, their vulnerability with respect to the intruder. Clothing messages in this period had political implications so strong that they already vied in importance with their older messages of 'national affiliation'. All clothing statements were heavily loaded. There was no middle ground. One was with one group and opposed to another. There was affiliation and there was differentiation. Depending on circumstances, groups capitulated to or actively endorsed encroaching values and showed it in their attire, or they hung on tight to their own and showed it in their attire.

Early affiliation with the invading forces correlates with the Batak groups which emphasized social hierarchy (Simalungun and Southern Batak), perhaps because the invaders also emphasized social hierarchy. Resistance correlates with the Batak groups of more egalitarian style (Toba and Karo). Where the Batak leaders gave in, the people followed, and where the leaders gave in, they lost their powers, paving the path for class structures to develop within the tribal structures. The processes of clothing change in a tribal society compared with a class society are deserving of more thorough study. The factors of ethnicity and trade complicate such a study. In the Batak case, the heights of status were characterized by foreign features, and these were also the features which had economic advantage in trade. In this sense, the options which the Batak enjoyed for selecting their clothing futures were not wide, but it is how they manipulated these options which is important for comparative studies of the clothing change process.

If the Batak, in the first phase of clothing change, focused inwardly on their own traditions, the second phase was characterized by an increasing loss of control over what was potentially fashionable. European and Malay fashion dynamics assumed increasing control and the Batak, sights now focused outwardly, learned to pick up and operate within—or against—the new system. This second phase has dominated the moments of Batak clothing history presented in the chapters above.

Since that time, the flagrant slogans that were Batak attire, representing deep and apparently irresolvable rifts in the society, have been gradually accommodated and defused. Clothing messages have lost their virulence as have the social factions which they represented. Indigenous, national dress items can now be trotted out on ritual occasions without presenting a threat to the ruling administration; symbols of the indigenous religion have found a home in ritual without posing a threat to the modern religions of Islam and Christianity; G. M. Panggabean, rich and modern businessman, may dress as a 'heathen worshipper of spirits' (*sipele begu*) when it suits his interests, without this interfering either with his status in the church or in modern worldly circles; worshippers of the SiSingamangaraja cults today pay their taxes just as their neighbours do, and, except in the ritual

setting, are indistinguishable from their neighbours; the Karo dye pot still makes the *batu jala* for wedding ceremonies and the *julu* for burial rites, and those textiles are now used in combination with the high status red and gold cloth of Malayo-Islam. The rejection of the modern that is implicit in the preservation of indigenous rituals and religion, is also implicit in the garb which is now the 'correct thing to wear' on those occasions; however, the 'correct thing to wear' on worldly occasions and the day-to-day is European or Malay. The badges of political extremes have settled down to the realities of daily life and fill the wearers' need to both perform in the new setting and to keep cultural roots and local history alive.

While a dualism exists between the modern and the traditional which parallels the clothing worn in worldly and indigenous ritual settings, and also in the distinction between men's and women's clothing, what has 'remained the same' nevertheless bears the stamp of the changing times. It is not really possible to have a traditional sector in a modern world, for the very concept of traditional is a product of the modern. The traditional or conservative nature of Batak women's clothing, for instance, is the result of the increased social differentiation between the genders encouraged by colonial rule. Traditional is a concept which the Batak manipulate according to their present needs. The Batak live fully in their present world. They continue to skilfully manipulate their appearance, using the wide clothing vocabulary available to them, according to their changing needs of self-identification.

# Bibliography

Adam, T. (1919), *Batak Kunst*, Batavia.

———— (1930), 'Batak Days and Ways', *Journal of the Asia–American Asiatic Association*, 30: 118–41.

Adriani, N. and Kruyt, A. (1901), 'Geklopte Boomschors als Kleedingstof op Midden-Celebes', *Internationales Archiv fur Ethnographie*, 14: 139–91.

Andaya, B. W. and Andaya, L. Y. (1982), *A History of Malaysia*, London and Basingstoke: The Macmillan Press Ltd.

Anderson, J. (1826), *Mission to the East Coast of Sumatra in 1823*, Edinburgh: William Blackwood; reprinted Kuala Lumpur: Oxford University Press, 1971.

———— (1840), *Acheen and the Ports on the North and East Coasts of Sumatra*, London: W. H. Allen & Co., reprinted Kuala Lumpur: Oxford University Press, 1971.

Anon. (1852), 'Varia', *Tijdschrift voor Nederlandsch Indie*, 14: 433–5.

Anon. (1880), 'Annexatie's in Centraal Sumatra', *Tijdschrift voor Nederlandsch Indie*, 9(1): 57–80.

Anon. (1887), 'Het Verval der Kunstnijverheid in verband met het kwijnen van den landbouw', *Tijdschrift voor Nijverheid en Landbouw in Nederlandsch-Indie*, 35: 388–95

Anon. (1891), 'Uit de geschiedenis der Katoentjes', *Tijdschrift voor Nijverheid in Nederlandsch-Indie*, 42: 101.

Anon. (1894), *Catalogus van de verzameling Poppen, weergevende verschillende Kleederdrachten van de Volkeren van den Nederlandsch Oost-Indischen Archipel aangeboden aan Hare Majesteit, de Koningin der Nederlanden door de dames van Nederlandsch Oost-Indie*, Batavia: G. Kolff & Co.

Anon. (1904), 'Mededeelingen Betreffende Het Landschap Panei en het Rajahgebied behoorende tot de Residentie Oostkust van Sumatra', *Bijdragen tot de Taal-, Land- en Volkenkunde*, 56: 558–86.

Anon. (1909), 'Nota van toelichting betreffende de Simeloengoensche land-schappen Siantar, Panei, Tanah Djawa en Raja', *Tijdschrift voor Indische Taal-, Land- en Volkenkunde*, 51: 527–67.

Anon. (n.d.), *Sumatra's O.K.*, Medan: O. J. Kleingrothe, Gravure, J. B. Ober-netter, Munchen.

Bartlett, H. H. (1918), Unpublished journal.

Bastin, J. S. and Brommer, Bea (1979), *Nineteenth Century Prints and Illustrated Books of Indonesia: with particular reference to the print collection of the Tropenmuseum*, Antwerp: Het Spectrum Utrecht.

Bruch, A. (1895), *Den Batak: wie er leibt und lebt, von seiner Geburt an bis zu seinem Tode*, Barmen: Verlag des Missionshauses; 2nd edn., 1925.

Burton, R. and Ward, N. (1827), 'Report of a Journey into the Batak Country in the Interior of Sumatra in the Year 1824', communicated by

Sir Stamford Raffles, *Transactions of the Royal Asiatic Society of Great Britain and Ireland*, 1: 485–513.

Buys, M. (1886), *Twee Jaren op Sumatra's Westkust*, Amsterdam: A. Akeringa.

Castles, L. (1972), 'The Political Life of a Sumatran Residency: Tapanuli 1915–1940', Unpublished Ph.D. dissertation, Yale University.

Claus, W. (1982), *Economic and Social Change Among the Simalungun Batak of North Sumatra*, Vol. 15, Bielefeld Studies on the Sociology of Development, Fort Lauderdale, Saarbrucken: Breitenbach Publishers.

Cole, F. (1945), *The Peoples of Malaysia*, New York: D. van Nostrand Company, Inc.

Collet, Octave J. A. (1925), *Terres et Peuples de Sumatra*, Amsterdam: Elsevier.

Crawfurd, J. (1820), *History of the Indian Archipelago Containing an Account of the Manners, Arts, Languages, Religious Institutions, and Commerce of Its Inhabitants*, 3 vols., Edinburgh; reprinted London: Frank Cass & Co, Ltd, 1967.

Cremer, J. T. (1883), Unpublished documentation accompanying textile collection series 340 in the State Museum of Ethnology, Leiden.

Dalenoord, G. (1926), 'Textiel-nijverheid in Nederlandsch-Indie', *Koloniale Studien*, 10(1): 167–77.

De Boer, D. W. N. (1915), 'Haradjaon-Beschouwingen', *Tijdschrift van het Binnenlandsch Bestuur*, 49: 1–10.

De Haan, C. (1875), 'Verslag van eene reis in de Battaklanden', *Verhandelingen van het Bataviaasch Genootschap*, 38: 1–57.

Dodge, B. S. (1984), *Cotton: The Plant that would be King*, Austin: University of Texas Press.

Dubin, L. S. (1987), *The History of Beads, from 30,000 B.C. to the Present*, New York: Harry N. Abrams.

Farnie, D. A. (1979), *The English Cotton Industry and the World Market 1815–1896*, Oxford: Clarendon Press.

Giglioli, H. H. (1893), 'Notes on the Ethnographical Collections formed by Dr Elio Modigliani during his recent explorations in Central Sumatra and Engano', *Internationales Archiv fur Ethnographie*, 6: 109–31.

Hagen, B. (1883), 'Eine Reise nach dem Tobah-See in Zentralsumatra', in Dr A. Petermann, *Mittheilungen aus Justus Pethes' Geogr. Anstalt*, 29: 42–53, 142–9, 167–77.

_____ (1884), 'Die Kunstlichen Verunstaltungen des Korpers bei den Batta', *Zeitschrift fur Ethnologie*, 16: 217–25.

_____ (1886), 'Rapport uber eine im Dezember 1883 unternommene wissenschaftliche Reise an den Toba-See (Central Sumatra)', *Tijdschrift van het Bataviaasch Genootschap*, 31: 328–82.

Hamerster, M. (1926), *Bijdrage tot de Kennis van de Afdeeling Asahan*, Amsterdam: Uitgave van het Oostkust van Sumatra-Instituut, Mededeeling, No. 13.

Hemmers, J. H. (1928), *Schetsen uit het Leven van Ludwig Ingwer Nommensen den Apostel der Batakkers*, Weltevreden: Druk Emmink.

Henny, W. A. (1858), 'Reis naar SiGompoelon en SiLindong in Maart en April', *Tijdschrift van het Bataviaasch Genootschap*, 17: 1–58.

Holmgren, R. J. and Spertus, A. E. (1989), *Early Indonesian Textiles from Three Island Cultures*, New York: The Metropolitan Museum of Art.

James, K. A. (1902), 'De Geboorte van Singa Maharadja en het Ontstaan van de Koeria [District] Ilir in de Onderafdeeling Baros', *Tijdschrift van het Bataviaasch Genootschap*, 45: 134–43.

Jasper, J. E. and Pirngadie, M. (1912), *De Weefkunst, De Inlandsche Kunstnijverheid in Nederlands Indie*, Vol. 2, 's-Gravenhage: Mouton.

Jessy, J. S. (1961), *History of Malaya (1400–1959)*, Penang: United Publishers and Peninsular Publications.

Joustra, M. (1910), *Batakspiegel*, Leiden: Van Doesburgh, Uitgaven van het Bataksch Instituut, No. 3.

———— (1912), *De Bataks. Wie Zij Waren en Wat Wij Naar de Opgedane Ervaringen van hen Mogen Verwachten*, Leiden: S. C. van Doesburgh, Uitgaven van het Bataksch Instituut, No. 7.

———— (1914), 'De Weefschool te Lagoeboti', *Eigen Haard*, 40: 66–7.

———— (1915a), *Van Medan Naar Padang en Terug [Reisindrukken en- Ervaringen]*, Leiden: S. C. van Doesburgh, Uitgaven van het Bataksch Instituut, No. 11.

———— (1915b), 'Zwerftochten in den omtrek van het Tobameer', *De Aarde en Haar Volken, geillustreerd Maandblad*, 51(5).

Junghuhn, F. (1847), *Die Battalander auf Sumatra*, Berlin: Druk und Verlag von G. Reimer.

Kipp, R. Smith (1990), *The Early Years of a Dutch Colonial Mission: The Karo Field*, Ann Arbor: University of Michigan Press.

Koh Sung Jae (1966), *Stages of Industrial Development in Asia: A Comparative History of the Cotton Industry in Japan, India, China, and Korea*, Philadelphia: University of Pennsylvania Press.

Kohler, H. J. (1926), *Habinsaran: Het Land van den Zonnestraal. Mijn Leven onder de Bataks*, Zutphen: W. J. Thieme & Cie.

Korn, V. E. (1953), 'Batakse Offerande', *Bijdragen tot de Taal-, Land- en Volkenkunde*, 109: 32–51, 97–127.

Krajenbrink, J. A. (1874), 'Over spinbare vezelstoffen in Nederlandsch-Indie', *Tijdschrift voor Nijverheid en Landbouw in Nederlandsch-Indie*, 19: 261–9.

Kroesen, J. A. (1899a), 'Rapport betreffende de aanvaarding van de onderwerping aan het Nederlandsch oppergezag van het landschap Tanah Djawa', *Tijdschrift voor Indische Taal-, Land- en Volkenkunde*, 41: 211–52.

———— (1899b), 'Nota omtrent de Bataklanden (Speciaal Simeloengoen)', *Tijdschrift voor Indische Taal-, Land- en Volkenkunde*, 41: 253–85.

Kuper, H. (1973), 'Costume and Identity', *Comparative Studies in Society and History*, 15(3): 348–67.

Loeb, E. M. (1935), *Sumatra, Its History and People*, Wien; reprinted Singapore: Oxford University Press, 1972.

Loeber, Jr., J. A. (1914), *Textiel Versieringen in Nederlandsch-Indie*, Amsterdam: Koloniaal Instituut.

McCracken, Grant (1988), *Culture and Consumption: New Approaches to the Symbolic Character of Consumer Goods and Activities*, Bloomington and Indianapolis: Indiana University Press.

Manik, Tindi Radja (1977), *Kamus Bahasa Dairi Pakpak-Indonesia*, Jakarta: Pusat Pembinaan dan Pengembangan Bahasa, Departemen Pendidikan dan Kebudayaan.

Marsden, W. (1811), *The History of Sumatra, containing an account of the Government, Laws, Customs, and Manners of the Native Inhabitants*, London; reprinted Kuala Lumpur: Oxford University Press, 1966.

Maxwell, R. J. (1990), *Textiles of Southeast Asia: Tradition, Trade, and Transformation*, Canberra: Australian National Gallery and Melbourne: Oxford University Press.

Meerwaldt, J. H. (1894), 'Aanteekeningen betreffende de Battaklanden', *Tijdschrift van het Bataviaasch Genootschap*, 37: 513–50.

Middendorp, W. (1922), 'Het Inwerken van Westersche Krachten op een

Indonesisch Volk (De Karo Bataks)', *De Socialistische Gids: Maandschrift der Sociaal-Democratische Arbeiderspartij*, 7(4): 329–465.

_____ (1929), 'The Administration of the Outer Provinces of the Netherlands Indies', in B. Schrieke (ed.), *The Effect of Western Influence on Native Civilisations in the Malay Archipelago*, Batavia: Royal Batavia Society of Arts and Sciences, G. Kolff & Co.

Misc. (1883), Scrapbook stored in the Central Library of the Royal Tropical Institute, Amsterdam: Internationale Koloniale Tentoonstelling.

Modigliani, Elio (1892), *Fra i Batacchi indipendenti*, Roma: Societa Geografica Italianna.

Myers, M. A. (1989), 'Sacred Shawls of the Toba Batak: "Adat" in Action', Unpublished Ph.D. dissertation, University of Michigan.

Neumann, J. B. (1887), 'Het Pane- en Bila-Stroomgebied op het Eiland Sumatra', *Tijdschrift van het Nederlandsch Aardrijkskundig Genootschap*, Pt. III.

Neumann, J. H. (1916), *Een jaar onder de Karo-Bataks*, Medan: Typ. Varekamp & Co.

_____ (1951), *Karo-Bataks—Nederlands Woordenboek*, Medan: Lembaga Kebudayaan Indonesia/Koninklijk Bataviaasch Genootschap van Kunsten en Wetenschappen, N. V. Boekhandel en Drukkerij v/h Varekamp & Co.

Niessen, S. A. (1984), 'Textiles are Female ... but what is Femaleness? Toba Batak Textiles in the Indonesian Field of Ethnological Study', in P. E. de Josselin de Jong (ed.), *Unity in Diversity: Indonesia as a Field of Anthropological Study*, Dordrecht and Providence: Foris Publications.

_____ (1985a), 'Sirat: Getwijnde Randen v.d. Toba-Batakweefsels', *Handwerken Zonder Grenzen*, 3: 51–8.

_____ (1985b), *Motifs of Life in Toba Batak Texts and Textiles*, Verhandelingen Series of the KITLV, No. 110, Dordrecht: Foris Publications.

_____ (1988), 'Modigliani's Batak Textiles: Evaluation of a Collection', *Archivio per l'Antropologia e la Etnologia*, 118: 57–91.

_____ (1988/89), 'Exchanging Warp in the Batak Ragidup and Bulang', *The Textile Museum Journal*, pp. 40–55.

_____ (1991a), 'A Tale that 1001 Batak Textiles Tell about Twelve European Museums: A Collection History', in B. Volger and K. von Welck (eds.), *Indonesian Textiles, Symposium 1985, Ethnologica*, 14: 132–52.

_____ (1991b), 'Meandering Through Batak Textiles', *Ars Textrina*, 16: 7–47.

_____ (1991c), 'Changes in Batak Textiles during the 19th Century', presented to the Basel Symposium on Textiles from Indonesia and Related Areas, Basel, 26–30 August.

_____ (1992), 'More to it than Meets the Eye: Photo-Elicitation amongst the Batak of Sumatra', *Visual Anthropology*, 14: 415–30.

Nieuwenhuys, R. (1962), *Herman Neubrenner van der Tuuk, de Pen in Gal Gedoopt: Brieven en Documenten Verzameld en Toegelicht door R. Nieuwenhuys*, Amsterdam: G. A. van Oorschot Uitgever.

Oudemans, R. (1973), 'Simalungun Agriculture: Some Ethno-Geographic Aspects of Dualism in North Sumatra Development', Unpublished Ph.D. dissertation, University of Michigan.

Parker, R. (1989), *The Subversive Stitch: Embroidery and the Making of the Feminine*, New York: Routledge.

Pelzer, K. J. (1961), 'Western Impact on East Sumatra and North Tapanuli: The Roles of the Planter and the Missionary', *Journal of South East Asian History*, 2: 666–71.

_____ (1978), *Planter and Peasant: Colonial Policy and the Agrarian Struggle in East Sumatra 1863–1947*, Verhandelingen van het Koninklijk Instituut

voor Taal-, Land- en Volkenkunde, No. 84, 's-Gravenhage: Martinus Nijhoff.

Reid, A. (1979), *The Blood of the People: Revolution and the End of Traditional Rule in Northern Sumatra*, Kuala Lumpur: Oxford University Press.

_____ (1984), 'The Pre-Colonial Economy of Indonesia', *Bulletin of Indonesian Economic Studies*, 10(2): 151–67.

_____ (1988), *Southeast Asia in the Age of Commerce 1450–1680, Vol. 1: The Lands below the Winds*, New Haven and London: Yale University Press.

Renne, E. P. (1992), 'The Decline of Women's Weaving Among the North-east Yoruba', *Textile History*, 23(1): 87–96.

Rijkoek, D. (1931), *Hoe wij onze vacantie op Samosir doorbrachten*, Amsterdam–Batavia: W. Versluys.

Ritter, W. L. (1838–9), 'Korte aánteekeningen over het Rijk van Atjin, voor zoo verre het zich uitstrekt van den hoek van Singkel tot aan het zoogenaamd Groot-Atjin langs de Noord-west kust van Sumatra, gelijk ook over de tusschen dien hoek en de baai van Tappenoelie gelegen, onafhankelijke Staten Singkel, Tapoes en Baroes: opgemaakt op een reis langs die kust, in het begin van 1837', *Tijdschrift voor Nederlandsch-Indie*, 1(2): 454–76; 2(1): 1–27, 67–90.

Rouffaer, G. P. and Ijzerman, J. W. (eds.) (1915), *De Eerste Schipvaart der Nederlanders Naar Oost-Indie onder Cornelis de Houtman 1595–1597*, Vol. 1, 's-Gravenhage: Martinus Nijhoff.

Schreiber, A. (1876), 'Die Battas Auf Sumatra: Ihre Mohamedanisirung und Christianisirung', *Allgemeine Missions Zeitschrift*, 2: 257–70.

_____ (1899), *Eine Missionsreise in den fernen Osten 1898–1899*, Gutersloh: Druck und Verlag von C. Bertelsmann.

Siahaan, N. (1964), *Sedjarah Kebudajaan Batak: Suatu Studi Tentang Suku Batak (Toba, Angkola, Mandailing, Simelungun, Pakpak Dairi, Karo)*, Medan: C. V. Napitupulu & Sons.

Sibarani, P. (1984), *100 Taon HKBP Laguboti: 26 Augustus 1884–26 Augustus 1984*, Laguboti.

Sillem, E.-J. (1879–80), 'Le Lac Toba au Pays des Battaks', *Annales de l'Extreme Orient*, 2: 33–7.

Stavorinus, J. S. (1798), *Voyages to the East Indies, 1768–1771*, translated and edited by Samuel H. Wilcocke, London; reprinted London: Dawsons of Pall Mall, 1969.

Steedly, M. M. (1989), 'Hanging Without a Rope: The Politics of Representation in Colonial and Post-Colonial Karoland', Unpublished Ph.D. dissertation, University of Michigan.

*Survai Monograpi Kebudayaan Pakpak Dairi di Kabupaten Dairi. Proyek Rehabilitasi dan Perluasan Musium Sumatra Utara* (1977/8), Medan: Departemen Pendidikan dan Kebudayaan Republik Indonesia.

Tampoebolon, H. M. (1944), 'Het sneuvelen van Si Singa Mangaradja', *Tijdschrift van het Aardrijkskundig Genootschap*, 61: 459–82.

Tichelman, G. L. (1938), 'Over Bataksche Weefsels', *Natuur en Mens*, 3: 64–8.

_____ (1949), *Batakse Kunst*, Mededeeling No. 86, Afd. Volkenkunde No. 33, Amsterdam: Koninklijke Vereeniging Indisch Instituut.

Tideman, J. (1922), *Simeloengoen: Het Land der Timoer Bataks in Zijn Vroegere Isolatie en Zijn Ontwikkeling tot een Deel van het Cultuurgebied van de Oostkust van Sumatra*, Leiden: Van Doesburgh.

Van Asselt, G. (1905), *Achttien Jaren onder de Bataks*, Rotterdam: D. A. Daamen.

Van Bemmelen, S. (1989), 'Zwart-wit versus kleur. Geschiedschrijving over

Indonesische vrouwen in de koloniale periode', in F. de Haan et al. (eds.), *Het raadsel vrouwengeschiedenis: Tiende Jaarboek voor Vrouwengeschiedenis*, Nijmegen: SUN, pp. 11–45.

Van der Tuuk, H. N. (1861), *Bataksch-Nederduitsch Woordenboek*, Amsterdam: Frederik Muller.

Van Dijk, P. A. L. E. (1894), 'Rapport betreffende de Si Baloengoensche Landschappen Tandjoeng Kasau, Tanah Djawa en Si Antar', *Tijdschrift voor Indische Taal-, Land- en Volkenkunde/Bataviaasch Genootschap van Kunsten en Wetenschappen*, 37: 145-200.

—— (1895), 'Nota van toelichting op "Eene bijdrage tot de geschiedenis der ontdekking van het Toba-meer" door C. M. Pleyte Wzn', *Tijdschrift van het Aardrijkskundig Genootschap*, 12(2): 491–3.

Van Langen, K. F. H. (1888), 'De Inrichting van het Atjehse Staatsbestuur onder Het Sultanaat', *Bijdragen tot de Taal-, Land- en Volkenkunde*, 37(3): 381–471.

Van Leur, J. C. (1955), *Indonesian Trade and Society: Essays in Asian Social and Economic History*, The Hague: W. van Hoeve: reprinted Amsterdam: G. A. van Oorschot, 1983.

Vergouwen, J. C. (1932), 'Een Italiaan onder de Bataks', *Koloniaal Tijdschrift*, 21: 547–60.

—— (1964), *The Social Organization and Customary Law of the Toba-Batak of Northern Sumatra*, Koninklijk Instituut voor Taal-, Land- en Volkenkunde Translation Series 7, The Hague: Martinus Nijhoff; originally published as *Het Rechtsleven der Toba-Bataks*, 1933.

Veth, P. J. (1867), *Schets van het Eiland Sumatra*, Amsterdam: P. N. van Kampen.

Visser, H. F. E. (1918–19), 'Tentoonstelling der Oost-Indische Weefsel-Collectie van Kerckhoff in het Museum voor Land- en Volkenkunde te Rotterdam (Eind Maart tot Half Juni 1918)', *Cultureel Indie*, 7: 17–33.

Volz, W. (1909), *Noord-Sumatra, Band 1, Die Bataklander*, Berlin: Dietrich Reimer.

Von Brenner-Felsach, J. F. (1890), 'Reise durch die unabhangigen Battak-Lande und auf der Insel Nias', *Mittheilungen der Kai, Konigl. Geographischen Gesellschaft in Wien*, pp. 276–305.

—— (1894), *Besuch bei den Kannibalen Sumatras: Erste Durchquerung der unabhangigen Batak-lande*, Wurzburg: Verlag von Leo Woerl.

Voorhoeve, P. (1958), 'Batakse Buffelwichelarij', *Bijdragen tot de Taal-, Land-en Volkenkunde*, 114: 238–48.

—— (1977), *Codices Batacici*, Leiden: Universitaire Pers.

Warneck, J. (1915), 'Das Opfer bei den Tobabatak in Sumatra', *Archiv fur Religionswissenschaft*, 18: 333–84.

—— (1911), *50 Jahre Batakmission in Sumatra*, Berlin: Verlag von Martin Warneck.

—— (1932), 'Mission und Volksleben in den Bataklanden', *Mededeelingen Tijdschrift voor Zendingswetenschap*, 76: 84–103.

Wadsworth, A. P. and de Lacy Mann, J. (1931), *The Cotton Trade and Industrial Lancashire 1600–1780*, Manchester: Manchester University Press.

Willer, T. I. (1846), *Verzameling der Battahsche Wetten en Instellingen in Mandheling en Pertibi; gevolgd van een overzigt van Land en Volk in die Streken*, Batavia: Bataviaasch Genootschap.

Winkler, J. (1925), *Die Toba-Batak auf Sumatra in gesunden und kranken Tagen*, Stuttgart: Chr. Belsen U. B. Verlagsbuchhandlung.

Wisselink, J. (1931), *De Vestiging Eener Katoen-Industrie in Nederlandsch-Indie*,

Rotterdam: Nijgh en van Ditmar N. V., Rede bij de aanvaarding van het Ambt van bijzonder hoogleeraar aan de Nederlandsche Handels-Hooge-school te Rotterdam, op 3 juni 1931, Rotterdam, Economisch Instituut voor de Textiele-Industrie Nederlandsch Economische Hoogeschool.

Ypes, W. H. K. (1907), 'Nota omtrent Singkel en de Pakpak Landen', *Tijdschrift voor Indische Taal-, Land- en Volkenkunde*, 49: 355–642.

_____ (1932), *Bijdrage tot de Kennis van de Stamverwantschap, de Inheemsche Rechtsgemeenschappen en het Grondenrecht der Toba- en Dairibataks*, Leiden: Adatrechtstichting.

Zuelzer, F. D. (1929), 'Die Battakker', *Zeitschrift fur Ethnologie*, Organ der Berliner Gesellschaft fur Anthropologie, Ethnologie und Urgeschichte, 61: 202–7.

# Index